PHOTOGRAPHING
PEOPLE

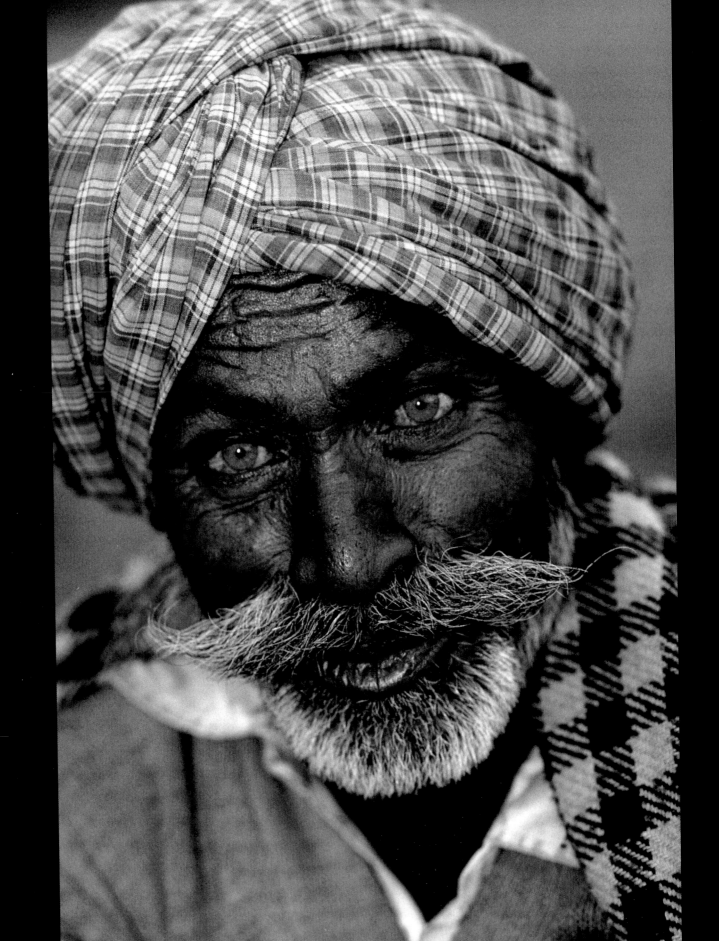

PHOTOGRAPHING PEOPLE

Roderick Macmillan

photographers'
pip
institute press

First published 2005 by Photographers' Institute Press,
an imprint of The Guild of Master Craftsman Publications,
166 High Street, Lewes, East Sussex BN7 1XU

Text and photographs © Roderick Macmillan, 2005
Copyright in the Work © Photographers' Institute Press/GMC Publications, 2005

ISBN 1 86108 313 0
A catalogue record of this book is available from the British Library.

All rights reserved

The right of Roderick Macmillan to be identified as the author of this work has been asserted in
accordance with the Copyright Designs and Patents Act 1988, Sections 77 and 78.
No part of this publication may be reproduced, stored in a retrieval system, or transmitted in any form
or by any means without the prior permission of the publishers and copyright owner.
The publishers and author can accept no legal responsibility for any consequences arising for the
application of information, advice or instructions given in this publication.
Views expressed in these images do not necessarily represent those of the publishers or author.

Production Manager: Hilary MacCallum
Managing Editor: Gerrie Purcell
Commissioning Editor: April McCroskie
Photography Books Editor: James Beattie
Project Editor: James Evans

Cover design: Oliver Prentice
Book design: Geoff Francis
Typefaces: Garamond/Frutiger

Colour origination by Icon Reproduction, London
Printed and bound by Kyodo Printing, Singapore

Acknowledgements

First and foremost, thanks are due to Margaret
for her encouragement, understanding, tolerance
and direct assistance. She has shared every mile
of the long and sometimes difficult road to
completion of this book project.
I am truly grateful.

I must also acknowledge the advice of Jonns
Frégence and Philippe Bricart of Focus Image,
Paris, and the support of all the models and
dancers – professional, semi-professional and
amateur – who contributed so much.
Other people, too numerous to name
individually, helped in countless different ways.
They contributed key pieces of information,
good advice, equipment, props and of course
their time and effort. Some made the ultimate
sacrifice and became my subjects – sincere thanks
to them all. Finally, I am grateful to those who
granted photographic access to business and
private premises.

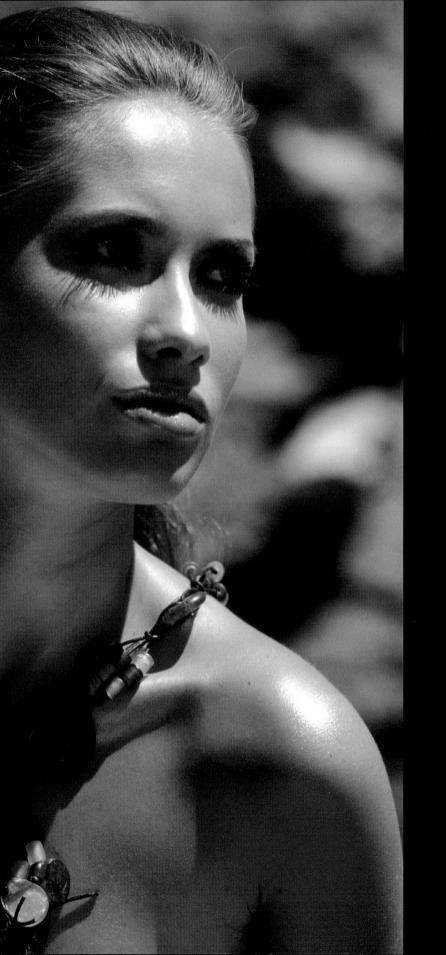

Contents

Introduction

Everyone is involved in social photography to some extent. High-street photolabs process millions of pictures of people – family and friends, clubbers, wedding guests and so on. The prints go into pockets and bags alongside the digital cameras and mobile phones that are increasingly used to capture and transmit their electronic equivalents. However, most of them have little aesthetic value and consequently are of limited interest to anyone but those directly involved.

This book aims to broaden the appeal of people pictures by explaining sound techniques for their planning and creation. It addresses the photography of people in a wide range of circumstances and environments, and provides guidance on numerous interrelated human, artistic and technical issues.

FINDING INSPIRATION

Snapshots taken with no particular purpose in mind are unlikely to record more than simple likenesses. They are merely the first tentative step on the long and fascinating road to successful people photography. Consequently, whether you are a committed social photographer, wish to do better in your local photographic society's competitions, or just improve how you record the everyday life of your family, motives and objectives must be clarified.

Enthusiasm for photographing people should arise from an interest in human beings as well as photography. People are all individuals, free spirits with unique personalities and circumstances – look at their extraordinarily expressive faces, observe their behaviour, and you should see something of their lives. Try a bit of people watching. Relax in a coffee shop and study the interactions of people dealing with everyday events, or watch the theatrical performances on foreign beaches inspired by sunshine, distance from home and a colourful sarong. If you find the whole pantomime intriguing, you are off to a good start.

It was travelling that did it for me. Over the years, a series of journeys has taken me to a hundred countries and all seven continents. Driven by global curiosity and a passion for photography I searched for extraordinary but honest images of the world. At first I was interested in anything and everything, and wanted to go everywhere. I photographed everything that moved – and most things that didn't. Then I realized it couldn't all be done, and anyway it wouldn't mean very much. The world was too large and varied, and life was far too short. I had to be more selective.

Gradually my focus shifted to the living world, and then on to human beings. Encounters with tribal people, and with the harsh but colourful reality of their traditional lives, invariably left their mark. Those in India, Tibet, Southeast Asia, South America and Papua New Guinea were particularly memorable. However, it was the simple realization that the hopes and fears of these dignified people were basically the same as my own that obscured cultural differences and eventually led to a broader interest in photographing people everywhere. I had come home and finally found my niche, but still had too many subjects.

PEOPLE AND IMAGES

An interest in people is an important foundation, but is not, on its own, enough. It is also vital to be image-driven. The priorities of too many photographers are centred on cameras and the latest digital technology rather than the joys and merits of successful images. Think about people and images rather than tools and technology; it is much more creative and satisfying.

Of course, it is necessary to have appropriate equipment and to know how to use it, but that is merely preparation. We must also learn to choose appropriate locations and understand how they might be used. We must recognize the characteristics of light, and observe how a subject is illuminated. Finally, we should think carefully about how to capture the best moments, expressions and moods.

As photographers we are the key element of the image-making process and must be able to establish a rapport with our subjects. With this in mind it is probably also worth acknowledging our own nature. Do we have effective interpersonal skills? Do we enjoy approaching strangers, communicating with others and getting involved? Despite inhibitions, most of us do.

Masqueraders at Venice Carnival are easy to approach and want to be photographed. Good depth of field was needed to keep both subjects acceptably sharp, and this dictated my choice of aperture.
Nikon F5 with 85mm f/1.8 Nikkor AFD, Fujichrome Sensia 200, 1/250sec at f/8

Finally, remember that the achievement of high standards implies the investment of a lot of time and effort. Good images of people are not easily created, so do a lot of photography and learn to be selective. Regard waste bins and delete buttons as friends. If your work attracts criticism, or is rejected in some way, listen and try to remain objective. Recognize the problems, get advice on how to do better, and spend a lot of time looking at comparable work by acknowledged experts. There is always room for improvement in creative endeavour.

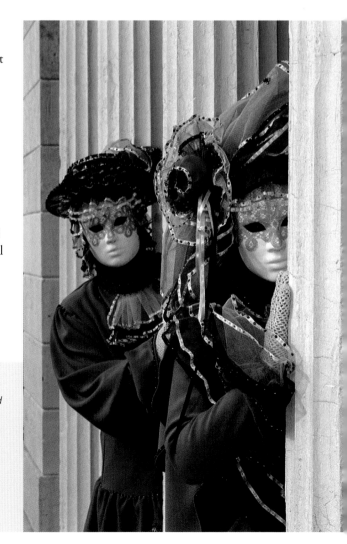

 EQUIPMENT & ACCESSORIES

A bewildering array of equipment is available to photographers, from cameras and lenses to accessories of every description. Nevertheless, photography is about images – cameras and lenses are merely the tools of the trade.

Technical quality and aesthetic value are both desirable aspects of an image, but they should not be confused. Better equipment may make a difference when it overcomes performance limitations, but is unlikely to enhance the artistic merits of your images.

This Indian woman was photographed using automatic focus, exposure and fill-in flash settings. The only manual intervention was to set –²/₃ stop flash compensation. **Nikon F4 with 135mm f/2 DC Nikkor AFD, Kodachrome 200, 1/250sec at f/11**

CHOOSING THE RIGHT CAMERA

The wisest long-term approach to the process of acquiring camera equipment is to buy into a comprehensive system of compatible items produced by a major manufacturer. The first step is to choose an appropriate camera format, a choice that must be based upon personal objectives and budget. However, reliability, flexibility, robustness, image quality, size, features and ease of use should all be considered. This decision is important because it sets the future pattern for purchasing lenses and accessories.

Professional cameras are expensive and may have fewer features than cheaper amateur models. Nevertheless, they are more robust and reliable, and are likely to be faster and more precise in operation. In general, good-quality basic features are more valuable than gimmicks, so buy the highest quality camera body you can afford and add lenses, flashguns, a second body and other accessories later. Finally, it is important to feel comfortable with whatever equipment you choose, so make sure it suits your hands, eyesight and preferred methods of working.

For photographing people the choice is really between a 35mm SLR (or the digital equivalent) and medium format. Compact cameras are more useful for snapshots, where image quality is not critical, and medium and large-format cameras are often impractical.

Digital and 35mm SLRs are unrivalled in terms of versatility, automation and the availability of lenses and accessories. They offer various combinations of automatic and manual modes for focus and exposure control, and although automatic settings are not appropriate in all circumstances, their speed and accuracy can be invaluable when photographing people. In particular, they free the photographer to concentrate upon composition and expression. SLRs are also less intimidating and intrusive than larger cameras, and this has a bearing upon the reactions of subjects.

Medium-format cameras are also flexible, and their larger film size is easier to view without magnification and provides excellent image quality, but only a few models feature automation comparable with digital or 35mm SLRs. Also, such cameras are less suited to location work because of the size and weight of the lenses, and the need to use a tripod for support.

EQUIPMENT

CAMERA SYSTEMS

Camera equipment can represent a major investment, so it is worth taking the time to think carefully about which system you buy into. The decision will inevitably be dependent upon budget constraints, but should also reflect the uses to which the equipment will be put. In this respect, different systems have different strengths and weaknesses. A further key consideration is the choice of manufacturer, as this will, to some extent, influence future purchases of lenses and accessories.

Compact

Compact 35mm equipment is probably the cheapest option and can produce acceptable results, especially if image quality is not critical. Advanced Photographic System (APS) equipment is the easiest to use and offers different frame-size options, but it is more expensive to run and is now falling out of favour with manufacturers in face of competition from digital. Although some compact cameras have zoom lenses, no

models offer the versatility of interchangeable lenses.

Advantages: Cheap, lightweight, easy to use.
Disadvantages: Limited flexibility, inferior image quality, few accessories.

35mm SLR

35mm single-lens reflex (SLR) systems are by far the most versatile and highly developed. They are reasonably compact and light, provide good image quality (with a frame size of 24x36mm), and allow the user to view the subject through the lens. As well as interchangeable lenses, they offer through-the-lens (TTL) metering, and automatic and manual modes for exposure control, focus and film speed (DX) recognition. Wide ranges of other useful features and accessories are also available.

Advantages: Extremely versatile, huge range of features and accessories.
Disadvantages: Some models are battery-dependent, can be expensive.

Medium format

Medium-format systems are more bulky than their 35mm equivalents, and are typically used by those engaged in studio work or wedding photography. Most have interchangeable lenses and TTL viewing and metering systems, but only the more expensive models offer features comparable with those of 35mm or digital SLRs. Normal image sizes are 6x4.5, 6x6 and 6x7cm, and many models have interchangeable backs so that film types can be switched conveniently at any time. The large frame sizes mean that image quality is excellent.

Advantages: Excellent image quality, robust design, versatile.
Disadvantages: Larger, heavier and more expensive than 35mm or digital SLRs, also fewer accessories.

Large format

Large-format systems use a single sheet of film, commonly 5x4, 5x7 or 10x8in, and give the ultimate in image quality. They also allow total control over every aspect of the picture-taking process, including some advanced techniques relating to perspective and depth of field (such as tilt, shift or swing) not available on other formats. A versatile but expensive option, large-format cameras are mainly used by commercial and landscape photographers.

Advantages: Superb image quality and total control.

Disadvantages: Expensive, cumbersome, film less widely available, and demand technical proficiency.

Rangefinders

Available in 35mm (film and digital), medium and large formats, a major operating difference with cameras of this type is that the viewfinder image is gathered using a separate set of optics, rather than the main lens. By removing the need for a reflex viewing system, rangefinder cameras can generally be made smaller, lighter and quieter. However, the viewing system can make accurate composition difficult, especially at close range.

Advantages: Manual flexibility, unobtrusive (quiet) operation.

Disadvantages: Poor for close-up work, limited features (e.g. no autofocus or depth-of-field preview).

Digital

Digital systems are developing rapidly, and are arguably the future of photography. Compact, SLR and medium-format models are available, each offering varying degrees of sophistication and image quality. Images are stored as electronic data, and hence no film is required. Once downloaded onto a computer, the files can be manipulated using software, duplicated onto CD and printed using an ink-jet printer or at a high-street lab. Another major difference is the rear-mounted LCD screen, which can be used to preview composition and exposure.

Advantages: Possible low running costs, highly flexible, some lenses compatible with film SLRs.

Disadvantages: High set-up costs, steep learning curve, battery-dependent.

I met this girl in a crowded street and was attracted to her distinctive appearance. She allowed me just ten seconds of her time. The shot was possible only because my camera and flashgun were switched on and preset.

Nikon F5 with 105mm f/2.8 Micro Nikkor AFD, Fujichrome Sensia 200, 1/125sec at f/8

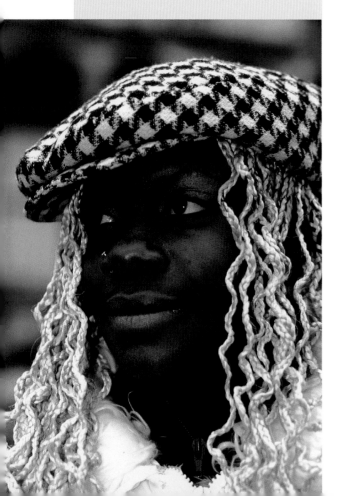

LENSES

More or less any lens can be used for photographing people, but the most useful ones are in the standard, wideangle and short telephoto ranges (see fig. 1). The focal length of a lens is measured as the distance (in millimetres) from the optical centre point of a lens to its focal point (i.e. the film or image sensor). However, the effect of focal length varies in relation to film format. For example, a standard lens for the 35mm format, designed to produce images that match human perception, has a focal length of 50mm. In the case of medium format, a comparable lens would have a focal length of about 80mm.

The effective focal length of lenses used on digital cameras is dependent upon the dimensions of the camera's image sensor. Full-frame sensors have the same surface dimensions as a 35mm frame, so the effective focal length is the same in both cases. However, many digital cameras have somewhat smaller cropped sensors. The apparent change in reproduction ratio varies with sensor dimensions, but a common guideline for digital SLRs is to assume that focal length is multiplied by a factor of about 1.5x – i.e. a 28mm lens (on 35mm format) becomes 42mm (when used on a cropped sensor). For convenience, most manufacturers provide 35mm-format equivalent focal lengths in specifications.

CHECKLIST

Useful facilities for portrait work:
- ◼ TTL exposure control
- ◼ Automatic exposure modes
- ◼ Exposure compensation facility
- ◼ Autofocus
- ◼ Depth-of-field preview
- ◼ Flash compensation
- ◼ Clear focusing screen and data display
- ◼ External flash synchronization socket

I frequently use a 20–35mm wideangle zoom with 35mm cameras, the zoom giving a little flexibility when framing shots. Wideangle lenses have fields of view as broad as 100°, extensive depth of field and are useful for showing people in their surroundings.

Telephoto lenses, on the other hand, let the photographer close in and isolate subjects from their environment. Focal lengths of 85mm, 105mm, 135mm, 200mm and 300mm are commonly used with 35mm cameras for this purpose. The shorter ones in this range are normally used at distances that imply some involvement with the subject; the longer ones are perhaps more useful for candid work. My own preference is for a wide-aperture 85mm lens and a 105mm macro lens that allows very close approach to the subject. Lenses having a focal length of 400mm or more are bulky and difficult to handle without a tripod.

Fig. 1 Lens focal length and field of view

This diagram shows the angle of view of popular wideangle, standard, short telephoto and telephoto lenses for the 35mm format.

A 300mm lens sees only 8° of a scene, whereas a 20mm lens sees about 94°. The apparent difference in perspective between lenses does not really exist. The narrow-angle view of the 300mm lens can be extracted from the centre of the field of view of wider-angle lens.

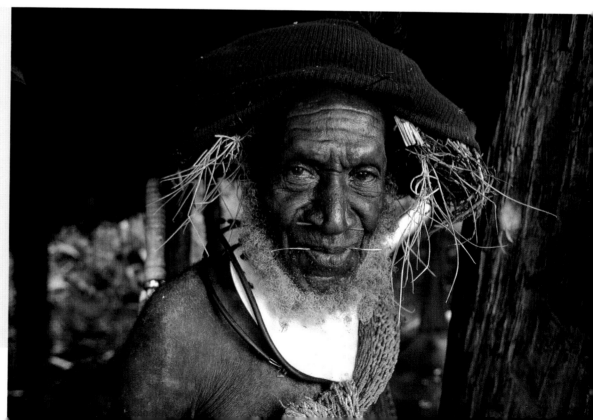

It is worth keeping a camera set for the prevailing conditions. This may mean changing lenses, exposure and flash settings in anticipation of a subject being found. This shot was obtained in poor light and the man moved on almost immediately.

Nikon F4 with 20–35mm f/2.8 Nikkor AFD, Kodachrome 200, 1/60sec at f/5.6

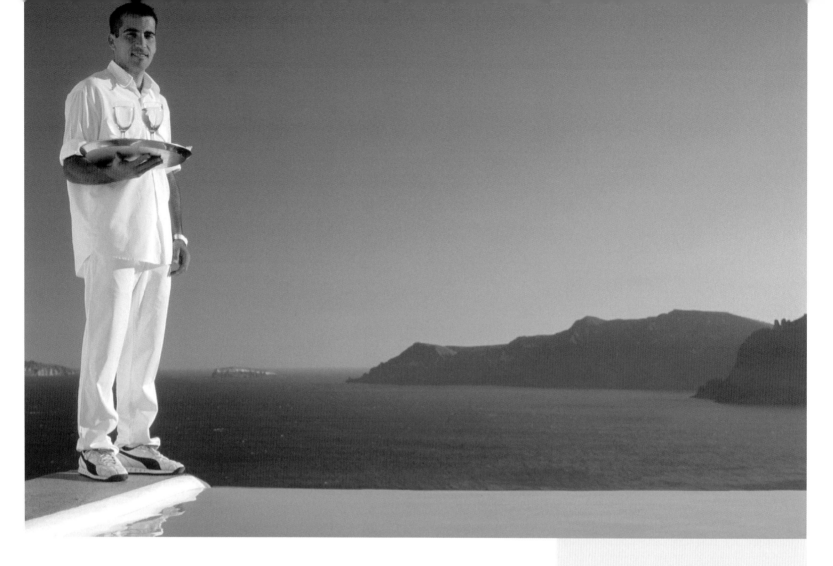

FLASHGUNS AND REFLECTORS

Flash units are most useful for filling shadows and reducing contrast. However, those built into compact cameras and some SLRs are inflexible and of limited power. If used frequently they soon exhaust expensive camera batteries.

A flashgun that fits on a hot-shoe on top of the camera, and uses its own batteries, is more satisfactory. Non-dedicated units are effective, but dedicated models are better. They are fully integrated with the camera's electronics, allow precise automated control of light output, and may feature red-eye reduction and autofocus-assist illumination.

With the correct lead, they can also be used off-camera, which increases flexibility and further helps to eliminate red-eye. More powerful hand-held units are also available. These use larger rechargeable batteries, have faster recycling times, and must be connected to the camera using an appropriate lead.

Although not always suitable for photographing people, the shadowless light produced by a ring flash (a circular lighting tube that surrounds the lens) can be useful for close-up and fashion photography. Ring flash also puts distinctive annular (i.e. ring-shaped) highlights in eyes.

I asked this waiter to stand on the wet edge of the infinity pool. However, the retaining wall was narrow and heralded a drop of about 15ft (4.5m) so he sensibly declined and stayed by the side of the pool. Fill-in flash was essential to balance the illumination of foreground and background. Thanks to Katikies Hotel, Santorini, Greece for photographic access.

Nikon F4 with 85mm f/1.8 Nikkor AFD, Fujichrome Astia 100, 1/250sec at f/11

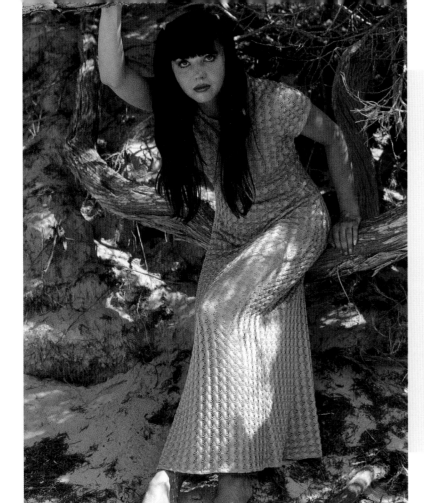

The bark of this fallen tree reminded me of a dress the model had in her bag. She changed on the spot, and within a few minutes we had a completely unplanned image. A half-gold reflector was used to fill the shadows.

Nikon F5 with 85mm f/1.8 Nikkor AFD, Fujichrome Astia 100, 1/125sec at f/5.6

READ ON

Red-eye phenomenon
p.21

Fill-in flash
p.52

Scattered and reflected light
p.66

Studios: Lighting
p.114

EQUIPMENT

BATTERIES

Fresh batteries are essential, and spares should always be available. Try to minimize the number of types required. I use only the widely available AA size. Experience shows that cheap brands save nothing in the long term, and may well let you down. Also remember to protect batteries from sub-zero temperatures, as capability may be impaired.

Reflectors are also useful for filling shadows and reducing contrast. Sheets of white paper or polystyrene are often employed, but tailor-made fold-up reflectors with various warm and cool surfaces are the most practical. Gold or half-gold surfaces are particularly effective for portraiture because they reflect warm light sympathetic to natural skin tones.

Controlling flash

The ability to apply compensation to automatic flash exposures is useful for portrait work when using daylight fill-in flash. It enables the photographer to adjust flash output relative to an automatically calculated base level. Any required ratio of flash to ambient light is therefore readily achievable. Compensation values between $-\frac{1}{3}$ stop and -2 stops are most commonly used.

It can also be beneficial to soften and warm the light emitted by a flashgun and hence give a more natural and flattering feel to a portrait. A diffuser placed over a flash head softens the light to some extent, and simple translucent plastic covers and more sophisticated miniature softboxes are available. A flash filter such as an 81A or 81B can also be placed over a head to warm up skin tones. This is particularly advantageous when photographing swimsuit models or nudes.

CAMERA SUPPORTS

Cameras need to be held particularly steady when using slow shutter speeds or telephoto lenses. In general, the slowest acceptable shutter speed for hand-held work is numerically equal to the focal length of the lens. For example, a speed of 1/200sec would be the slowest recommended speed when using a 200mm lens. Using a slower speed than this without support might produce an image blurred by camera movement.

Tripods

Tripods provide three-dimensional stability, but can be restricting when working with people. A lightweight carbon-fibre model with independently adjustable tubular legs is ideal. It should extend to head height and be used in conjunction with a remote release to further reduce the risk of camera movement at the moment of exposure.

Types of tripod head vary from one manufacturer to another, although they can be divided into two basic mechanisms: pan-and-tilt heads, and ball heads. The pan-and-tilt design uses two or three independent controls to position the camera; ball heads facilitate almost infinite adjustment under the control of a single knob. The latter is quicker to operate, but arguably less secure. Quick-release mechanisms that utilize a locking plate screwed into the tripod bush of a

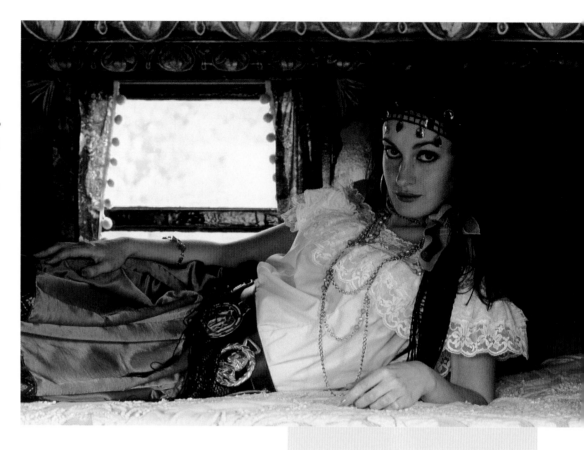

camera or telephoto lens are very easy to use and make changes of camera or lens possible in just a few seconds.

Monopods

Monopods offer support in only one dimension and must be used in conjunction with a steady hand. However, they are less restricting when it comes to moving about, and with practice can extend the range of useable shutter speeds by a couple of stops.

The light in this Romany caravan was poor and flash would have killed the atmosphere, so use of a slow shutter speed was essential. The camera was therefore mounted on a stable tripod and the girl was asked to remain motionless.

Nikon F5 with 50mm f/1.4 Nikkor AFD, Fujichrome Sensia 200, 1/20sec at f/5.6

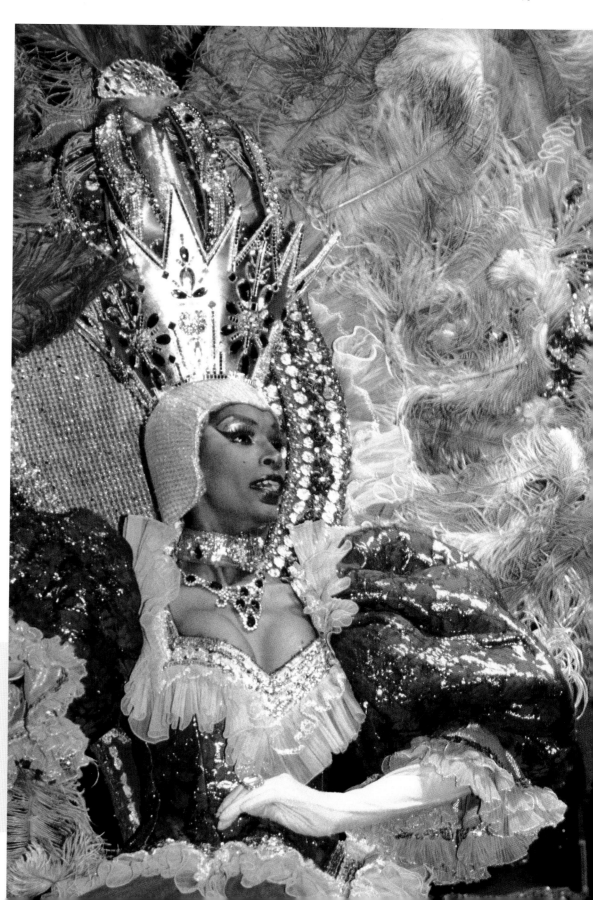

EQUIPMENT

CAMERA BAGS

A good camera bag or case protects
expensive equipment while leaving it
readily accessible. When working away
from base a secure, weatherproof product
is essential. Design and capacity are largely
matters of personal choice, but I prefer the
convenience of a medium-sized shoulder
bag. Small bags fill up quickly, and larger
ones can be very heavy when loaded.
I have two, but mostly use the older
shabbier one to avoid attracting attention.
Think carefully about what is needed for
each trip, and reject anything you can
cope without.

The only way to freeze the movement of this exuberant
dancer in Rio's Carnival was to use direct flash. A tripod
was impractical, but a monopod helped to keep the
camera reasonably stable.

Nikon FE with 135mm f/2.8 Nikkor MF,
Kodachrome 64, 1/60sec at f/4

READ ON

Lens flare

p.68

Sources of colour

p.71

Colour-conversion filters

p.73

EQUIPMENT

FILTERS

Filters are useful accessories in some circumstances. They are available in three basic forms. The circular screw-on type threads onto the front of a lens, and must be of the correct diameter. The rectangular type is more versatile, and slots into a standard holder that can be used with many different lenses. A third, less-common type slots into the rear of a lens. Any filter should be of high optical quality – there is little point in using an expensive lens with a low-quality filter, as image quality will be impaired.

FILTER	EFFECT
Soft focus	Flatters a less than perfect complexion; can also be used to change the mood of a scene.
Colour correction	Removes colour casts such as those produced by tungsten or fluorescent lighting; 81 series is useful for warming up skin tones.
Neutral density (ND)	Reduces the amount of light entering the lens without changing its colour, enabling a slower shutter speed to be set when required.
ND grad	A graduated version of a neutral-density filter that can be used to compensate for extreme contrast in a scene, such as when a sky is much brighter than the ground.
Polarizer	Reduces the intensity of reflections and increases colour saturation; circular, rather than linear, versions must be used with autofocus cameras.
Skylight and UV	Filters out UV (ultraviolet) light, which can cause a bluish haze in colour pictures and loss of definition in distant objects. Can be left on to protect the front lens element from damage. Skylight filter also adds warmth to a scene.

EQUIPMENT

LENS HOODS

Lens hoods offer some protection for the front lens element, but their principal role is to prevent light from outside the subject area reaching the film. They reduce flare, maximize contrast and colour saturation, and are particularly important when directing a lens close to a light source. Some lenses have their own built-in extendable hoods, but various accessory types are available: petal-shaped hoods help to avoid vignetting (dark edges in the corners of the frame), and flexible rubber hoods fold flat and are easy to store.

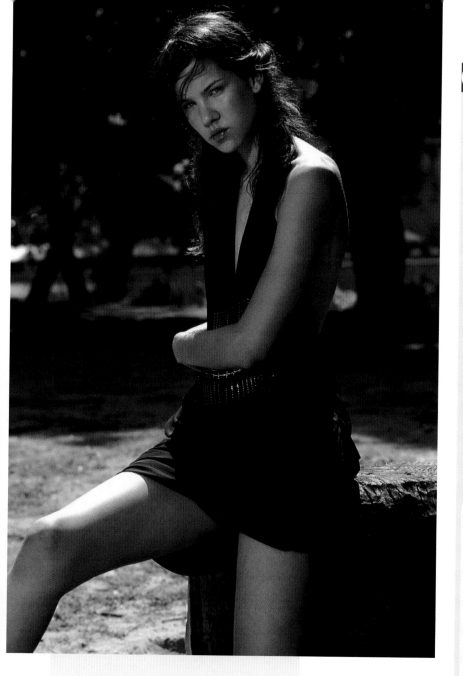

The camera was directed close to the sun for this shot, so a good lens hood was essential to avoid flare.

Nikon F5 with 85mm f/1.8 Nikkor AFD, Fujichrome Astia 100, 1/250sec at f5.6

CASE STUDY

THE RED-EYE PHENOMENON

The red-eye phenomenon reveals itself when the light from a flash is reflected back by the retina of a subject's eye (this is turned red or pink by blood vessels in the retina). The effect varies from person to person, but is worst in poor light or when the subject looks directly into the lens. It is most likely to occur when the angle subtended by the flashgun and lens, as seen by the subject, is less than about two degrees. With built-in flash and camera-mounted flash, this arises when the subject is more distant than six and 16 feet (two and five metres) respectively. It can be reduced or eliminated by averting the subject's eyes, moving closer to the subject, or shifting the flashgun away from the lens axis. Some cameras also have a red-eye reduction facility. This fires just before the shutter is released, reducing the diameter of the pupils and limiting the red-eye effect.

To reduce the possible occurrence of the red-eye phenomenon, which would have ruined this image, I moved in close to the subject (checking that she was willing to cooperate).
Nikon F4 with 135mm f/2 DC Nikkor AFD, Kodachrome 200, 1/125sec at f/5.6

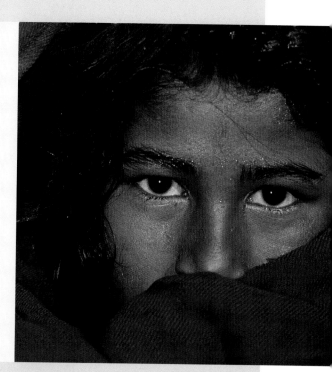

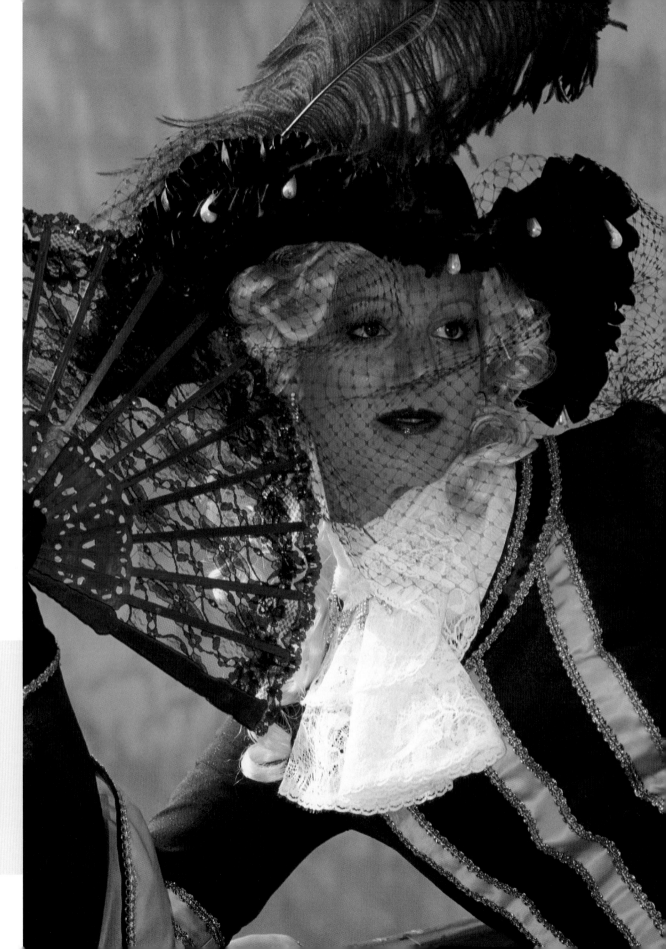

A film speed of ISO 200 has made it possible to freeze the movement of the fan with a reasonably fast shutter speed while retaining sufficient depth of field.

Nikon F5, 105mm f/2.8 Micro Nikkor AFD, Fujichrome Sensia 200, 1/250sec at f/5.6

EQUIPMENT

DIGITAL 'FILM'

Digital cameras use an array of light-sensitive sensors – usually a Charge-coupled Device (CCD) or Complementary Metal-oxide Semiconductor (CMOS) – in place of film. The camera's processor constructs an image by sampling the electronic signals from each sensor in the array. The image data is then written to a removable (and reusable) storage device – most commonly either a Microdrive or a CompactFlash card – from which it can be transferred to a computer.

FILM

Whatever camera format you choose, a huge array of films is available. As well as the more common varieties outlined below, this includes infrared film (both colour and black & white), those balanced for artificial light sources (e.g. tungsten), instant types (e.g. Polaroid) and low-contrast duplicating films.

It is undoubtedly worth standardizing on film stock. Every variety has slightly different exposure latitude, contrast, grain and so on, so sticking with one or two types helps to achieve an understanding of relevant characteristics. A further consideration is that films have a shelf life indicated by dates displayed on packaging. To avoid unwanted colour casts they should be used fresh, stored in a cool place and processed as soon as possible after exposure.

Most 35mm film cassettes feature DX coding, a chequer-board pattern used by cameras to set film speed automatically. DX coding also tells the camera how many frames there are on the roll.

Colour reversal film

If colour is the most appropriate medium for a subject, colour reversal film (also known as slides or transparencies) has a number of advantages. It has excellent colour saturation and sharpness, and produces positive first-generation images. Because they are easy to view and produce such high-quality results, transparencies are preferred by picture libraries and publishers. Try neutral, moderate-contrast films such as Fujichrome Astia or Ektachrome 100 Professional for portraiture.

READ ON

Exposure latitude

p.49

Infrared

p.170

Image sensors

p.178

Colour negative film

Colour negative film has greater exposure latitude than transparency film, and further correction is possible as second-generation positive images (usually prints) are produced. This makes it the first choice for the mass amateur market, and for compact cameras that may have less accurate exposure meters. While negative film cannot match transparency film for colour saturation, it is nevertheless extremely capable and versatile. It is also the medium of choice for many professional photographers. Kodak's Portra range and Fujifilm Fujicolor are good starting points.

Black & white

Black & white film is often used for general portraiture, reportage and nudes. The available range of speeds and other characteristics satisfies every imaginable application. Ilford Delta, Kodak T-MAX and Fujifilm Neopan are all excellent black & white films. 'Chromogenic' types, such as Ilford XP2 Super, Kodak BW400 CN and Fujicolor Neopan 400CN, can be processed using the standard high-street colour process (known as C-41) to produce monochrome prints.

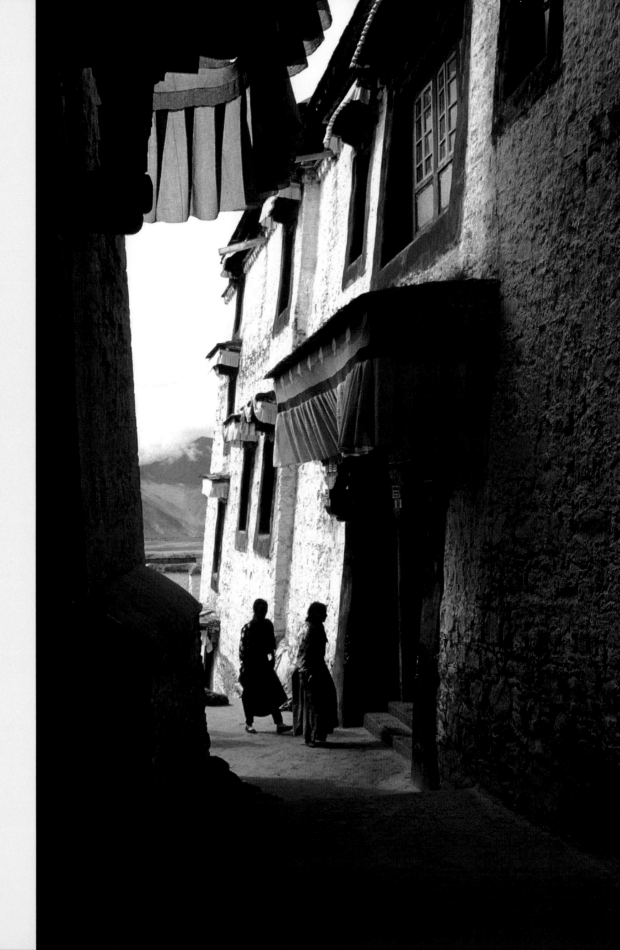

THEMES

THEMES

TRAVEL

THEMES

THEMES

Travel offers limitless photographic opportunities to those with the curiosity to explore. The first few days in an unfamiliar part of the world stimulate the senses and provoke fresh perception. This initial period is an excellent time to capture national or cultural characteristics.

The world is vast and offers more than one can absorb in a lifetime. Consequently, it is not possible to photograph every aspect of a region or culture. With this in mind it is worthwhile focusing on particular aspects of a journey that catch the eye. You might choose street life, people engaged in local crafts, or a particular ethnic group. Other subjects can still feature to some extent, but having a focus reduces the photographic challenge to a more manageable level.

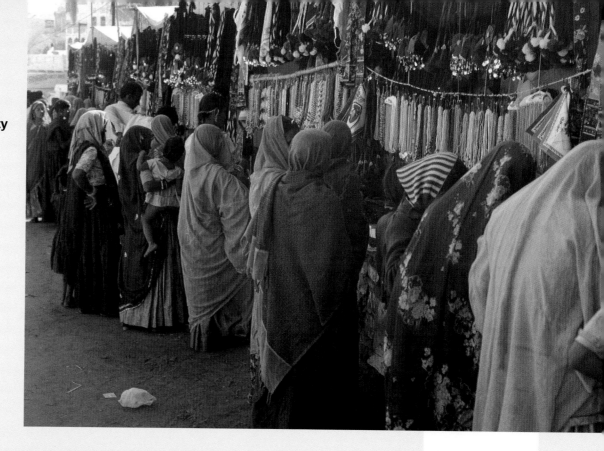

Over the years I have developed techniques that make my images possible. I travel for difference, seek the exotic and rely largely on non-verbal forms of communication. I never offer money to subjects as it damages interaction, but I give rather than take and always retain humility and a sense of humour. I research and respect local customs and sensitivities whatever their nature, and try to spend time with subjects before and after photographing them. How these principles are implemented is a matter for individual photographers, but they do work and have served me well.

The two figures are dwarfed by the vast walls of Tibet's Drepung Monastery – a reflection of the building's significance to devout Buddhists.

Nikon F4 with 35mm f/2.8 Nikkor AF, Kodachrome 64, 1/60sec at f/8

Dust suspended in the air has scattered the strong desert light. The result is a softer image with reduced colour saturation and contrast.

Nikon F4 with 50mm f/1.4 Nikkor AFD, Kodachrome 64, 1/250sec at f/8

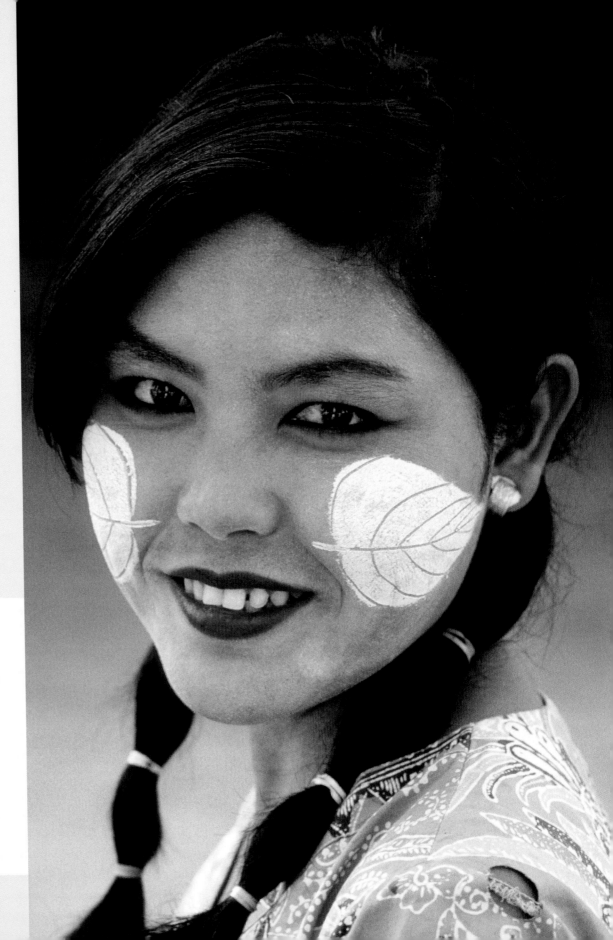

For this travel portrait
I have focused on the
characteristic Burmese
thanaka cosmetic and the
beautiful shape of the
woman's eyes.
**Nikon F4 with 135mm
f/2 DC Nikkor AFD,
Kodachrome 200,
1/125sec at f/8**

The face painter in St Mark's Square in Venice made an interesting portrait in her own right, but the inclusion of environmental detail and a disinterested secondary subject provides a broader context.
Nikon F5 with 20–35mm f/2.8 Nikkor AFD, Fujichrome Sensia 200, 1/250sec at f/11

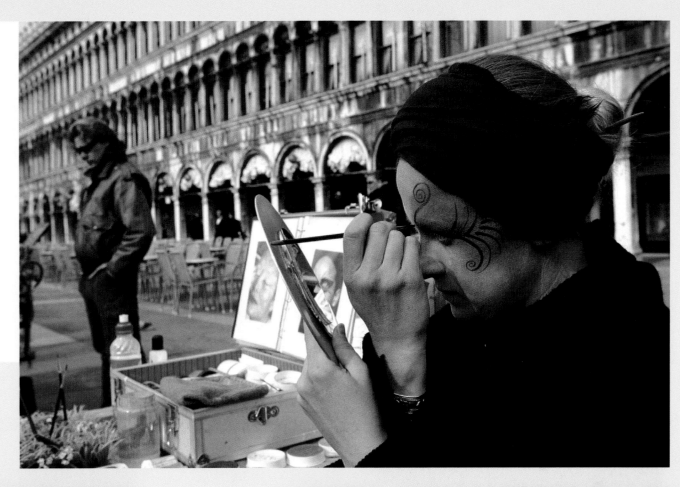

The old woman spinning the Buddhist prayer wheels at this Tibetan temple chose to ignore my camera. Images of this type can say a great deal about a country's culture and traditions.
Nikon F4 with 135mm f/2 DC Nikkor AFD, Kodachrome 64, 1/125sec at f/8

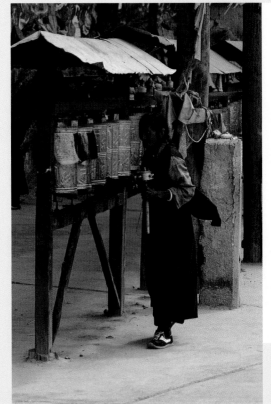

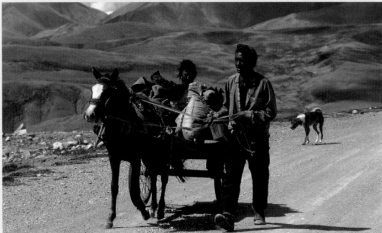

This man was moving quite fast despite the three-mile (5km) altitude of Tibet's Lung La Pass. I almost missed the shot in the moment it took to select a suitable shutter speed.
Nikon F4 with 135mm f/2 DC Nikkor AFD, Kodachrome 64, 1/250sec at f/5.6

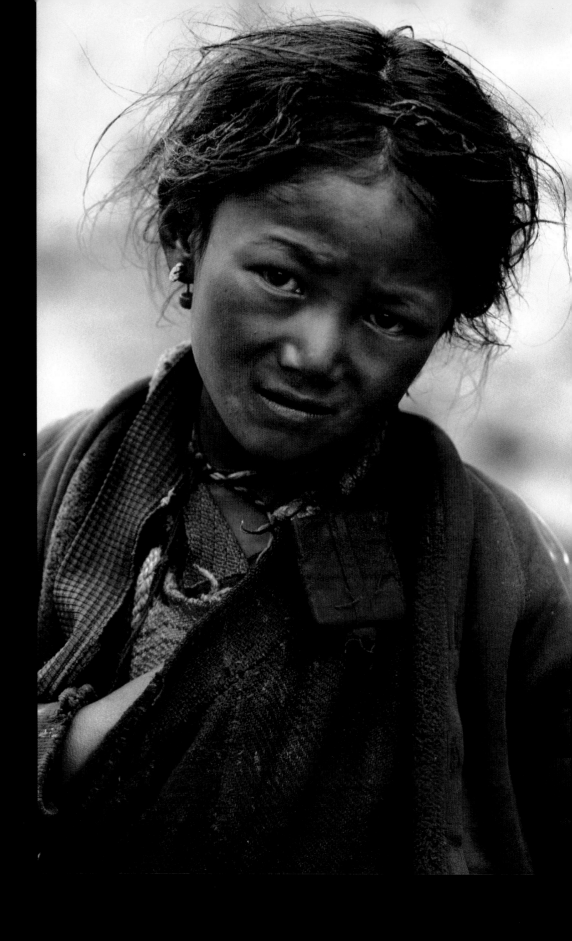

02 THE BASICS

Clear objectives, good preparation, confidence, technical competence and speed are fundamental in people photography. Before the creative process can begin, subjects must be found, and the lighting and general environment assessed. The photographer must also know how to capture an expression and be ready to seize the moment.

The serious expression on this little girl's face seemed indicative of the plight of the Tibetan people. She was photographed as part of an extensive travel portraiture project.
Nikon F4 with 135mm f/2 DC Nikkor AFD, Kodachrome 64, 1/125sec at f/4

OBJECTIVES

The objective of people photography is to reveal something of the lives and personalities of the subjects. Photographers should therefore engage with those involved to an extent that makes this possible. There is of course a degree of arrogance in this view, since it may be argued that perception is unlikely to achieve such clarity. Indeed, in our portrayal of others we may succeed only in revealing what lies inside ourselves. Nevertheless, a purely representational image captured for no particular reason is likely to fail because it cannot communicate with the viewer. The best possible starting point is therefore a clear understanding of intentions and purpose.

Objectives can be as simple as recording the retirement years of an elderly relative, or obtaining sports action shots for a photographic competition. Alternatively, try building a photographic project around a theme, aim to submit a portfolio of work to a magazine, photograph weddings or develop portfolios for aspiring models. A focus of this nature will provide beneficial direction and encourage depth and objectivity.

MASTERING EQUIPMENT

Having obtained photographic equipment appropriate to your chosen field of work and specific objectives, it is important to come to terms with it. Knowing how to operate the various bits and pieces is obviously important, but not sufficient. Speed is essential in many types of people photography, and split-second timing is necessary if fleeting expressions are to be captured. Familiarity should extend to a feel for every dial and menu. Modern cameras have very capable exposure calculation and focusing systems that operate almost instantaneously. The photographer should aim to raise the human game to a comparable level.

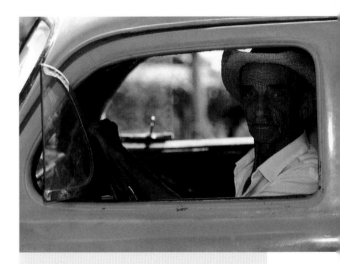

This Cuban man assumed I was interested in his old American car – Cuba is full of them. In fact, it was his deeply wrinkled face that caught my eye. The car's window became a convenient frame.
Nikon F5 with 135mm f/2 DC Nikkor AFD, Fujichrome Sensia 100, 1/125sec at f/5.6

Being at ease with hardware should liberate the mind from technical practicalities to an extent. This is important because photographing people is as much about interpersonal skills as it is about shutter speeds and lenses. Attention must be properly focused on the subject, human interaction and the need to find or elicit particular expressions. The right moment may pass very quickly, and we must be ready.

GETTING ORGANIZED

People who know they are being photographed soon tire of watching someone fiddle with bits of equipment. They do not necessarily understand the minutiae of photography, and are probably not interested – they just want to see the pictures. It is therefore wise to prepare everything as thoroughly as possible before engaging creatively in a photographic session.

There are many aspects to consider. Begin by visiting and assessing the chosen location. Measure light and contrast, decide what film is required, and consider whether to fill shadows by using reflectors or flash. Then find suitable locations and means of support for the various items of equipment. Also consider what circumstances may prevail at the time of the session, and how they might then change.

EQUIPMENT

TRAVEL CONSIDERATIONS

The practical considerations of travelling demand a degree of compromise with camera gear. Knowing what you intend to do reduces significantly the weight and volume of the equipment required.

I take a range of wideangle and short telephoto lenses, a couple of camera bodies and flashguns, and a handful of small accessories. When flying, this is all carried as hand baggage.

Film can be protected from the cumulative effects of airport X-rays by using lead-lined bags or requesting hand inspections. Digital cameras and memory cards should not be affected. In humid tropical conditions, exposed film should be stored in sealed polythene bags containing silica gel, and kept as cool as possible.

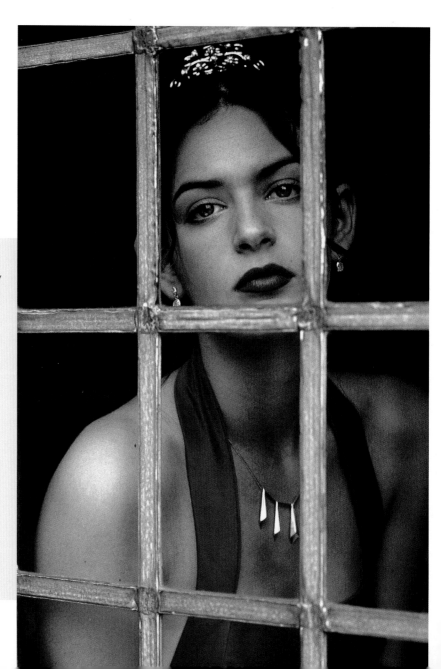

For this shot I found and cleaned the leaded window before involving the model. This left only the weather to chance. A reflector under the window reduced contrast and softened the shadow beneath the girl's chin.
Nikon F5 with 85mm f/1.8 Nikkor AFD, Kodachrome 200, 1/60sec at f/5.6

Is it likely to rain or be very windy? Is your presence likely to attract the interest of others? Indoors, check that there is sufficient room for people, equipment and props. Also make sure that there are no obvious hazards, and that you are not trespassing or likely to cause an obstruction. Last, but not least, provide for the safety, comfort and convenience of your subject or model.

Similar preparation should be made with regard to equipment. All the required items should be assembled before a session, and cameras should be loaded with film and batteries. The front and rear elements of each lens should be inspected and, where necessary, cleaned with a soft brush or micro-fibre anti-static cloth to reduce flare. Check that flash units are complete with suitable leads and supports, and that portable units are equipped with fresh batteries. Ensure that accessories, such as filters, camera supports and notebooks are available, and make sure you have sufficient spare batteries. Take more film than you expect to use – it is all too easy to run out. Finally, adjust cameras, lenses and flash units to their initial settings. These invariably change, but you will at least make a flying start.

These girls were photographed at a local fête. They were inside a white tent that diffused the direct sunlight. Fill-in flash has balanced foreground and background illumination and generally livened up the image.
Nikon F4 with 20–35mm f/2.8 Nikkor AFD, Fujichrome Astia 100, 1/60sec at f/5.6

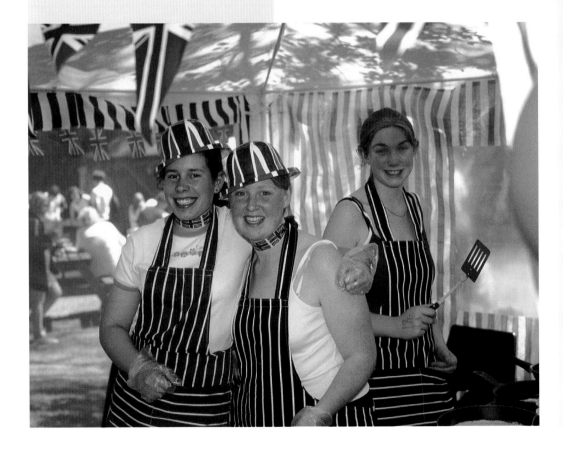

EQUIPMENT

LENS CLEANERS

Various forms of lens cleaner are available. These include camelhair brushes, blower brushes, lens tissues, micro-fibre anti-static cloths and compressed-air canisters. Specialist lens-cleaning fluids, which should be applied to a cleaning cloth rather than directly onto a lens, are also available. Eyeglass tissues should not be used as they are impregnated with chemicals that will damage lenses. The most important thing when cleaning a lens is to remove dust and other unwanted particles from the front and rear lens elements, which, if left, can cause flare. Larger grains should be removed gently with a soft brush or air blower to avoid scratching, and other marks (such as fingerprints or water droplets) can be wiped off using a soft optical cleaning cloth. Finally, do not clean lenses unnecessarily or excessively – it can lead to damage. The best solution is to avoid contamination by careful handling, and perhaps by leaving a skylight filter attached to the front of the lens.

CHECKLIST

Preparing your equipment:

- Load camera with film
 (or storage card)
- Select lens or lenses
- Inspect front and rear lens elements,
 and clean if necessary
- Assemble leads and supports for flash
 units and reflectors
- Load all equipment with batteries
- Pack filters, tripod and other
 accessories
- Pack spare film (or storage cards) and
 fresh batteries
- Establish initial camera, lens and flash
 settings

FINDING SUBJECTS

The world is full of people, currently something
like six billion of them. A few of them live in
your street, work with you or share your leisure
time. They are all potential subjects.
Every individual is different – unique in
appearance, personality and circumstances.
The challenge is to capture that individuality.

*The smiles of these three outgoing girls lit up the street.
They were members of a local dance group in Cuba and
were relaxing before an evening performance. People with
backgrounds of this type often make excellent subjects.*
**Nikon F5 with 85mm f/1.8 Nikkor AFD, Fujichrome
Sensia 100, 1/125sec at f/8**

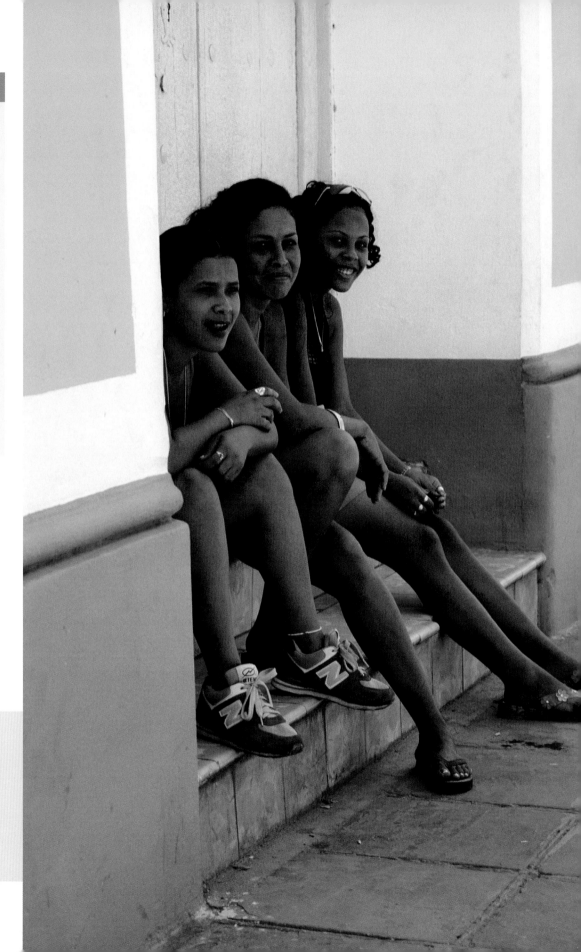

There are a number of basic approaches, each implying a different degree of involvement. Some people do candid work, using a telephoto lens, where no contact is necessary. Little planning is required, but the lack of communication shows in the images. Braver souls go in closer, get involved and use standard or wideangle lenses. Success here is much more dependent upon interpersonal skills.

Photographing people is not just about placing someone in front of your lens – far from it. It is about relating to people and communicating effectively. On too many occasions I am asked what camera, lens and film were used for a particular image with never a mention of how the subject was found or approached.

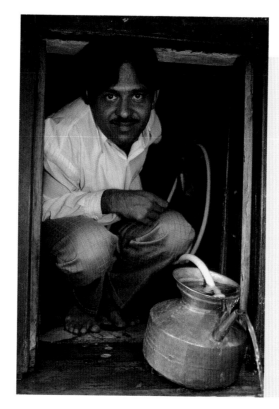

This Indian water seller was busy with a stream of customers and had no time for photographs. A smile and a sense of humour broke the ice, but I managed only a couple of shots.
Nikon F4 with 50mm f/1.4 Nikkor AFD, Kodachrome 200, 1/60sec at f/5.6

READ ON
Communicating with subjects
p.83
Seeing pictures
p.99
Approaches
p.116
Model release form
p.198

If the direct cooperation of subjects is required, more planning and preparation is needed. It may be necessary to find suitable people who are willing to make themselves available at a particular time and location. Start by seeking help from family and friends. It is easier and safer to approach those you know. However, the net will inevitably be cast wider as confidence grows and the enthusiasm of this inner circle wanes.

Where and how you search for new subjects will be dependent upon the type of photography you have in mind. Make sure this is clear in your own mind before you begin, then try placing an advertisement in a shop window, newspaper or magazine. Also make your interest known at local photographic clubs, college art departments, dance or drama groups and other similar organizations. People who have been trained to perform often make interesting subjects.

Another approach is to print cards giving your name and contact information. These can then be distributed locally and even handed to strangers in the street. Explain that you are a photographer working on a particular project, and that you are looking for models or subjects. Don't expect an immediate answer, and don't ask a second time – just leave your card and move on before embarrassment sets in. If those you meet want to make contact, they will do so.

People are often flattered by your interest in them, but make sure they understand your real motives. If you are planning to photograph anyone under the age of 18, seek the permission of a parent or guardian and, if appropriate, arrange for them to be present. Where this is simply not practicable – when working overseas, perhaps – your approach should be tailored to suit the specific circumstances.

A hidden agenda always leads to problems. If you like the local fishmonger's face because it is friendly and deeply wrinkled, then explain this to him – he knows anyway, so it will not come as a surprise. And if your interest in him is based upon making money, declare it. He is after all profiting by selling fish to your family. If you want to photograph a girl in a bikini because you think she has a beautiful face and a perfect figure, then be honest about it. If you intend sending the images to a magazine, explain this to her and ask her to sign a model release form.

Above all, don't get involved unless you can explain your motives. Openness will be rewarded with trust, and trust is the basis upon which good images are built.

EQUIPMENT

PORTFOLIOS

It is extremely helpful to assemble a credible portfolio – good prints of your best images in a well-presented case or folder. This is a convenient way to demonstrate genuine interest and show prospective subjects what type of work you have in mind. You can then discuss what the subject or model would like in return – perhaps prints.

CASE STUDY

CANDID PHOTOGRAPHY

The candid approach allows you to capture unposed, natural portraits, but has limitations. Furtive behaviour may arouse suspicion, but candid work does not have to be undertaken surreptitiously. When conducted openly, perhaps at a large open-air event, it is likely to be more acceptable. However, attitudes are not the same all over the world. In my experience, it is easier to earn trust in less-developed parts of the world than in the West, but mistakes can be made anywhere. In any case, don't expect every subject to share your enthusiasm. A few people may protest if they realize what you are doing, but most do not object to a camera used with sensitivity. This is where your cultural and social judgement comes into play. Consider in an appropriate local context how those around you will view your activities, then plan accordingly.

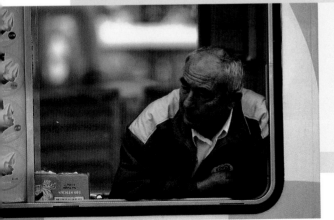

A quiet moment and a bit of people watching distracted this ice-cream salesman. I sat some distance away until he lost interest in me.
Nikon F4 with 300mm f/4 Nikkor AFD, Fujichrome Sensia 200, 1/250sec at f/4

APPROACHING PEOPLE

Should you choose to close in on a subject, the requirement to get involved will increase; the closer you go the greater the involvement. Many photographers admit to shying away for this reason. Try to see situations from the subject's point of view and remember that pointing a camera at a stranger may be regarded as rude or intrusive. Even those who enjoy the attention may soon lose interest. Gain experience with sitting ducks – buskers, street traders and performers, market folk and so on. Have the courage of your convictions and go for it, but retain a degree of sensitivity and don't expect universal acceptance. With experience you will develop a feel for who might enjoy or tolerate your attention. A helper can reduce the self-consciousness of the subject by distracting attention and keeping conversation flowing, but two people cause greater disruption than one. Do not persist if things feel wrong. Vulnerable people living on the streets, alcoholics, and various other groups may with some justification be suspicious of your motives. In such situations it is easy to get your camera smashed.

The simple courtesy of asking permission before photographing someone demonstrates initial sensitivity. If you don't speak the local language, use a gesture or make some small offering. If permission is refused, do not persist – how would you like it? Otherwise try to get involved in conversation. This breaks down barriers and encourages understanding on both sides. Openness and humility are usually appreciated and returned. Show an interest in your subject's activity and offer a smile, but not money – it changes attitudes and kills communication. Demonstrate that you are human, and that you have a sense of humour. Show your feelings and encourage emotional responses. Laugh at yourself and at preposterous situations. Aim to find some common ground or experience.

Even in today's fast-moving and cynical world there is a great deal of good in the majority of folk. Human warmth and compassion penetrate every social and cultural barrier. Give the best of yourself and some of it will be reflected. Be polite, take your time, say thank you and know when to leave.

Although many people are flattered by a photographer's interest in them, it is important to read expressions. This man's smile encouraged an approach.
Nikon F4 with 20–35mm f/2.8 Nikkor AFD, Kodachrome 200, 1/125sec at f/8

TECHNIQUE

Choosing a lens to photograph a particular subject is never easy. There is no definitive answer, no perfect focal length. Selection must be based upon personal style and the type of image required. The same subject in the same location can be portrayed in numerous different ways without moving from the spot. A telephoto lens will reduce the field of view and depth of field, and isolate subjects from their surroundings. A standard lens will give a more natural feel to the picture, with greater depth of field and perhaps some part of the surroundings included. A wideangle lens will portray subjects in the broader context of their environment; depth of field can be extensive, but care must be taken to avoid unsightly distortion.

CASE STUDY

THE IMPORTANCE OF EYES

The eyes are the point of contact when communicating with people and we tend to be drawn to them in a photograph, so it is important that they are in sharp focus. If this is impossible because of limited depth of field, as in a profile, keep the nearer eye sharp and let the more distant one go soft. In general, it is good practice to focus on the nearer eyelid. This is normally easy to achieve, but subjects and photographers move around and depth of field can be minimal. Where accuracy is critical, autofocus may prove beneficial. It achieves the necessary precision very quickly, and thus improves the chances of capturing the moment.

I spent some time with this bright little girl in Papua New Guinea, and used quite a bit of film. However, only this one image revealed her stunning wide eyes.
Nikon F4 with 20–35mm f/2.8 Nikkor AFD, Kodachrome 200, 1/60sec at f/5.6

This sadhu (a wandering Hindu holy man) was accustomed to being ignored as people stepped over him in the street, and was delighted when I sat down to talk to him. He subsequently invited me to take his photograph.
Nikon F4 with 105mm f/2.8 Micro Nikkor AFD, Kodachrome 200, 1/60sec at f/5.6

Ergonomic issues also have some bearing upon technique. When comfortable you are more likely to concentrate and attend to detail. Consequently it is worth making a situation as convenient as possible. I have sat in open sewers in India to photograph disabled people at ground level, but it is difficult to ignore the unpleasant aspects. Under more normal circumstances a tripod may be desirable to steady a heavy lens but its physical size and inconvenience can also make it impractical. Similarly, reflectors may need to be positioned on a stand, held by an assistant or rejected in favour of the simpler on-camera fill-in flash.

In achieving a degree of convenience, don't allow yourself to become rooted to the spot. Remain mobile – move up and down and from side to side. This reveals numerous subtly different angles of view and gives some control over the background. Try chin level for a man to give him an air of authority, and forehead level for a woman to give a more demure image. Even in this politically correct modern world your subjects may prefer these views.

READ ON

Depth of field: a

definition

p.55

Focus and depth of field

p.57

Collateral colours

p.73

Using movement

p.163

Hundreds of people were flowing past this band at a county show. However, by using a telephoto lens and waiting for a gap in the crowd I was eventually able to achieve a uniform background.
Nikon F5 with 300mm f/4 Nikkor AFD, Fujichrome Sensia 100, 1/250sec at f/5.6

BACKGROUNDS AND ENVIRONMENT

People can be photographed in any environment, and may be surrounded by unattractive clutter. Consequently, the background deserves a good deal of care. Look for a background that is reasonably uniform, muted and lacking in detail. Failing to do so is one of the most common mistakes made by inexperienced photographers, largely because the need to focus closely on a subject can distract the eye from other elements of an image.

Background distractions take many forms. Lack of uniformity, strong colours or a mass of detail in sharp focus can lead the eye away from the centre of interest. Avoid posts that project from the subject's head and disembodied limbs that creep into the edges of the frame.

A number of techniques can be used to remove interest from an unhelpful background. When a telephoto lens is set to a wide aperture, depth of field is limited and background detail drops out of focus. The effect is more pronounced when the subject is kept well away from background objects – a distance of just a couple of metres could be sufficient. Defocusing a background in this way softens transitions from dark to light, and from one colour to another, but strongly contrasting colours or light levels may be more difficult to conceal. For example, a startling mixture of complementary colours, such as red and blue, will still distract the eye. Consequently, it may be preferable to avoid a background of this nature unless it is a feature of the image. In difficult situations, move around and observe how the background changes. A single step in a particular direction may resolve the problem.

CASE STUDY

PANNING

When there is movement in a scene, unwanted background detail can be obscured by panning the camera. Setting a slow shutter speed, perhaps 1/30sec, will reduce the background to nondescript streaks while still retaining a good degree of sharpness in the main subject.

A completely different approach is to ensure that the background complements the subject in an unobtrusive manner. An easel bearing a canvas might provide a suitable background for a portrait of an artist, for example. Alternatively, broader background detail can be incorporated into the design of the image and used to provide context for the subject. The artist might, for instance, be shown working in a complete studio environment with much of the background detail clearly visible. A wideangle lens used close to the subject will achieve this result, although the design of the image may be more difficult to control. A measure of balance, such as that provided by a lightweight secondary subject, may be beneficial in images of this type.

LIGHT AND COLOUR

As photographers we must learn to understand light and to use it as our medium – the word photography means 'drawing with light'.
The ability to observe how light falls upon people and changes their appearance is fundamental. Three basic considerations are the harshness, direction and colour of light. These are discussed in detail in a later chapter, but we can make a start by recognizing each of these characteristics.

The harshness of the main source of light and the angle at which it falls onto a person determines the nature of the shadows present. A point source such as the sun or a naked lamp produces deep, well-defined and often

unattractive shadows. Larger, more diffused sources produce softer and more manageable illumination. If it is not possible to move the camera or subject to achieve reasonably uniform illumination, additional light, perhaps from a flashgun or reflector, must be thrown into the shadows to reduce contrast. Of course, flash can

The use of a wideangle lens has revealed something of the interesting environment in which this woman of the Palong tribe lives in Northern Thailand. The discoloration of her mouth is permanent, and has been caused by chewing betel nuts.
Nikon F4 with 20–35mm f/2.8 Nikkor AFD, Kodachrome 200, 1/125sec at f/5.6

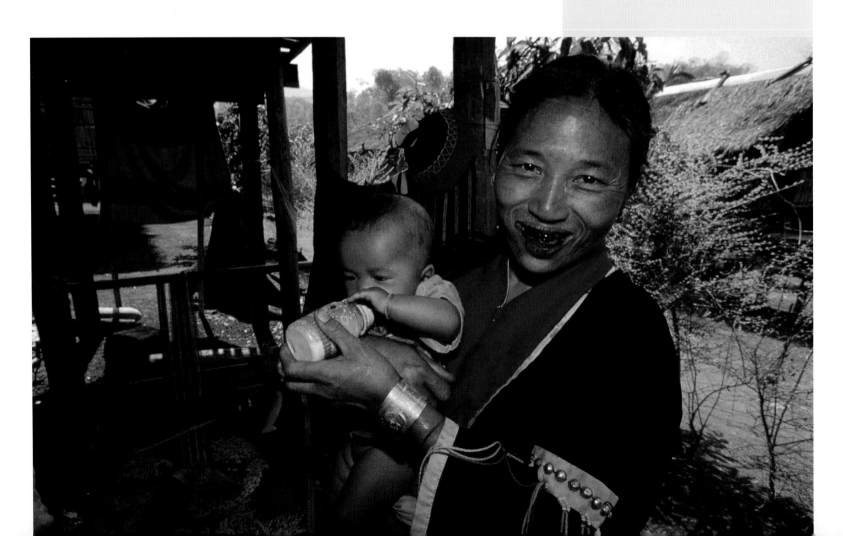

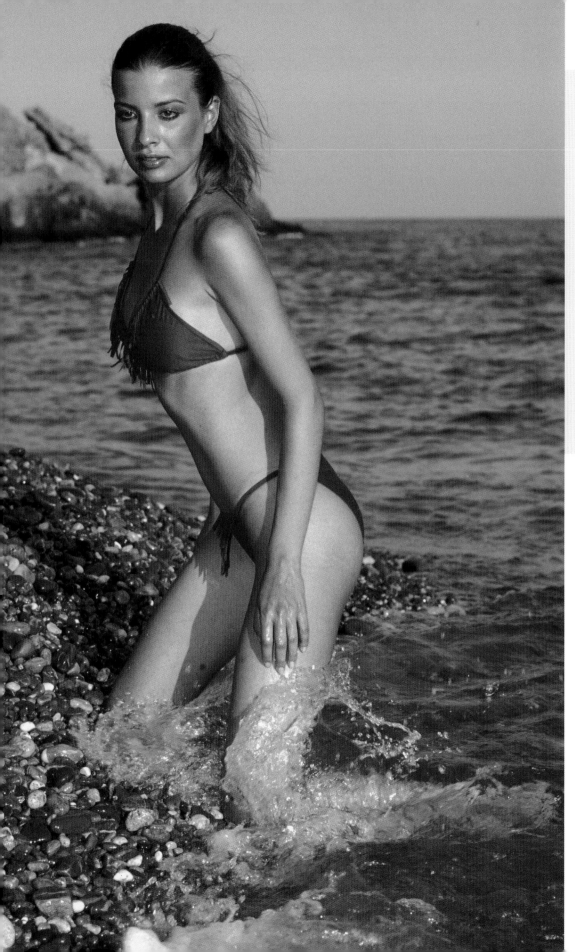

READ ON

The direction of light

p.65

Contrast

p.69

Sources of colour

p.71

Although harsh light produced deep shadows on this model's body, contrast was reduced by using a gold reflector and fill-in flash. Asking the model to kneel on the shingle was a mistake; when she stood up her knees revealed long-lasting red marks.

Nikon F5 with 85mm f/1.8 Nikkor AFD, Fujichrome Astia 100, 1/250sec at f/11

be used as the principal source of light, but it is more commonly employed to supplement available light. A reflector serves a similar purpose by redirecting and diffusing light from the principal source. It does not need to be a tailor-made photographic product – a large sheet of white paper or polystyrene will suffice.

The colour of light is more difficult to observe. Large colour shifts, such as those evidenced by the red light of sunset, are obvious. More subtle changes affect our perception of mood and atmosphere but tend to be corrected by the eye and brain. They may therefore not be registered in a conscious manner.

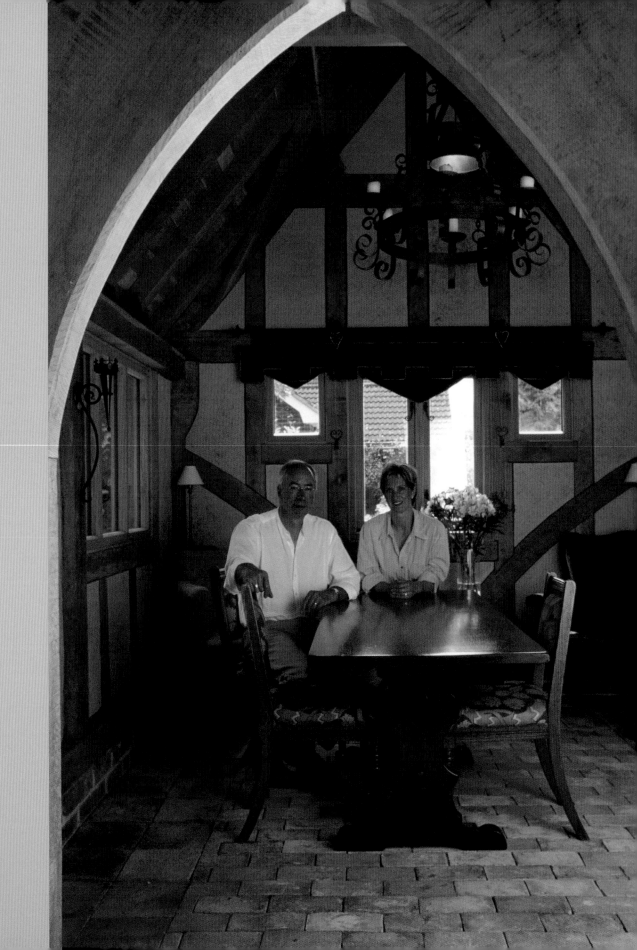

ON LOCATION

ON LOCATION

INTERIORS

ON LOCATION

ON LOCATION

GENERAL CONSIDERATIONS

Interiors are designed for people rather than photography. Natural light intensity may be inconveniently low, contrast excessive and space restricted. Human beings are extraordinarily well equipped to deal with these problems. Our eyes adapt rapidly to light and shade, and can easily handle a typical ten-stop range of brightness. We also have a wide field of view, extended by our ability to move our eyes and heads. Cameras, films and image sensors are much less sophisticated.

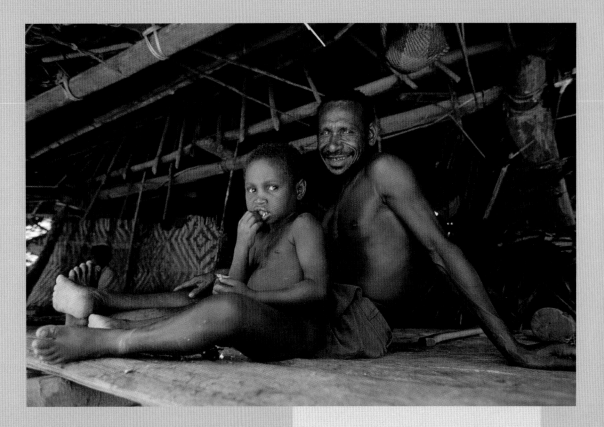

EQUIPMENT AND TECHNIQUE

When using restricted indoor environments for photographing people, a lens with a broad field of view can be employed to give a feeling of spaciousness. It can also be important to show that the environment is a room rather than just a wall or corner.
The angles of view of 16mm and 18mm lenses are about 180° and 100° respectively (on 35mm format), so these are the sorts of focal lengths we might consider using. Bear in mind that wideangle lenses exaggerate perspective and appear to distort objects close to the edge of an image. It is therefore generally good practice to move furniture away from the camera and keep subjects within the central half of the frame.

A difficulty with this sort of shot is getting into position to capture it. Here, I was lying on the raised living platform of a private house beside the Sepik River in Papua New Guinea. This attractively monochromatic image was captured with a wideangle lens.
Nikon F4 with 20–35mm f/2.8 Nikkor AFD, Kodachrome 200, 1/60sec at f/5.6

I lit this room by bouncing the output from a single studio flash unit off a large sheet of polystyrene. The near side of the archway was lit by a smaller slave unit.
Nikon F5 with 20–35mm f/2.8 Nikkor AFD, Fujichrome Sensia 100, 1/60sec at f/8

LIGHTING

Rooms are normally illuminated by light from windows and artificial lamps. Areas close to windows are well lit, but other regions are much darker. If, as a consequence, contrast exceeds the latitude of the film or sensor, action must be taken to reduce it. The situation can be relieved by excluding most of the window areas from the frame or by using flash, perhaps bounced off a reflector or white ceiling. Tungsten photofloods can also be used, but their lower colour temperature produces a warm yellow cast on daylight film. This can be rectified by using an appropriate blue colour-correction filter such as an 80B, by changing to Type A film that is balanced for photofloods, or by selecting the appropriate white balance setting on a digital camera. However, when natural and artificial light sources are mixed the situation gets more complicated. The simplest solution is then to ensure that one type of light dominates, and use an appropriate filter, film or shooting parameter. Imbalance from other sources usually remains tolerable.

This couple were photographed in the magnificent hallway of their ancestral home. I used two studio flash units directed diagonally into the far corners of the room.
Nikon F5 with 20–35mm f/2.8 Nikkor AFD, Fujichrome Provia 100, X sync at f/11

PRO TIP

Those who occupy domestic or business premises stamp their personalities upon them. While doors and windows are useful features around which to design an image, personal adaptations provide insight. In a private home, be sure to notice the interests and possessions of the occupants. Collectively they make a clear statement about the subjects' lives and provide context for the images.

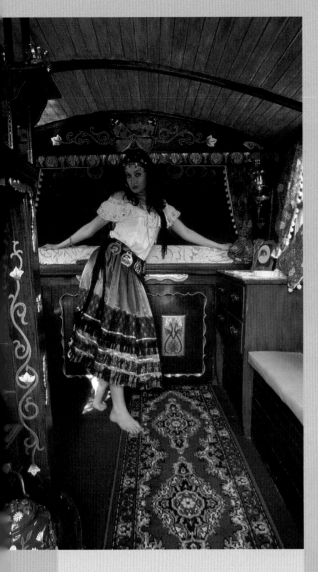

Space was very restricted in this caravan. I therefore positioned myself in the low doorway and used a 20mm lens to include as much of the interior detail as possible. The image was captured using available light only.

Nikon F5 with 20–35mm f/2.8 Nikkor AFD, Fujichrome Sensia 200, 1/20sec at f/5.6

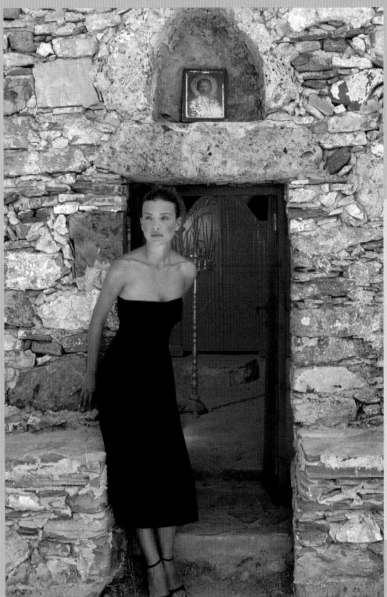

This picture required careful planning and preparation. Permission to use the tiny Greek church had to be obtained, and battery-powered studio flash equipment had to be set up both inside and outside the building.

Nikon F5 with 85mm f/1.8 Nikkor AFD, Fujichrome Astia 100, 1/125sec at f/8

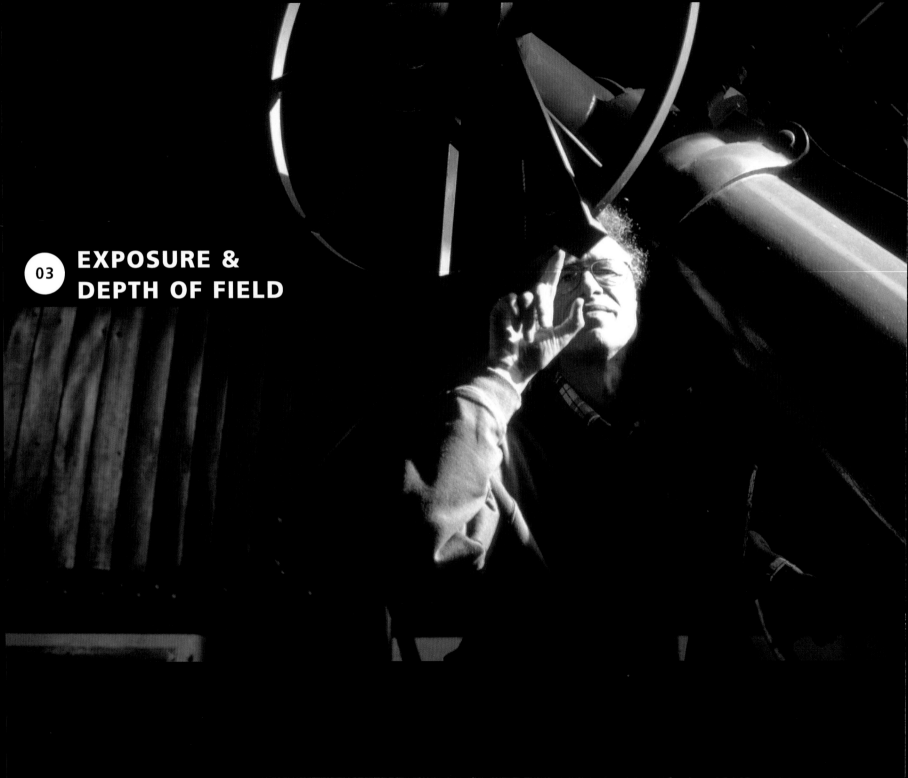

EXPOSURE & DEPTH OF FIELD

There is no such thing as correct exposure,

and certainly no correct depth of field.

Both are elements of the creative process and

can be manipulated to achieve our objectives.

However, we can hope to achieve both

exposure and depth of field that satisfy

perfectly our requirements.

The astronomer was motionless for a moment while positioning his telescope. I mounted the camera on a tripod and took a spot-metered exposure from his grey sleeve. Contrast exceeds the film's latitude and so detail has been lost.
Nikon F5 with 35mm f/2.8 Nikkor AF, Kodachrome 200, 1/30sec at f/5.6

DETERMINING EXPOSURE

The introduction of integrated electronic circuits into cameras allowed built-in through-the-lens (TTL) exposure meters to be linked to sophisticated exposure-setting systems. Precise automatic control of exposure suddenly became a reality – well, almost.

Many images include wide ranges of brightness, colour and tone, and ideal exposure varies across the frame. Exposure meters are therefore designed to provide an averaged reading for a defined area. They are calibrated using a standard grey card that reflects 18% of the light falling upon it; the assumption being that when all the variations of a real image are stirred together the result will be a mid-tone 18% grey. This system works well in most cases but can prove deceptive where light or dark tones dominate a scene.

Cameras are used in many different ways, and a designer cannot know where in an image a person might be placed. The frame is therefore commonly divided into a number of zones, and exposure determinations can be made for each one. These zone readings are then combined into a compromise value using pre-programmed algorithms based on typical picture compositions.

Zones are arranged in a number of different configurations, and the use of their data is dependent on the selected exposure mode. Centre-weighted metering, which is useful for portraits, assumes that the subject occupies the centre of the frame and gives greater priority to this area when calculating exposure for the whole scene. Matrix metering (also known as multi-segment or evaluative metering) uses at least five zones, four quarters and a reserved central area, and gives excellent all-round results. Spot metering, on the other hand, measures exposure exclusively for a very small and sometimes moveable area, usually close to the centre of the frame. This can be useful for measuring shadows and highlights.

TTL METERING

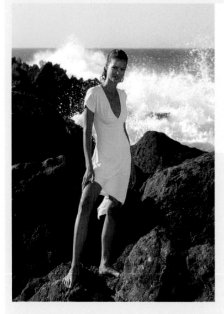

Metering proved difficult in this dynamic and sometimes wet situation. The bright seascape and darker rocks demanded a compromise that was complicated by the variability of the white spray behind the model. Multi-segment (or matrix) metering is usually effective in such situations.

A centred portrait such as this is ideally suited to centre-weighted metering. Although parts of the background are quite bright, greater weight has been given to correct exposure of the subject's face.

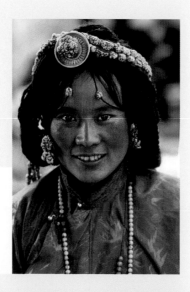

Patchy cloud produced ever-changing light and shade in this scene. However, despite its off-centre position, the subject's face was by far the most important element in the image. Exposure was therefore based on a spot reading taken from his forehead.

HAND-HELD METERS

Separate hand-held light meters can be used to measure light reflected from the surface of a subject – known as reflected light. However, since they have broader fields of view and the light does not have to pass through lenses or filters, readings may have to be adjusted accordingly. The key advantage of hand-held meters is that some can also be used to measure the light falling upon a subject, known as incident light, which is independent of a subject's colour or tone. Measurements of this type are consequently more reliable, particularly where light or dark tones predominate. Incident light measurements are made by holding a suitable meter close to the subject and directing it towards the camera. Exposure determinations made in this way may therefore be more practical in controlled situations (e.g. studios).

CONTROLLING EXPOSURE

Once exposure has been determined, the information must be used to ensure that the film or digital sensor is exposed to the appropriate amount of light. Two basic mechanisms are used to control this: a shutter and an aperture.

Shutter speed

A shutter is a blind that opens and closes to admit light for a precisely controlled period of time. Various mechanical and electronic systems have been employed to create shutters, but all are basically the same. Thin, lightweight blinds of fabric or metal are held in place to block light entering the lens. When the shutter is released, the blinds are rapidly withdrawn to expose the sensor or a section of the film. When the period of exposure has elapsed, the blinds are returned.

Pre-set exposure periods, or shutter speeds, are arranged in a convenient and reasonably precise doubling sequence. Standard speeds are one second, then 1/2, 1/4, 1/8, 1/15, 1/30, 1/60, 1/125, 1/250, 1/500 and 1/1000sec. These are marked as reciprocals for convenience and hence shown as 1, 2, 4, 8, 15, and so on to 1000.

Aperture

An aperture is a hole of variable size that controls how much light passes through the lens while the shutter is open. A series of crescent-shaped blades set within the lens slide over each other under the control of an external ring to form a near-circular opening at the centre of the lens. The aperture can be varied from a tiny opening a few millimetres in diameter to the maximum diameter of the lens.

The aperture is calibrated using a series of standard numbers such as 1.4, 2, 2.8, 4, 5.6, 8, 11, 16, 22 and 32. These are a measure of the lens aperture, known as f-numbers or f-stops, each step on the scale halving or doubling the area of the aperture and hence the amount of light that passes through the lens. Each stop is in fact the number by which the focal length of the lens must be divided to give a particular aperture diameter. For example, in a lens with a focal length of 200mm, 4 (usually written f/4) represents an aperture diameter of 200/4 = 50mm.

EQUIPMENT

FILM SPEEDS

Film is available in a variety of sensitivities, or speeds, denoted by International Standards Organization (ISO) ratings. The most common speeds are 25, 50, 100, 200, 400, 800, 1600 and 3200. Each of the speeds listed indicates an increase or decrease in film speed of one stop, which represents an halving or doubling of the amount of light required for 'correct' exposure – the higher the ISO number, the faster the film reacts to light and the shorter the exposure required.

Fast films, such as those rated at ISO 800, tend to exhibit pronounced grain and reduced colour saturation. Slow films, for example those rated at ISO 50, produce higher quality images, with crisp detail and smoothly rendered colours. However, they may need inconveniently long exposures. ISO 100 and 200 films are commonly used for photographing people in daylight or under studio lighting. Exceptionally fast and very slow films are also available, although these are generally only used in extreme conditions.

Film speed retains its significance in digital cameras in the form of an ISO function, which can be adjusted on a shot-by-shot basis as circumstances demand. Just as fast films can exhibit graininess, setting a high ISO (e.g. 400 or greater) can increase the image interference known as 'noise'.

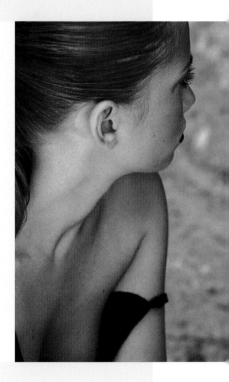

A slow shutter speed might have been possible here, but I had to work quickly using a hand-held camera and a slow film, so I opted for 1/100sec.
Nikon F5 with 105mm f/2.8 Micro Nikkor AFD, Fujichrome Astia 100, 1/100sec at f/5.6

The beauty of the ratio-based f-stop system is that it is independent of focal length. Lenses can therefore be interchanged without altering exposure settings. A 50mm lens set to f/4 passes the same amount of light as a 300mm lens set to the same aperture. In addition, the doubling sequence complements the parallel scale of shutter speeds. Consequently, changing shutter speed and aperture by the same number of stops in opposite directions leaves exposure unchanged – e.g. 1/250sec at f/4 gives the same exposure as 1/125sec at f/5.6. This is known as the law of reciprocity.

SETTING THE CONTROLS

Shutter speed and aperture can be set using a number of different exposure modes. Those most frequently used, and that offer the photographer the highest degree of control, are manual, shutter priority and aperture priority. Alternatively, various program modes can be used to set both parameters automatically according to pre-programmed algorithms, leaving the photographer free to fire at will.

Exposure modes are chosen to suit subject and circumstances. If the photographer needs a high shutter speed it can be set directly in shutter-priority mode. If a particular aperture is required then aperture-priority mode may be preferred. Either way the exposure is the same – only the means of selection and the degree of manual intervention change. A key advantage of automatic exposure modes when photographing people is speed of operation.

EQUIPMENT

USEFUL EXPOSURE MODES

Symbol	Mode	Effect
M	Manual	Aperture and shutter speed are set independently by the photographer.
S (or Tv)	Shutter priority	Requires the photographer to select the shutter speed and leaves the camera's automatic exposure system to set the appropriate aperture.
A (or Av)	Aperture priority	Allows manual selection of aperture, with the corresponding shutter speed set automatically.
	Portrait	Aperture and shutter speed are set automatically. Used with a telephoto lens this will set a wide aperture to throw background detail out of focus; with a wideangle lens it will give an extended depth of field to help keep large groups sharp.
	Night portrait	Designed for photographing people in low light. Gives balanced exposure to both the subject and background by automatically synchronizing the flash with a slow shutter speed. A tripod may therefore be required.
	Action (or Sport)	Ideal for fast-moving subjects. Aperture and shutter speed are adjusted automatically, with priority given to setting a fast shutter speed that will freeze motion. Some cameras may focus continuously while the shutter-release button is partially depressed. Flash is normally switched off automatically.

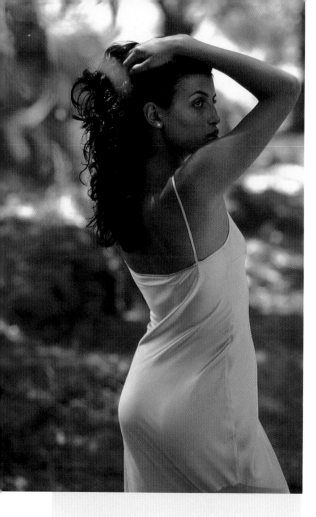

Latitude was sufficient for the soft dappled light in this woodland scene despite harsh background illumination. The colours give a deceptively cool feel to the image.

Nikon F5 with 85mm f/1.8 Nikkor AFD, Fujichrome Astia 100, 1/125sec at f/4

EXPOSURE LATITUDE

Exposure latitude is a measure of the range of exposure variation that a film, or electronic sensor, can tolerate without loss of image quality. At a certain point it no longer matters how much additional light reaches a recording medium, as its ability to record becomes exhausted. In the extreme case, a film exposed to daylight will be blank and further exposure will have no effect.

Similarly, there is a lower limit to the level of light that can be recorded. The difference between these points is known as the 'latitude' or 'dynamic range' of the medium, and photographers must aim to operate within it.

Various types of film exhibit different latitudes. In general, colour films have less latitude than black & white films, transparencies less than negatives, and slow films less than fast ones. Exposure errors have most effect in bright highlights and deep shadows, as these are the areas where a film is closest to the limits of its capability. Since these extremes are rarely encountered in low-contrast scenes, greater exposure error can be tolerated in images of this nature.

Latitude should be a consideration when choosing film for a particular purpose. Since slide films have less latitude than comparable colour negative films, perhaps five and seven stops respectively, they may be less satisfactory in conditions of extreme contrast. The latitude, or dynamic range, of sensors used in digital cameras is arguably comparable with that of colour negative film, although most digital SLR manufacturers are unwilling to reveal precise figures.

DIFFICULT LIGHT

When light levels fall, most photographers put away their cameras and head home. However, with a little imagination, rewarding images can still be produced. All that is needed is a flashgun, a sturdy tripod, a fast lens with a wide aperture such as f/2, and a suitably fast film. Choice of film will depend on the environment and particular application. As a rule, I use the slowest that is practical, as this preserves image quality.

These steps were dark and uninteresting, and the figure was silhouetted against a bright sky. I took spot measurements and used fill-in flash, but the resulting foreground lighting looks unnatural.

Nikon F5 with 20–35mm f/2.8 Nikkor AFD, Kodachrome 200, 1/125sec at f/8

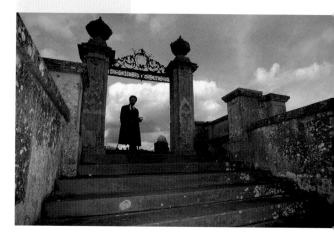

READ ON

Camera supports
p.18

Using movement
p.163

Low-light work
p.165

Remote releases
p.168

Some subjects benefit from the use of slow shutter speeds and the motion blur that this can create, and in these cases no additional light is needed when the camera is mounted on a tripod. Determine exposure from the centre of interest, and bracket exposures widely. Other subjects can be lit by flash bounced from a reflector or a white surface or, if there is no alternative, by direct flash. Don't be afraid to use the largest lens aperture available – just focus carefully and accept the consequent shallow depth of field.

EXPOSURE COMPENSATION

On many cameras it is possible manually to apply small steps of exposure compensation. These are added to, or subtracted from, the automatically calculated value (usually in half or one-third stop increments). Compensation is useful for creative purposes, and also in difficult light conditions. A photographer seeking to achieve an airy atmosphere dominated by lighter tones may choose to overexpose an image. A degree of underexposure might be used to produce a preponderance of darker tones and hence a gloomy atmosphere. In difficult light conditions, the photographer may choose to bias the automatically calculated exposure in a particular direction in the knowledge that it will not otherwise satisfy requirements. Some cameras even provide for automatic bracketing, where exposure is varied incrementally in cycles of a few frames. The photographer can then obtain rapidly a number of slightly different exposures from which to choose the most pleasing image.

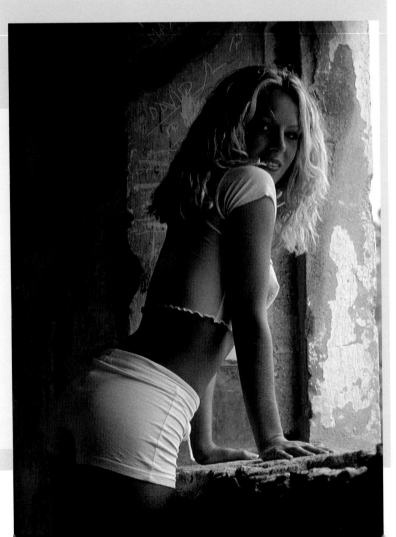

Here, contrast has been reduced to a manageable level by excluding most of the bright window area from the frame. I used a matrix measurement and compensated by +⅔ stop.

Nikon F5 with 85mm f/1.8 Nikkor AFD, Kodachrome 200, 1/60sec at f/5.6

RECIPROCITY FAILURE

Although very long exposures are not often used when photographing people, they do have occasional relevance. It is therefore important to be aware that some colour films, particularly slides, react in a non-linear manner under these circumstances. The effect, known as reciprocity failure, is caused by a breakdown in the reciprocal relationship between aperture and shutter speed.

The extent of the problem varies with the length of the exposure and the film type. It can occur after one second on some (such as Ektachrome 64) and ten seconds on others (such as Fujichrome Velvia 50). It can also occur when using exposures faster than 1/10,000sec, so photographers working with professional cameras can encounter this limit.

Reciprocity failure may reveal itself through incorrect exposure or as a colour cast. Film manufacturers supply detailed reciprocity characteristics for particular emulsions. Alternatively, use films such as Fujichrome Provia 100 and Ektachrome E100 S, which are known for their good reciprocity performance.

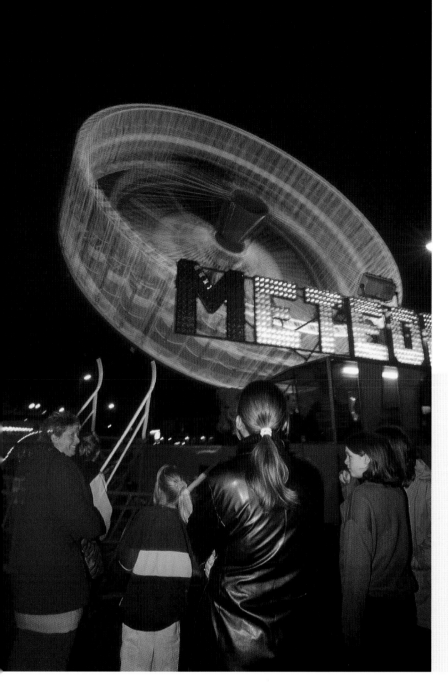

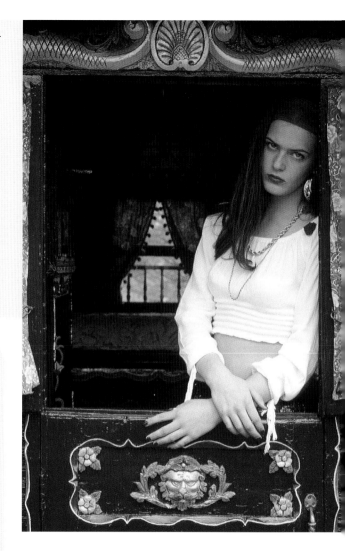

This girl was shot in direct sunlight that would normally have produced harsh shadows. A sun sail introduced between sun and subject has reduced contrast considerably.
Nikon F5 with 135mm f/2 DC Nikkor AFD, Kodachrome 200, 1/125sec at f/8

A slow shutter speed has reduced the big wheel to an attractive blur of light. The foreground figures are rendered more or less sharp by the short duration of the flash.
Nikon F5 with 20–35mm f/2.8 Nikkor AFD, Kodachrome 200, 2secs at f/8

When photographing people in direct sunlight, or indoors close to a window, contrast may exceed the latitude of the film or sensor. If exposure is set for the highlights, detail will be lost in the shadows; if it is set for the shadows, the highlights will burn out. An averaged exposure measurement is a good compromise but may not solve the problem – detail may still be lost, particularly when using slide film with minimal latitude.

To ensure that all the detail in this type of scene is rendered satisfactorily, it is necessary to reduce the contrast. One way to do this is to soften the primary light source with a diffuser. This is routinely done in studios by using softboxes on the flash heads, but the same principle can be employed elsewhere. In the case of windows, net curtains soften shadows and reduce contrast considerably. Outdoors, I occasionally use a sun sail – a large homemade square of white material with a fine mesh, such as tulle, supported by long poles. Introducing this between the sun and the model is surprisingly effective, if somewhat inconvenient. Lastolite make professional equivalents, known as 'Skylite' diffusers, the largest of which is 6.5ft (2m) square. Comparable products are also available from other manufacturers.

FILL-IN FLASH

Fill-in flash is a useful technique for reducing contrast in a daylight scene. A dedicated flashgun equipped with a small softbox provides a reasonably diffused, controllable light source to fill dark shadows, such as those formed in strong light around the eyes and under the nose and chin. Flash also puts attractive highlights, sometimes known as 'catchlights', in otherwise dark eyes.

The basic principle of fill-in flash is to adjust flash output to balance the ambient light. Foreground subjects and shadows are consequently illuminated to match the wider scene – a 1:1 ratio. However, this can produce a rather brash, unnatural portrait. More subtle effects may be realized by using flash compensation – for example, reducing the power of the flash by one or two stops (halving or quartering the output). Precise levels of fill and

compensation must be decided with knowledge of the basic flash strategy used by a particular camera – which might be based upon a ratio less than 1:1. They are also dependent on ambient light, contrast, film latitude, the nature of the subject and the type of image required.

In practice, in strong light the shadows on black or dark skin might be adequately filled with flash output set about two-thirds of a stop below the predetermined balance. For a pale or white-skinned subject the level might be reduced to about one-and-a-half stops below the normal balance. These figures are merely a starting point, and uncertainties remain. People with similar-coloured skins reflect different amounts of light, so bracketing is desirable.

The use of fill-in flash imposes a number of limitations on normal camera operation. The recharging cycle of all but the most sophisticated flashguns will be much slower than motor-driven

This sequence shows the effects of fill-in flash and how it can be adjusted to get the best results. From left to right, these images have been compensated by $-1\frac{2}{3}$, $-\frac{2}{3}$ and $+\frac{1}{3}$ stops respectively, with the centre image giving the 'best' overall exposure.

film transport, so firing rate must be reduced. But, more significantly, it is necessary to keep the shutter speed below the camera's flash synchronization speed. Above this speed the trailing blind of a focal plane shutter begins moving before the leading blind has stopped. Exposure is achieved progressively as a narrow opening between the shutter blinds sweeps across the frame. Consequently, only part of the frame will be exposed to the comparatively brief burst of flash. This limitation imposes a corresponding restriction on aperture, and hence depth of field.

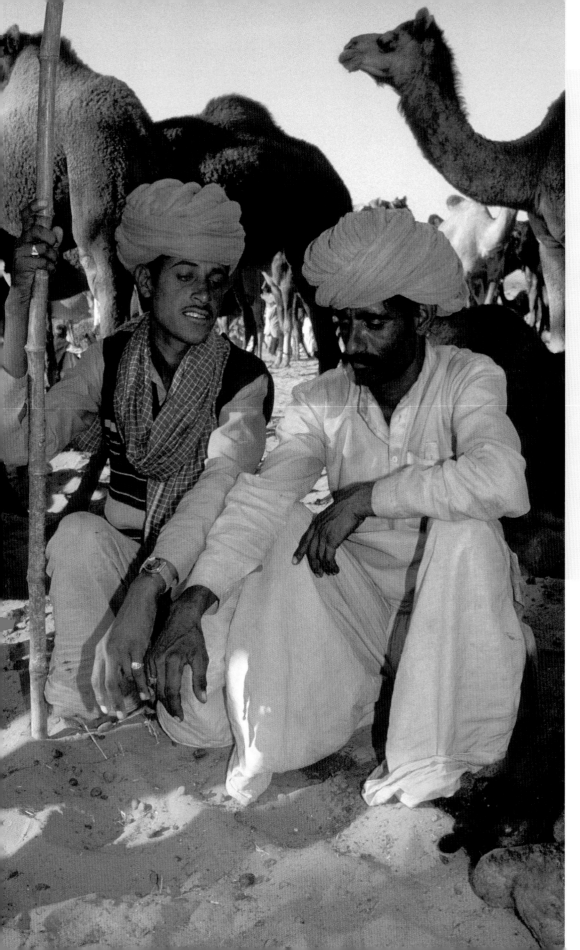

These two men were negotiating the sale of their camels in the shade provided by the animals. Without the use of fill-in flash, contrast would have exceeded the film's latitude. Either shadow or highlight detail would have been lost as a consequence. **Nikon F4 with 35mm f/2.8 Nikkor AF, Kodachrome 200, 1/125sec at f/8**

EQUIPMENT

REFLECTORS

As an alternative to fill-in flash, or perhaps to supplement it, a reflector can be used to direct additional light onto a subject and reduce contrast. Various types are available; gold and half-gold reflectors return a warm glow appropriate for lighter skin tones, whereas white surfaces produce a cooler effect. Reflectors are easier to use than fill-in flash in the sense that their effect can be seen and adjusted before the shutter is released. In practice, however, they can be cumbersome, need to be held in place and may attract unwanted attention.

The light was coming from behind and to the left of the model – and spray from breaking waves was going everywhere. Fill was provided mainly by two reflectors positioned just out of shot to the right of the camera.

Nikon F5 with 85mm f/1.8 Nikkor AFD, Fujichrome Astia 100, 1/250sec at f/8

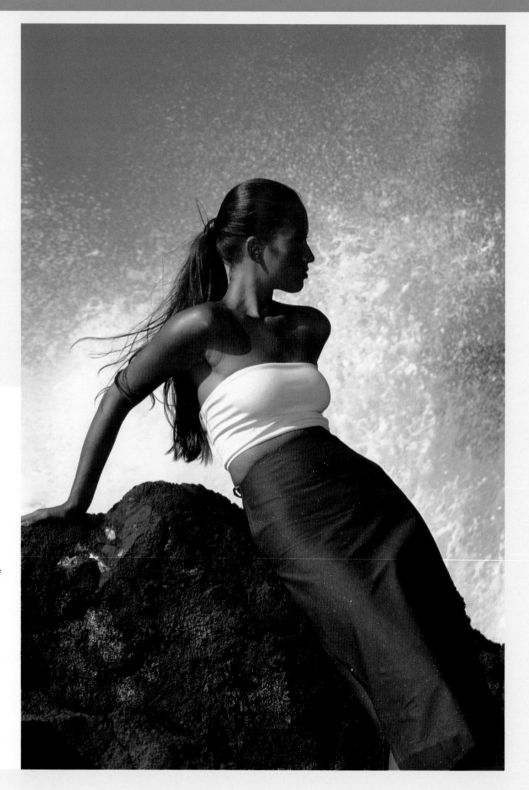

Fig. 2 Aperture and depth of field

Key:

N = $\frac{1}{30}$mm diameter circle of confusion representing near limit of depth of field

F = $\frac{1}{30}$mm diameter circle of confusion representing far limit of depth of field

Large aperture e.g. f/2

Medium aperture e.g. f/5.6

Small aperture e.g. f/16

Point of critical focus

Near limit of depth of field

Far limit of depth of field

As the aperture decreases in diameter, and the cone of light narrows, so the standard $\frac{1}{30}$mm diameter circles of confusion move further apart and depth of field increases. Note: diagram not to scale.

| | 0 | 3 | 3.5 | 4 | 4.5 | 5 | 5.5 | 6 (meters) |

85mm f/2
85mm f/5.6
85mm f/16

Point of critical focus

DEPTH OF FIELD: A DEFINITION

Depth of field may be defined as the range of distances from a lens within which objects appear acceptably sharp (see fig. 2). In broad terms, this range extends one-third before and two-thirds beyond the point of focus (the only point at which the image is critically sharp).

Depth of field is nevertheless a subjective measurement. The concept arises from the inability of the eye to distinguish between a small blurred circle and a point within an image. It is also a product of the geometry of image formation, and hence something that no lens designer can eliminate.

It may be considered that a perfectly sharp image is composed of pinpoints of light. In reality, however, sharpness falls off as the distance from the point of focus increases; each 'pinpoint' of light blurs into a tiny circle, the diameter of which increases as the distance becomes larger. Most importantly, the larger the lens aperture, the faster the blurred circle expands. Lens designers use this to decide what may be considered sharp. Subjective measurements are made to determine the maximum diameter of the so-called 'circle of confusion' before the image is no longer perceived as being in focus. Depth of field measurements are then based upon a particular diameter for the circle of confusion – typically $\frac{1}{30}$mm.

Depth of field is proportional to the diameter of the circle of confusion, the f-number and the square of the focused distance, and inversely proportional to the square of the focal length of the lens. In practical terms, this means that depth of field increases as the aperture gets smaller (large f-numbers such as f/16 or f/22), and as distance from the subject increases. It decreases as the focal length of the lens increases, so in that sense telephoto lenses have less depth of field than wideangle lenses.

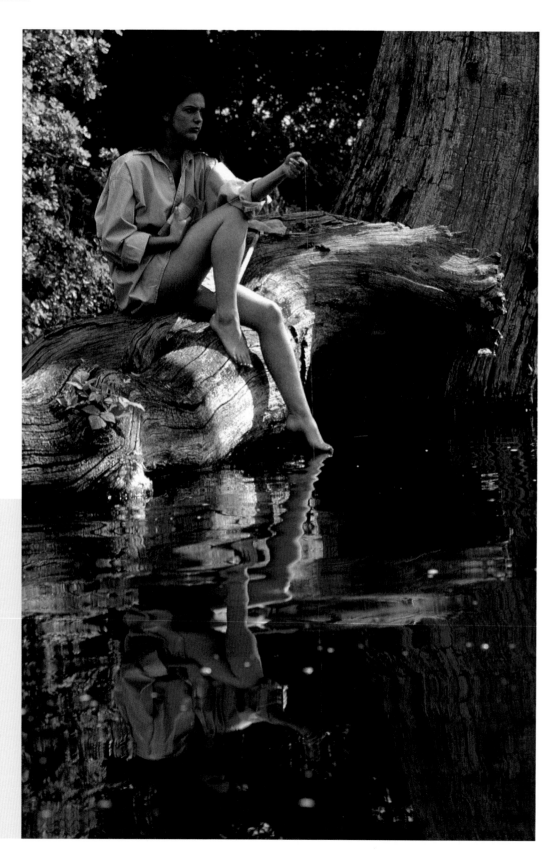

This shot was captured from an inflatable dinghy that would not remain stationary and almost sank under my weight. The model consequently found it difficult to stop giggling. A small aperture was used to maximize depth of field.
Nikon F5 with 85mm f/1.8 Nikkor AFD, Kodachrome 200, 1/125sec at f/11

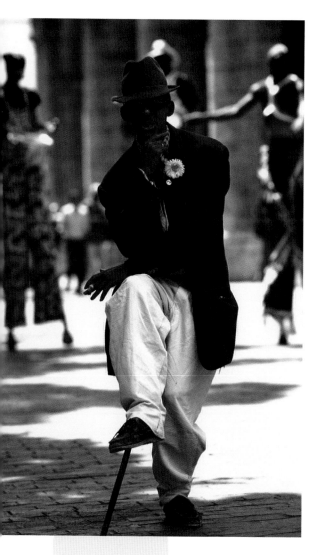

This Cuban circus artist has been extracted from the busy background of stilt walkers by focusing on his body and using a large aperture.
Nikon F5 with 135mm f/2 DC Nikkor AFD, Fujichrome Sensia 100, 1/500sec at f/4

FOCUS AND DEPTH OF FIELD

Focus can be achieved in a number of ways. The lens may be adjusted manually while the photographer observes the image, or set directly to a predetermined distance using a calibrated scale. In daylight, autofocus systems achieve precise focus in a split second. When ambient light is insufficient for normal operation, the autofocus-assist illuminator function of a suitable flashgun or camera may be required to increase subject contrast. The focused distance is then maintained as long as light pressure remains on the shutter release. Some systems can also continuously track a moving subject while maintaining focus.

When focusing on a person the photographer must bear in mind not only the focused distance, but also the depth of field (sometimes called the depth-of-field envelope). Depth of field is always important when photographing people, but particularly so when the subject is close to the camera. If a typical 85mm lens is used at a distance of about 5ft (1.5m) for a head and shoulders portrait, the depth of field at f/5.6 will be approximately 4in (10cm). At f/2 this reduces to 1½in (4cm). When one considers the contours of the human face, it is easy to understand why the depth of field envelope must be carefully positioned if the features are to remain in focus.

CASE STUDY

HYPERFOCAL FOCUSING

Depth of field can be maximized by focusing a lens at the hyperfocal distance, which is the shortest distance from the lens to an in-focus subject, for a particular aperture, when the lens is focused at infinity. When set to the hyperfocal distance, depth of field extends from infinity down to halfway between the camera and the hyperfocal distance. This can be useful in wideangle environmental portraiture, where you may want both the subject and background to remain sharp.

By setting the focus to the hyperfocal distance, depth of field has been maximized and the entertainer's audience has been kept as sharp as his wit.
Nikon F4 with 20–35mm f/2.8 Nikkor AFD, Fujichrome Sensia 200, 1/250sec at f/11

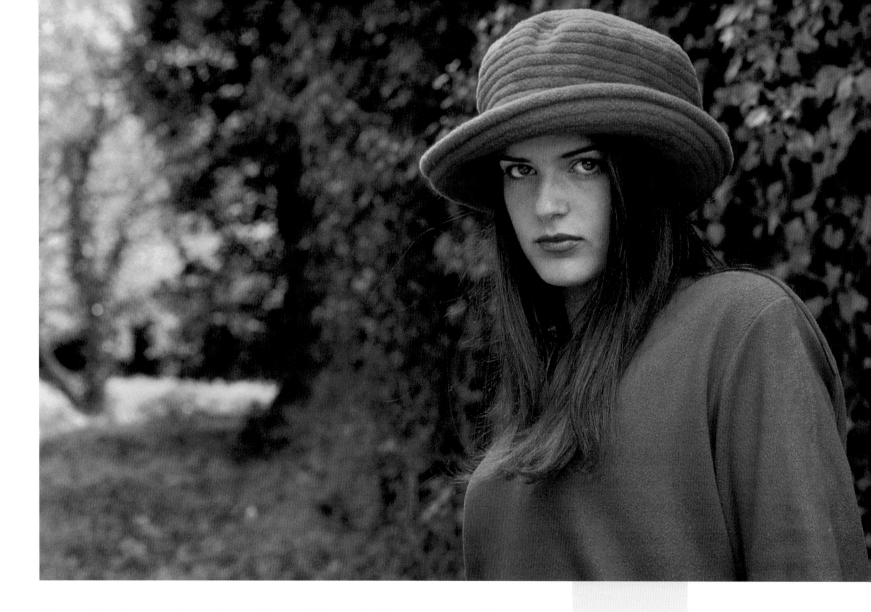

When working close to a subject, photographers often have to decide which features should remain in focus and which should, by necessity or design, be allowed to go soft. In most cases it is important to keep the eyes sharp, so focus on an eyelid and ensure that the depth-of-field envelope covers the nose, eyes and nearer ear. Background detail will probably be defocused. With this in mind, for close-up work it is important to 'select' the appropriate depth of field when choosing film or when setting the

ISO on a digital camera. A rating of ISO 200, for instance, will enable greater depth of field than ISO 100 because a smaller aperture can be selected (without making it necessary to change shutter speed). Of course, shallow depth of field is not always a problem. A large aperture might be chosen specifically to minimize depth of field, exaggerate the impression of depth and consequently highlight the centre of interest in an image. This selective technique is known as differential focusing.

Contrasting colours and shallow depth of field lift the model out of the surroundings. The sunlit background areas further increase the feeling of depth.
Nikon F5 with 20–35mm f/2.8 Nikkor AFD, Kodachrome 200, 1/125sec at f/4

EQUIPMENT

DC LENSES

Defocus-image Control (or DC), a facility exclusive to Nikon lenses, is designed specifically for portrait and still-life photographs. It gives the photographer greater control of out-of-focus blur by allowing the depth of field envelope to be moved back and forth relative to the focus point. The effect is controlled using a separate (DC) ring on the lens, and should be set after the aperture but before focusing (using autofocus). Blur can be applied to either the background (rear defocus) or foreground (front defocus), or can be balanced between the two. The degree of control is limited by the chosen aperture, and normal factors (such as subject-to-background distance) must still be taken into account. As the effects cannot be previewed in the viewfinder, bracketing might be necessary to achieve the desired results.

REPRODUCTION RATIO

Many photographers find it difficult to keep track of depth of field as they work. They move around and the focused distance changes. They may also alter the aperture and focal length of the lens. Depth-of-field scales marked on lenses certainly help, but reading them interrupts the flow of work.

Preview facilities, which close lenses down to chosen apertures, are intended to make depth of field visible through the viewfinder, but consequently reduce the brightness of the eyepiece image. Some people can cope with these things – I can't. My preferred solution is to use reproduction ratio (as shown in figs. 3 and 4).

Fig. 3 Depth of field, reproduction ratio and focal length

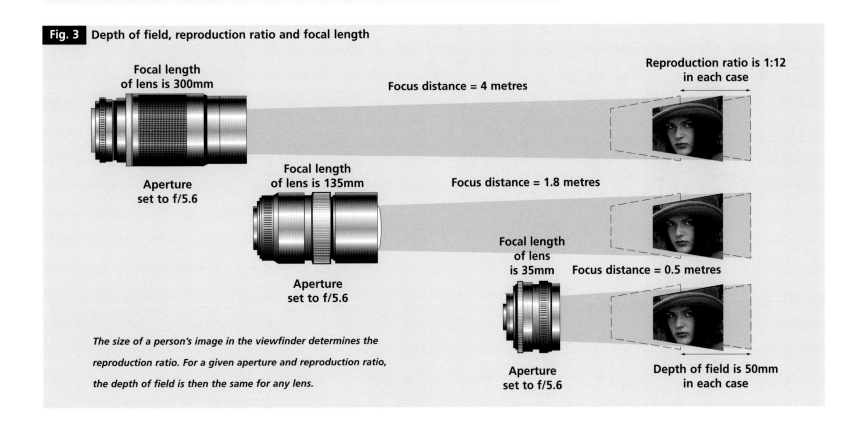

Focal length of lens is 300mm

Aperture set to f/5.6

Focus distance = 4 metres

Reproduction ratio is 1:12 in each case

Focal length of lens is 135mm

Aperture set to f/5.6

Focus distance = 1.8 metres

Focal length of lens is 35mm

Focus distance = 0.5 metres

Aperture set to f/5.6

Depth of field is 50mm in each case

The size of a person's image in the viewfinder determines the reproduction ratio. For a given aperture and reproduction ratio, the depth of field is then the same for any lens.

Fig. 4 Reproduction ratio

Reproduction ratio = Height of image: Actual height

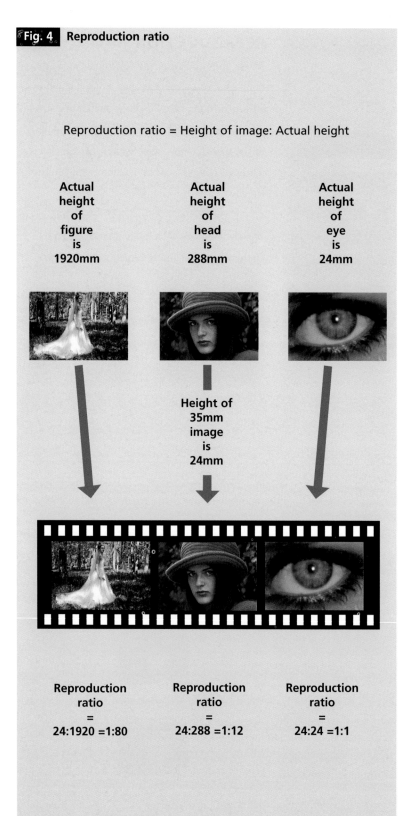

| Actual height of figure is 1920mm | Actual height of head is 288mm | Actual height of eye is 24mm |

Height of 35mm image is 24mm

| Reproduction ratio = 24:1920 =1:80 | Reproduction ratio = 24:288 =1:12 | Reproduction ratio = 24:24 =1:1 |

Reproduction ratio is a very simple but little used measurement. I know of experienced photographers whose eyes glaze over at the very mention of the term. However, even a rudimentary understanding is useful in a practical way.

We have seen that depth of field depends principally upon three variables: aperture, focal length and focused distance. It is nevertheless beyond most of us to do the mental arithmetic on the fly. Fortunately, two of the variables – focal length and focused distance – combine to give reproduction ratio. This is the ratio of the size of the subject's image on film to its actual physical dimensions – a product quantified simply by observing how large the subject appears in the viewfinder.

The wideangle lens was just 18in (45cm) from the woman's face, but has allowed some of the environment to be included. The reproduction ratio is approximately 1:17 and the depth of field is about 5in (12cm).
Nikon F4 with 20–35mm f/2.8 Nikkor AFD, Kodachrome 200, 1/40sec at f/5.6

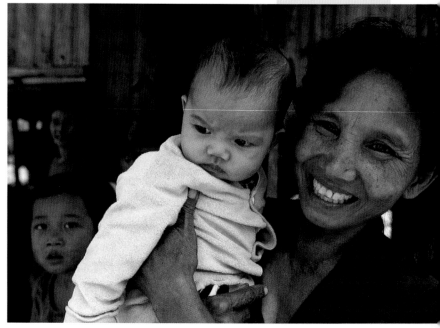

Consider an example. If a head comfortably fills a landscape-format 35mm frame, using any lens, the image is about 24mm in height. If we assume for convenience that a person's head is actually 288mm in height, the reproduction ratio is 24:288 or 1:12. Since lens manufacturers quote depth of field figures for given reproduction ratios and apertures, all the brain has to do is track aperture and memorize the corresponding depth of field.

There is nothing clever about this. When working close to a subject just remember, for instance, that when a head fills a horizontal 35mm frame the reproduction ratio is 1:12. At f/5.6 this gives a depth of field of about 5cm. It is as simple as that. You can forget about lenses, zooming and distances.

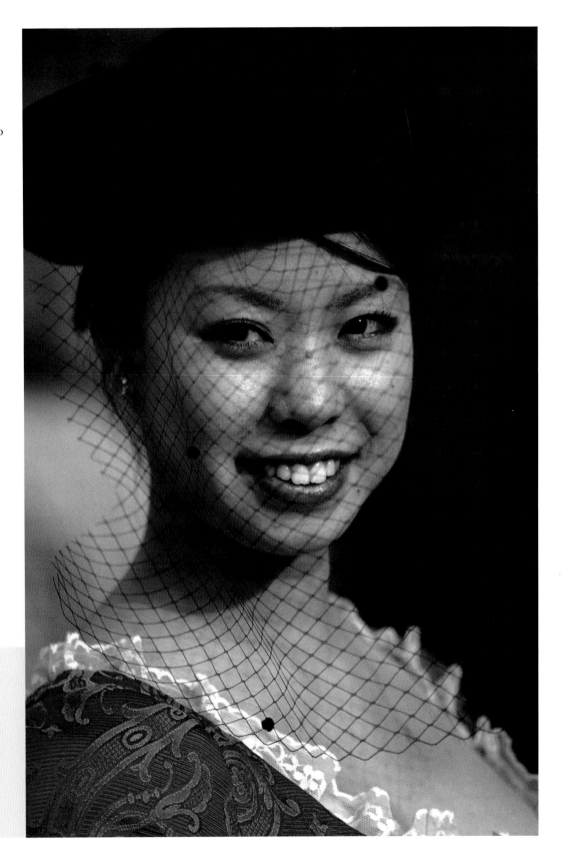

This girl was photographed in a crowded street. I used a short telephoto lens from a distance of 6½ft (2m) to exclude background detail. The reproduction ratio is approximately 1:17 and the depth of field is about 5in (12cm).
Nikon F5 with 105mm f/2.8 Micro Nikkor AFD, Fujichrome Sensia 200, 1/250sec at f/5.6

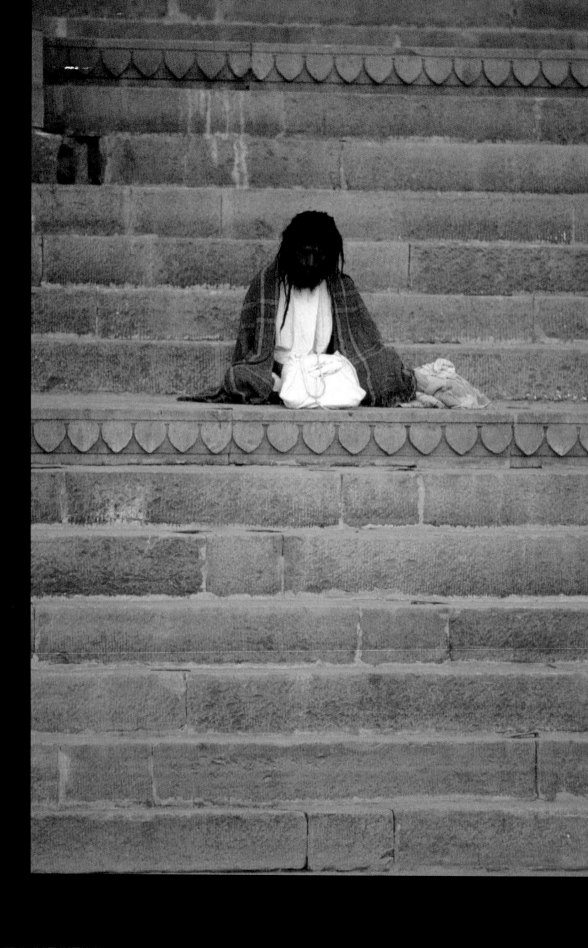

04 SEEING LIGHT & COLOUR

Natural light illuminates our world, gives us life and colour, and fuels the changing moods that make each day unique. As photographers, we cannot afford to take it for granted – it is our medium, and the key to everything we do. If we are to use it effectively we must be sensitive to its ephemeral nature and learn to see how it illuminates our subjects.

The ability to 'see the light' is a fundamental part of photography. Obviously we see light in the simple physical sense, but that is only the tip of the iceberg. A much more perceptive approach has to be developed.

When we look at another person it is expressions, gestures, and dominant shapes and colours that are most readily retained by the brain. Subordinate detail, such as the illumination of a face, is unimportant in the context of everyday life and likely to be overlooked. Consequently, a loving sparkle in someone's eye, or a new hairstyle, will convey significance and probably be remembered; a shadow under the chin or the glow of backlit hair may not be noticed.

The eye must be trained to see the quality of light in an analytical manner. First, ask what attracted your attention to a subject and strive to incorporate this into your image. Then identify and evaluate the more subtle characteristics of light that make a scene special – they are essential ingredients for a successful image. Note the direction of the light and how it falls on your subject and be aware of shadows. Observe the light's harshness and colour, and remain sensitive to their implications in terms of mood.

THE QUALITY OF NATURAL LIGHT

Natural light is the most beautiful and varied of a photographer's light sources, capable of delivering extraordinary effects. Although inflexible in that it comes from a single source (the sun), the effects change with atmospheric conditions, the time of day, the angle at which it strikes the earth and the passage of the seasons. It is undoubtedly true that an eye trained to notice these subtle changes sees a visually more interesting world.

Early morning light has a frailty and freshness found only at this time of day. It produces a cool, delicate atmosphere with long shadows and deepening hues. The air is moist and often quite still, and wonderfully mysterious effects are created as the sun warms the air at first light. On overcast or misty mornings the tendency is towards the cooler blue end of the spectrum; the light is more diffused, the mood more intimate, and contrast significantly reduced.

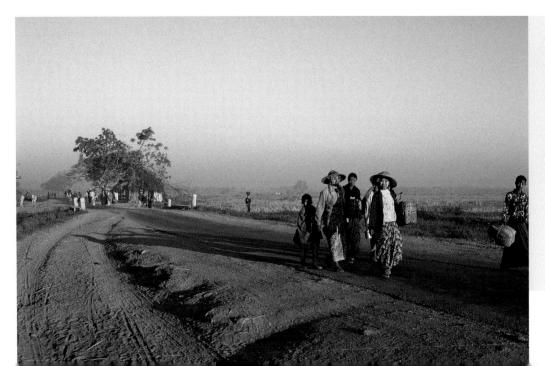

The soft light of dawn illuminates this meditator seated beside the Ganges. The sun was just emerging from a low mist and the diffused light was ideal for a shot of this type.
Nikon F4 with 300mm f/4 Nikkor AFD, Kodachrome 64, 1/125sec at f/4

The long shadows of early morning have been used as a feature of this scene captured near Kalaw in Myanmar (formerly Burma).
Nikon F4 with 35mm f/2.8 Nikkor AF, Kodachrome 200, 1/250sec at f/5.6

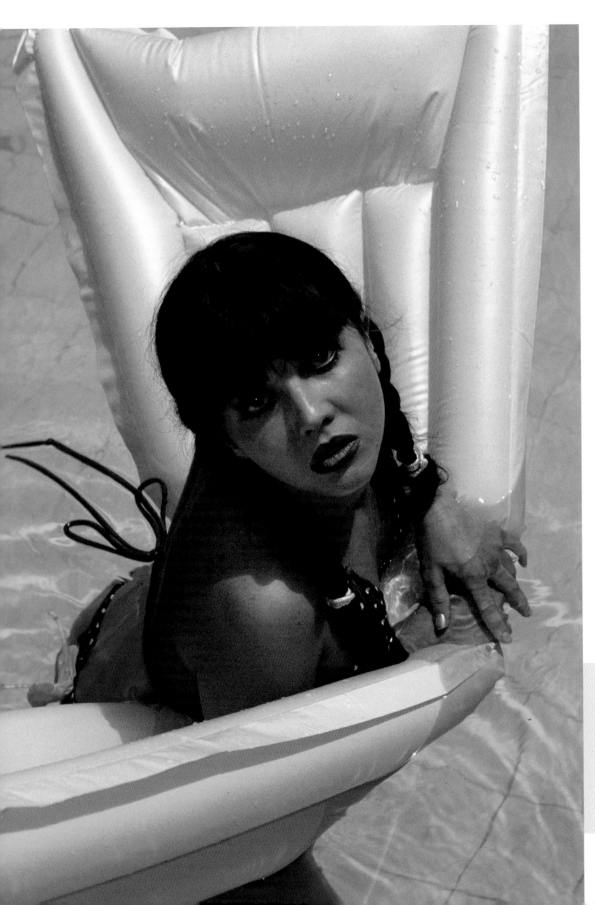

In the middle of a clear day the overhead sun is effectively a harsh white point source. Contrast is marked and hues are at their magnificent brightest. Stark conditions such as these require careful handling because deep shadows make portraiture difficult. If the sky is cloudy or overcast the light is softened, shadows are less dense and contrast is reduced. These gentler conditions are easier to handle, but colours may be less intense.

As the sun falls closer to the horizon, and its rays travel further through the atmosphere, a warm romantic glow appears. The longer wavelengths of light at the red end of the spectrum penetrate further, and so will be the last we see before the bluer light of night descends. Shadows lengthen and the low-angle rays emphasize texture. The light is diffused and tinged with gold as it paints the western sky, but changes very rapidly at this time of day. Sunset can be a magical time for photographing people, but speed is vital – the best conditions do not last very long.

Seasonal changes in the nature of daylight are also well known in many parts of the world. The European spring brings optimism as nature's fresh colours relieve the grey days of winter.

The strong light of midday reveals wonderfully bright hues. The airbed had just been punctured and the model was trying not to laugh as she slowly sank.
Nikon F5 with 85mm f/1.8 Nikkor AFD, Fujichrome Astia 100, 1/250sec at f/11

Summer is bright and cheerful with intense light, but colours can be muted by reflection and glare. Autumn is moody, moist and colourful. The light is lower in angle and slightly redder than in summer, but particularly soft at this mellow time of year. Winter is sombre and can be grey and dull as the days shorten. But in cold, cloudless conditions there is a bleak freshness that brings exceptional clarity.

THE DIRECTION OF LIGHT

Natural-light photographers have no direct control over the position of their principal light source, and must live with this limitation. Nevertheless, the position of the sun changes on an hourly and seasonal basis, and consequently offers a wide range of opportunities. Sometimes it is possible to choose a time of day to work, and hence select the angle of the light. Otherwise, the subject may have to be moved relative to the sun.

Light falling directly onto a frontlit subject is uniform and produces very little in the way of highlights or shadows. Form is destroyed, texture is subordinated and the image becomes rather flat and dull. The illusion of depth in a two-dimensional image arises in part from changes in the amount of light reflected from a subject, and the consequent tonal variations. In the absence of this structural information an image is unlikely to be interesting.

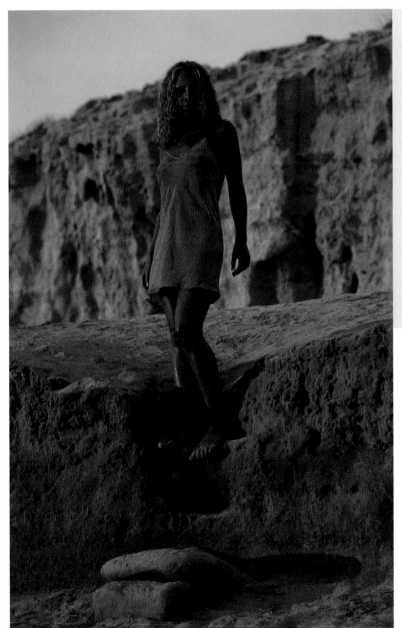

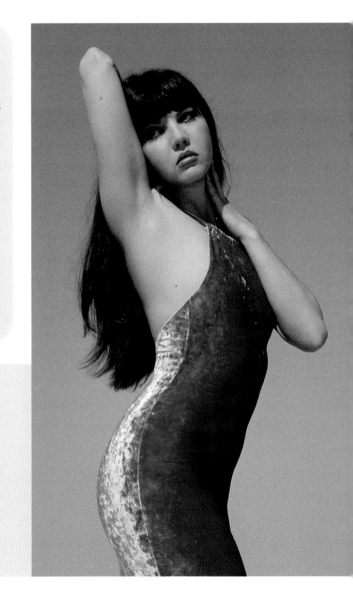

Daylight warms and reddens as sunset approaches, bathing the world in a romantic glow. No filters were used for this impromptu shot, captured as the model arrived for the session.
Nikon F5 with 135mm f/2 DC Nikkor AFD, Kodachrome 200, 1/125sec at f/5.6

Front lighting tends to flatten a subject, concealing form and texture.
Nikon F5 with 85mm f/1.8 Nikkor AFD, Kodachrome 200, 1/250sec at f/11

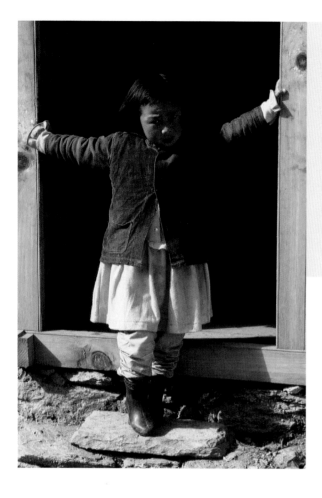

Sidelighting reveals form and texture but can also produce unwanted shadows. Here they have worked to strengthen the image.
Nikon FE with 135mm f/2.8 Nikkor manual, Kodachrome 64, 1/125sec at f/8

Backlighting produces beautiful highlights around the rim of the subject, but the figure may reduce to a silhouette unless additional light is directed into the shadow areas.
Nikon F5 with 135mm f/2 DC Nikkor AFD, Fujichrome Astia 100, 1/250sec at f/8

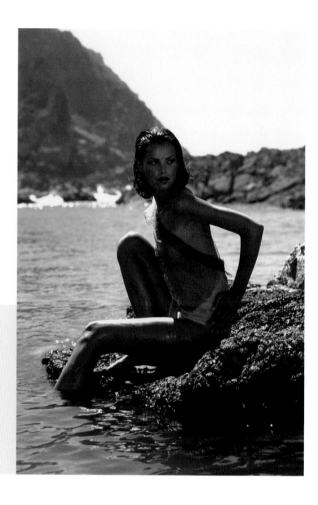

Sidelighting is most effective for emphasizing form and texture in portraits; when combined with a low sun angle it offers some of the finest photographic opportunities. Wonderful effects can be captured in the hour following sunrise and the period just before sunset. However, direct light falling on the face can also produce unwelcome shadows around the nose and chin, and may leave eyes underexposed.

Backlighting produces the most dramatic effects. It outlines the head and limbs with attractive highlights and renders hair incandescent, but facial features may be plunged into deep shadow. Such lighting is difficult to handle because a bright background has a significant effect upon

an averaged exposure measurement, and the subject may consequently be grossly underexposed or even reduced to a silhouette. The solution is to reduce contrast by directing additional light into the shadows, take spot measurements from shadow areas, and perhaps let detail in the bright background burn out.

SCATTERED AND REFLECTED LIGHT

Light is scattered when it encounters cloud, fog, smoke or dust in the atmosphere. Minute droplets or solid particles scatter rays in every direction and cause diffusion and polarization. The light is consequently softer and easier to use for portraits, but colours become less saturated

and a noticeable haze can develop. A similar effect becomes apparent when dust and dirt accumulate on the surface of a lens.

Reflected light is returned to the observer after striking surfaces such as water, photographers' reflectors or light-coloured walls. It is often modified by the reflecting surface and may be polarized, diffused or changed in colour.

Reflected light causes significant problems. It can conceal detail behind transparent reflective surfaces such as spectacles, or cause sufficient glare to mask brilliant colours. Particular difficulties arise when light is reflected from skin or eyes, or when it bounces around within lenses.

CASE STUDY

USING REFLECTIVE SURFACES

When light falls directly onto one side of a person's body, the other side will be in shadow. However, if the subject is positioned close to a reflecting surface the shadows will be filled to some extent by reflected light. Snow, sand and white fabrics reflect light in a similar manner and can be used to fill shadows from beneath a subject. More light is returned from the reflecting surface when it is directly lit, less when the source is indirect or diffused.

This monk was seated between two white walls. Directional light from the doorway on the left was reflected back into the shadows by the wall out of shot to the right.
Nikon F4 with 50mm f/1.4 Nikkor AFD, Kodachrome 200, 1/125sec at f/5.6

Human skin can be extremely reflective, and highlights may be sufficiently bright to be considered specular. Studio models have the option of using a light dusting of translucent powder to produce a smooth matt skin texture, but in most other situations such precautions are not possible. The sun striking the forehead, the tip of the nose or wet lips produces highlights that can be a problem; similar effects are sometimes produced by fill-in flash.

Overexposure can be severe and the burnt-out areas quite large, so dealing with them in a traditional darkroom or using image-manipulation software may not be possible. I tend to diffuse flash output by covering the head with a small softbox or a couple of layers of white handkerchief. The output is thus increased by the electronics, of course, but this still helps a little in my experience.

CASE STUDY

REFLECTIONS IN EYES

The human face is an extraordinarily eloquent guide to personality, and the eyes are its most recognizable and important features. Consequently, they demand and deserve special attention. The surface of an eye is smooth, moist and mirror-like. Primary highlights (also known as catchlights) add vitality, but other reflections may dilute the intensity of eye contact. It is not unusual to see a reflection of photographer, camera and tripod in the eyes of a subject. This is not always easy to control, but should be avoided wherever possible.

A miniature image of photographer and camera can be seen reflected in this man's glassy eyes. My personal preference is to avoid this phenomenon.
Nikon F5 with 135mm f/2 DC Nikkor AFD, Kodachrome 200, 1/250sec at f/8

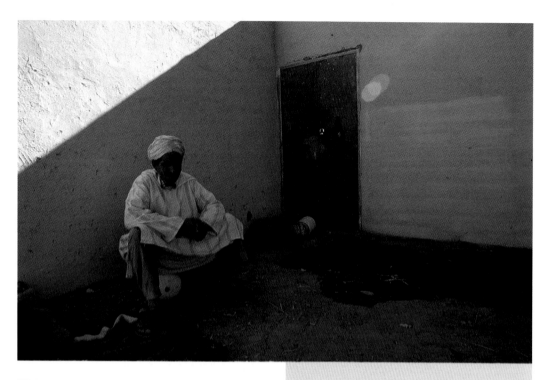

LENS FLARE

Most of the light entering a lens passes through the lens elements to the film or sensor, but a small percentage is reflected at each air-to-glass and glass-to-air surface. This internally reflected light reduces colour saturation and contrast, and may produce irregular smudges of colour across an image – effects known collectively as lens flare. Bright highlights or points of light in the frame are particularly likely to cause flare. Light reflected back through the diaphragm, and then back again to the film or sensor, can produce

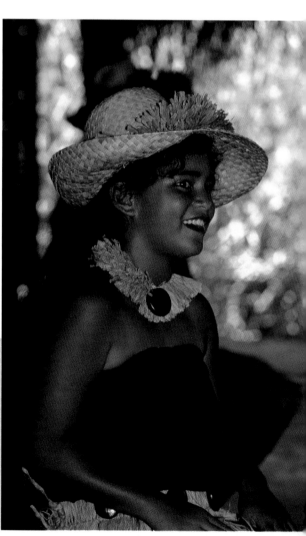

CHECKLIST

Preventing lens flare:

- Keep lenses scratch-free – do not touch unnecessarily
- Fit multi-coated skylight filters to keep lenses clean
- Remove filters when including light sources in frame
- Clean filters regularly
- Inspect front and rear lens elements regularly, and clean if necessary
- Use a lens hood or shade the lens with your hand
- Avoid very bright points of light in the frame
- Choose lenses with multi-coated elements

The wideangle lens used for this shot has been pointed too close to the sun. Internal reflection within the lens has produced flare – in this case a series of coloured smudges extending across the frame.
Nikon F5 with 20–35mm f/2.8 Nikkor AFD, Kodachrome 200, 1/125sec at f5.6

Bright spots of light behind the girl have caused flare, revealed in the green background areas of this image as a multitude of defocused diaphragm images. This can be attractive, but must be judged on an image-by-image basis.
Nikon F4 with 135mm f/2 DC Nikkor AFD, Kodachrome 64, 1/60sec at f/4

numerous out-of-focus images of the diaphragm aperture in an image. The acceptability of the phenomenon is dependent upon the number, size, shape and colour of the spots and their placement within the picture. In some circumstances the effect can be tolerated, but it is generally better avoided.

Flare is more likely to cause noticeable problems when the front and back elements of a lens are soiled, so these should be kept free from dirt and dust particles. A lens hood should also be used, especially when a lens with a wide field of view is directed close to the sun. This reduces flare by blocking light originating from outside the picture area. Another option is simply to shade the lens with your hand.

Finally, various materials, such as silicon dioxide, are used to coat lens surfaces. These layers reduce the reflections within the lens that can lead to flare. Modern multi-coating processes are particularly effective, cutting down reflections to about 0.5%. However, none can eliminate the problem completely.

CASE STUDY

LIGHTING THE FACE

Since the face is the most important part of many portraits, it is essential to observe how it is illuminated. Contrast and tonal variation create the illusion of depth, so if light becomes too uniform these three-dimensional qualities will be lost. Ideally, the changes of intensity used to reveal form should be soft and gradual. Shadows created by harsh light are deep and sharply defined, and produce dramatic effects that must be carefully handled. Those created by diffused light are less obvious and generally more acceptable.

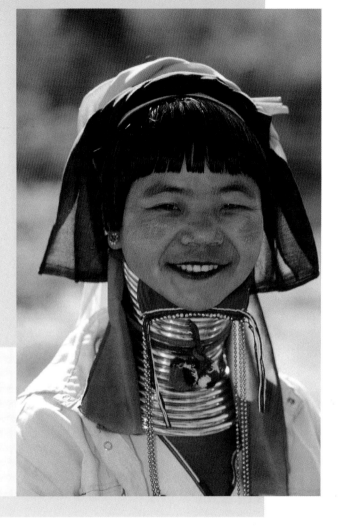

The shadows on the face of this Padaung girl have been over-filled by using too much fill-in flash. The result is a rather bland, flat portrait.
Nikon F4 with 135mm f/2 DC Nikkor AFD, Kodachrome 200, 1/250sec at f/11

CONTRAST

The ability of the human eye and brain to deal with different levels of illumination far exceeds that of any film emulsion or sensor. Indeed, the brightest light that the eye can handle is at least a billion times brighter than the faintest detectable glimmer. The eye examines only small areas of the field of vision at any one time, and can adapt rapidly to the prevailing intensity. The pupil contracts and dilates, and the sensitivities of the retina's cells and receptors change.

Detail detected at fractionally different times in shadow and highlight areas is then used by the brain to construct a coherent image. Films and sensors, on the other hand, have to cope with light and dark areas simultaneously, and without any adaptation of chemistry. The resulting compromise exaggerates human perception of light and shade, and means that contrast is more pronounced in the final image than was perceived through the viewfinder.

The exposure difference between shaded and directly lit parts of a subject can be five or six stops. A compromise that preserves detail in both must therefore be sought. Fortunately, modern cameras are extremely good at calculating the best exposure for a whole image. Only when very bright or dark tones dominate should it be necessary to intervene manually. Nevertheless, extreme contrast can be too much for the film or sensor to handle.

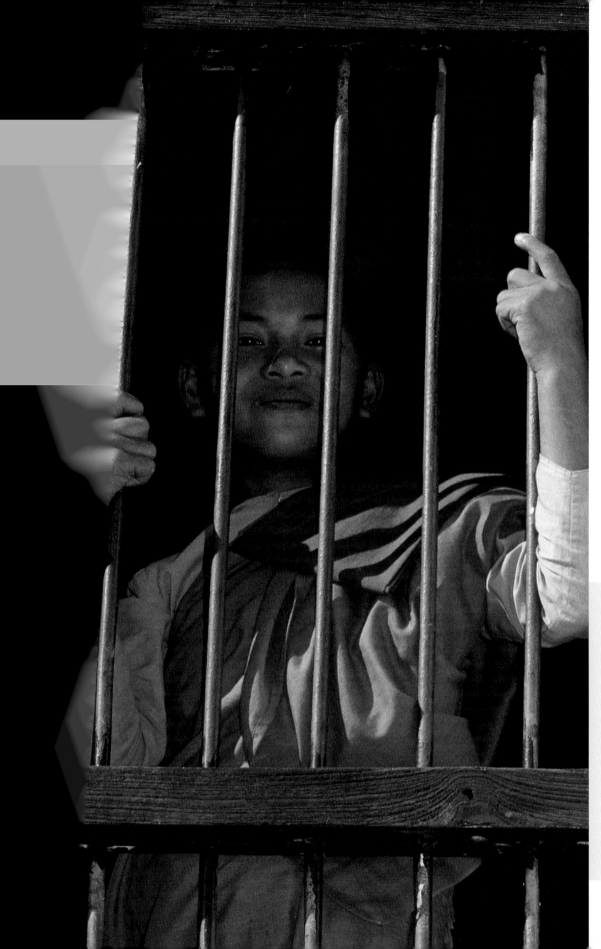

The simplest solution, though not necessarily the best, is to choose subjects that are either in the shade or illuminated by diffused light. Contrast will be reduced and shadows will be softened. Photographs obtained under these conditions are often acceptable, but can also be flat and lifeless.

Another approach is to photograph subjects in direct light and use fill-in flash to control contrast. This works provided that the shadows are filled by an appropriate amount. Over-filled shadows look unnatural and give the image a washed-out appearance. Under-filled shadows are equally unsatisfactory because the problems of excess contrast and lost shadow detail remain. The perfect level of fill is obtained when the use of reflector or flash is barely detectable in the image. Contrast is reduced but not eliminated, and detail is retained in all areas.

Harsh direct sunlight produces well-defined shadows and unacceptable contrast. In this situation reflectors were impractical so fill-in flash had to be used.
Nikon F4 with 135mm f/2 DC Nikkor AFD, Kodachrome 200, 1/250sec at f/5.6

SOURCES OF COLOUR

The colours recorded in an image have various possible sources. The most obvious is the inherent colour of the subject, although tones will vary as the amount of light reflected from its surface changes. The quantity of light returned to the camera depends on the nature and angle of the reflecting surface. A face becomes darker and cooler in tone as its surface curves away from the light, the angle of incidence increases and less light is returned.

The second source of colour is that of the illuminating light. The colour and quality of daylight changes, and so alters the colours recorded in an image. Also bear in mind that, when reflected, light acquires the colour of the reflecting surface. As a consequence, the predominant colours surrounding a subject may well influence the whole image. Colour is particularly critical in portraiture because people are able to judge flesh tones very accurately. Be warned that colour casts will be noticed very quickly.

Choice of film is also significant since no two emulsions behave in the same manner. Some have a warm reddish bias while others produce cooler images with stronger blues and greens. However, modern films are so good that the issue reduces to one of personal preference. The best advice is to try a range of films and stick with the favoured few. This encourages an understanding of the emulsions, which is probably more important than the choice of manufacturer.

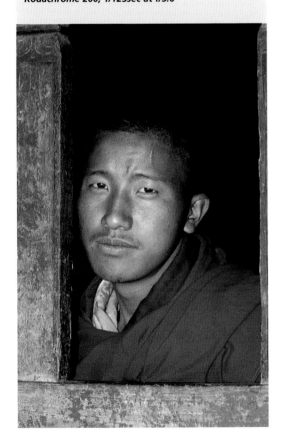

Tonal changes on the face of this Bhutanese monk demonstrate how less light is reflected to the lens as a surface turns away from the camera.
Nikon F4 with 135mm f/2 DC Nikkor AFD, Kodachrome 200, 1/125sec at f/5.6

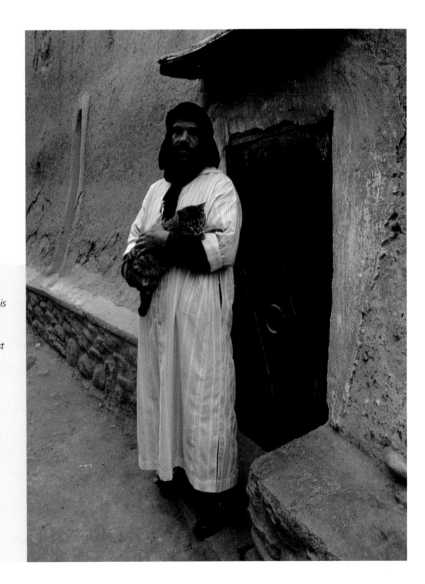

Light reflected from the sun-dried clay walls of this Moroccan kasbah has produced a brownish cast throughout the image.
Nikon F5 with 50mm f/1.4 Nikkor AFD, Kodachrome 200, 1/125sec at f/5.6

EQUIPMENT

WHITE BALANCE

The white balance facility on digital cameras can be used to adjust shooting parameters to suit the prevailing colour temperature. It is easy to set a white balance to suit most conditions. Standard settings include sunny, shade, cloudy/hazy, flash, fluorescent, tungsten and auto. Each one implies a degree of compromise, but errors of less than 250K are not normally visible to the human eye. It may be tempting to use the 'auto' setting and leave the camera to make the decision for you, but judicious use of 'wrong' white balance can be used for creative purposes. If daylight fill-in flash is used, white balance should still be based upon ambient light. When flash is used indoors, it is best to use the designated flash setting.

reasonably consistent, high-quality results, but small variations still occur and can be detected by direct comparison or an experienced eye.

COLOUR TEMPERATURE

The balance of colours in visible light, known to photographers as colour temperature, varies with different light sources and, in the case of daylight, with the time of day. It is usually measured in degrees kelvin (K), the international scientific unit of temperature, but has little to

Eventually, at much higher temperatures, the iron vaporizes and emissions shift to blue and ultraviolet wavelengths.

It is convenient to describe light with a similar spectrum as having a colour temperature measured on the same scale (usually about 2000–20,000K). However, the comparable colours are a consequence of the scattering of light rather than the changing wavelengths of radiated energy.

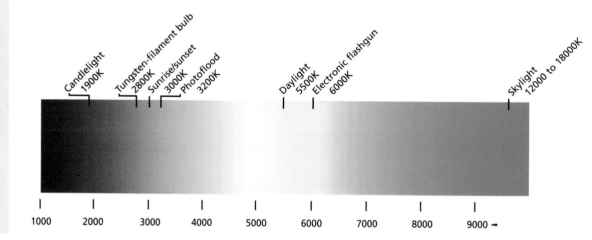

Two other sources of colour are filters and printing processes. Filters can be used to bring about all sorts of colour shifts, subtle and not so subtle, but if true-colour images are the ultimate goal, the more exotic varieties have little to offer. More useful are filters that can be used to correct a colour cast produced by using a film balanced for the wrong light source. In the processing lab or darkroom a final battle must be fought to produce what the photographer requires. Perfect colour matches are difficult to achieve even with well-regulated processes. A good lab produces

do with physical temperature. To understand why this scale is used, consider how the appearance of an iron bar changes as it is heated.

Iron radiates energy at ever-shorter wavelengths as its temperature is raised. At about 300K (room temperature) it appears black, but above about 1000K the energy it radiates begins to move into the visible spectrum and the metal glows red. Around 3000K the glow becomes pale yellow, and at 5500K most of the energy is in the visible wavelengths so the eye sees white heat.

Light emitted by tungsten-filament bulbs has a low colour temperature of about 2800K, and daylight is at its warmest at sunset – perhaps 3000K. Summer sunlight that we see as white is normally about 5500K (the colour temperature for which daylight film is balanced). A blue sky might, in some circumstances, have a colour temperature as high as 20,000K.

COLOUR-CONVERSION FILTERS

Large shifts in colour temperature, such as those required to correct tungsten lighting or other 'warm' light sources for use with daylight-balanced film, can be created using colour-conversion filters. A commonly used range is the blue 80 series, and the table below shows the shift given by each filter (and the corresponding light loss/exposure increase).

Filter	Colour-temperature shift (K)	Exposure increase
80A	+2300	+2 stops
80B	+2100	+1½ stops
80C	+1700	+1 stop
80D	+1300	+½ stop

Colour-temperature meters are available, and can be useful for assessing interiors where daylight is mixed with artificial sources. However, they are not generally required for photographing people.

COLLATERAL COLOURS

The effect that a colour produces in an image depends upon its brightness, the area it occupies, and its relationship with areas of other colours. Collateral colours – those that are close or adjacent in an image – should be handled with particular care.

It is all too easy to misuse assertive primary colours such as saturated reds, blues and yellows. They are more likely to fight each other than muted colours, and tend to grab the eye and divert attention from the centre of interest. When photographing people it is safer to restrict their use to small areas of the image and aim for good overall colour harmony. Look through the viewfinder not only at the subject but also at the background. If necessary, move around to alter the viewpoint – distracting colour can often be excluded or hidden behind the subject.

Colour harmony can be achieved in numerous ways, but the most obvious is by restricting the colours in an image to closely related desaturated hues. This enhances appreciation of the subtle differences between very similar areas. For this reason, successful images of people often consist of warm, muted colours that complement natural skin tones.

Harmony can also be achieved using contrasting colours, although the result is likely to be more striking. Areas of colour of different sizes and strengths can be positioned to achieve an effective pictorial balance, but when they are adjacent they may produce a distracting vibrancy. Similarly, small areas of dominant colours can be used to balance larger areas of more subdued hues.

One other effect is worth mentioning. Short telephoto lenses such as those typically used to photograph people have limited depth of field, and collateral background colours may blur and merge. Colours seen by the eye as separate entities consequently become more abstract. This is usually beneficial because it lifts the subject out of the clutter of background colour. The effect becomes more pronounced as the aperture gets larger and the distance between subject and background increases.

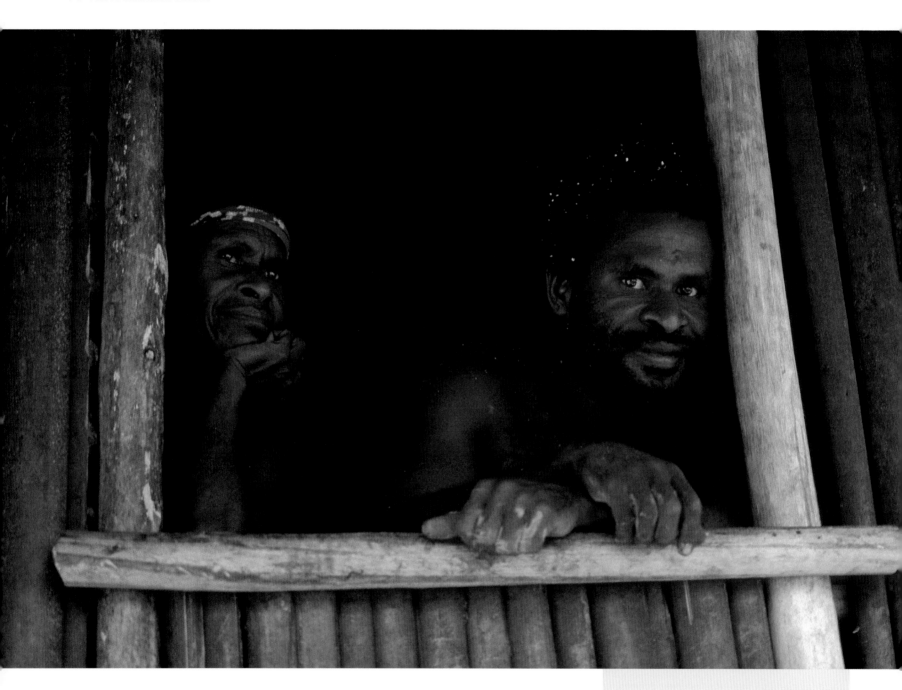

The similar muted hues that dominate this image remove
any possibility of distraction. The eye consequently
concentrates on the two faces.
*Nikon F4 with 135mm f/2 DC Nikkor AFD,
Kodachrome 200, 1/125sec at f/2.8*

Human perception of colour

Warm colours are central to portraiture because they are the colours of flesh, and tend to convey a message of intimacy and life. We are attracted to these in an image, and consequently describe them as 'foreground' colours. Cool colours such as greens and blues have the opposite effect, perhaps because they are the colours of the more remote forests and oceans. They are variously known as 'receding' or 'background' colours, and tend to create an impression of distance and space.

The response of the eye to colour is somewhat different from that of photographic emulsions. For reasons that are not very well understood, the eye is most sensitive in the yellow and green areas of the spectrum. This makes yellow sodium street lighting particularly effective. Photographic emulsions are generally more sensitive in the blue regions. The brain also adapts what the eye detects to a significant extent, and without us realizing what has happened. For example, light from fluorescent tubes or tungsten sources is seen as white despite having characteristic colours. But film does not behave in the same way and consequently may deliver an image quite unlike our recollection of the subject.

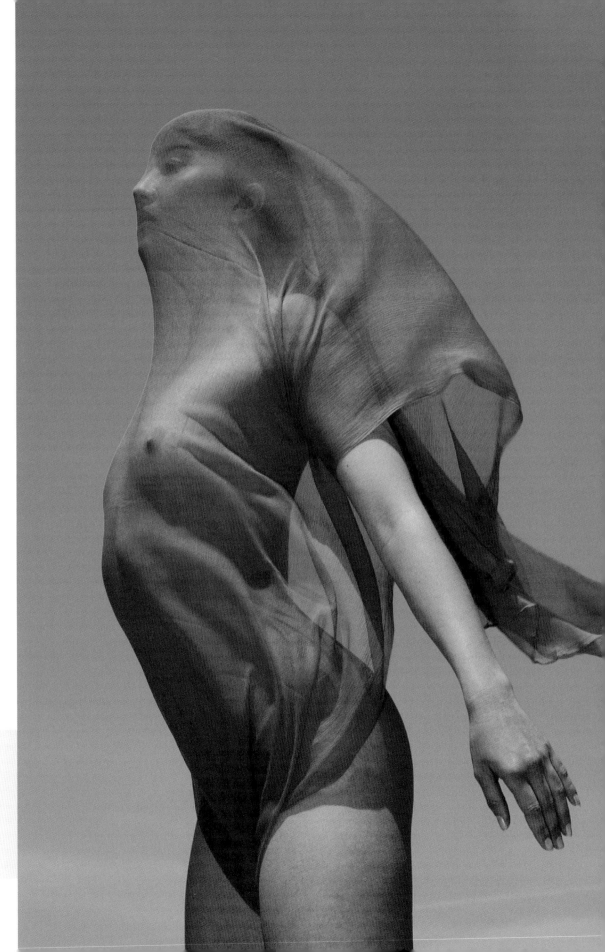

Contrasting collateral colours have the potential to produce dramatic results. Here, the orange chiffon seems to leap out from the blue background.

Nikon F5 with 85mm f/1.8 Nikkor AFD, Fujichrome Astia 100, 1/500sec at f/8

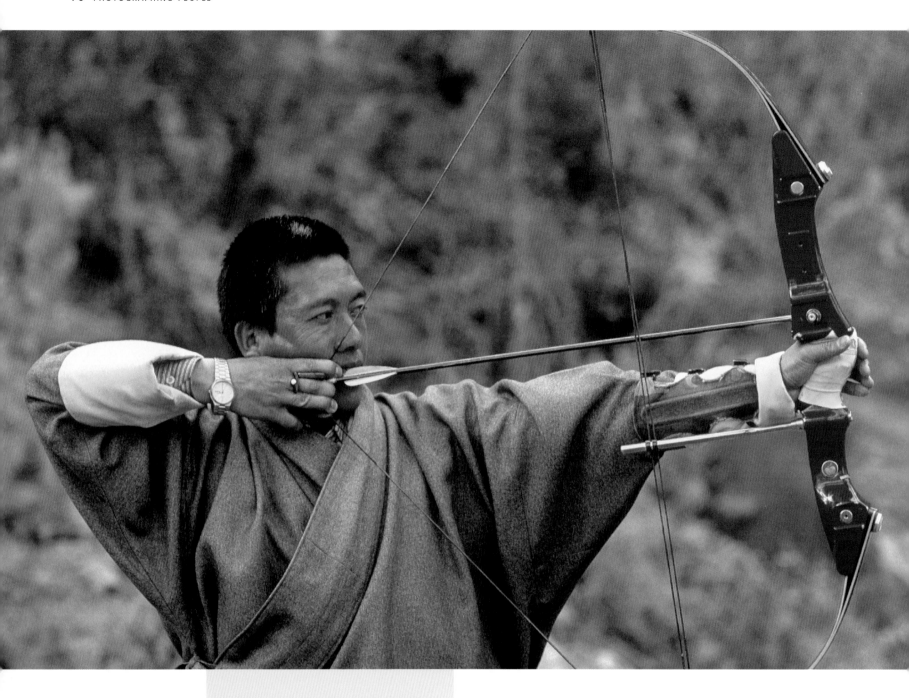

Background detail might have distracted the viewer's eye from the efforts of this Bhutanese archer. However, the shallow depth of field produced by a wide aperture has reduced the trees to an abstract blur.

Nikon F4 with 135mm f/2 DC Nikkor AFD, Kodachrome 200, 1/250sec at f/4

CASE STUDY

THE COLOUR WHEEL

Hues vary continually around the colour wheel, and become paler to merge into white at its centre. Colours harmonize when they are close in hue, saturation and lightness; closeness in any one of these three characteristics contributes to harmony. Adjacent hues therefore harmonize successfully, as may lighter tints of quite different hues. Hues on opposite sides of the wheel are complementary; if added they make white. These and other widely separated hues form effective contrasts.

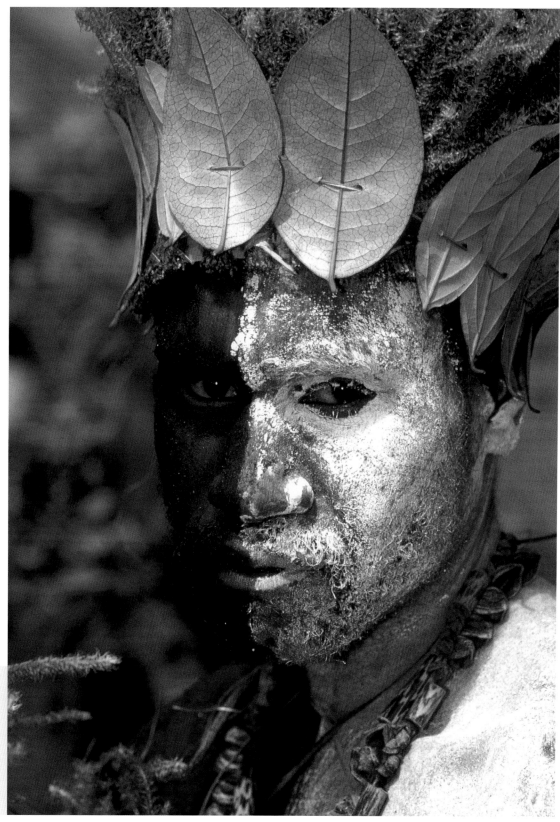

Tribal identities come in every form in Papua New Guinea. This one removes all the warmth of natural flesh tones and gives a distinctly cool feeling.

Nikon F4 with 135mm f/2 DC Nikkor AFD, Kodachrome 200, 1/250sec at f/5.6

ON LOCATION

ON LOCATION

OUTDOORS

ON LOCATION

ON LOCATION

GENERAL CONSIDERATIONS

It is not always easy to find a specific type of location at a moment's notice.

It is therefore worth routinely making notes about interesting or photogenic sites encountered on assignments.

A file of such information, perhaps including a simple reference shot, can save a lot of effort later on.

Having found a good location, and obtained permission to use it, make sure those concerned know your intentions. An open and responsible approach earns the trust of others, and sometimes attracts unexpected assistance. Plan properly for the shoot and be aware of other options should things go wrong. Identify features that might be useful in designing an image, and consider whether anything needs to be moved or changed.

EQUIPMENT AND TECHNIQUE

Location work is often undertaken using nothing more than available light and perhaps a couple of reflectors or a camera-mounted flashgun. However, it can also involve a full studio lighting set-up powered by suitable batteries or generators. Under these circumstances the logistics become a prime consideration, and the assistance of others may be required. Equipment should be prepared and checked well in advance, and packed in suitable bags or cases. Transport to the site, for both equipment and people, must also be planned carefully, although weight and quantity is less of a problem where vehicular access is practicable.

The assessment of a location should include consideration of weather, light quality, background, safety, privacy, trespassing and so on. Any one of these factors has the potential to ruin our shots.

This little girl disliked the insects rising from the long grass. Her attention was eventually diverted by a couple of sweets from her mother's goody bag.
Nikon F5 with 85mm f/1.8 Nikkor AFD, Kodachrome 200, 1/125sec at f/8

These two sisters soon forgot about the camera and became absorbed in a fairytale world. Flash, compensated −1½ stops, was used to fill in the foreground shadows.
Nikon F5 with 85mm f/1.8 Nikkor AFD, Kodachrome 200, 1/125sec at f/8

LIGHTING

Natural light is an excellent source of illumination for photographing people because the images show our subjects as we see them in real life. Indeed, artificial lighting systems are often used to reproduce as accurately as possible the characteristics of natural light. Nevertheless, working outdoors has its own problems.

We cannot control the weather and must accept that the season and time of day determines the quality of light. Some control of other factors may be achievable, but everything should be considered in conjunction with weather and light. Decide what time of day is most appropriate and, when working in colour, think about possible colour casts such as those from nearby foliage.

Although these two Balinese girls look angelic, they had just been holding each other under the water! I used a reasonably slow shutter speed to record the movement of the water.

Nikon FE with 135mm f/2.8 Nikkor MF, Kodachrome 64, 1/60sec at f/8

This group was enjoying local celebrations of the Golden Jubilee of Her Majesty Queen Elizabeth II in 2002. I liked the ice creams, the structure of the group and their collective concentration on some distant event.
Nikon F4 with 300mm f/4 Nikkor AFD, Fujichrome Sensia 200, 1/250sec at f/5.6

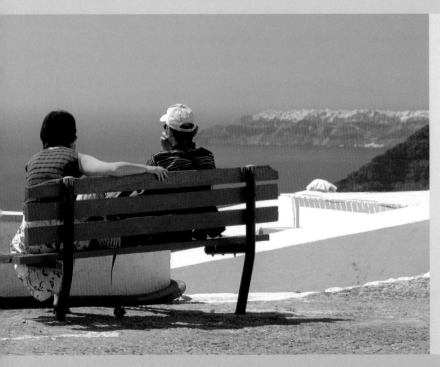

Despite the relaxed atmosphere of this shot, it was necessary to work quickly before the couple moved. The two figures provide foreground interest, create depth and transform a landscape into a simple story.
Nikon F4 with 105mm f/2.8 Micro Nikkor AFD, Fujichrome Astia 100, 1/250sec at f/11

PRO TIP

Initially, use knowledge of your immediate surroundings. Working locally is convenient and less time consuming than going further afield. Local streets, sports facilities, clubs, parks, woodland and riverbanks are all easy to check. I use all these and much more. I also seek permission to use private property of all sorts – houses, gardens, farms, country estates and even business premises. Sometimes permission is refused, but mostly it is forthcoming.

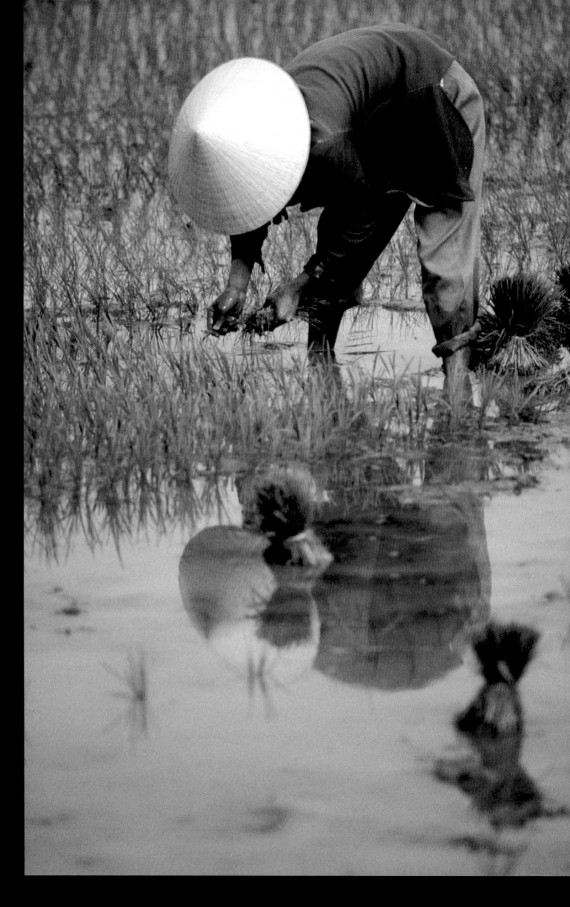

05 **COMMUNICATION, EXPRESSION & MOOD**

It should be the objective of every photographer of people to connect in some way with subjects. Communication can take many forms and can be revealed by countless expressions, moods or gestures. Where the photographer has engaged, and perhaps become sufficiently involved to elicit revealing expressions, this will be clear in the images. Where they have not, communication is likely to be subtle or nonexistent.

COMMUNICATING WITH SUBJECTS

Many people feel tense in front of a camera; not even professional models are immune. However, the circumstances under which a photograph is captured can have a considerable bearing on the atmosphere. At a happy social occasion, where the guests know each other, few will be concerned by the presence of a camera. When invited to a studio and asked to pose, the same people may feel apprehensive.

Whatever the circumstances, the subject should be encouraged to relax as much as possible. How this is achieved will depend upon the personalities involved, the relationship between the photographer and subject, and the environment in which they are working. Observe body language and assess how the subject is feeling. Start a conversation, be caring and introduce a little humour – simply demonstrating that you are human will break the ice.

Communication may be blocked to some extent by a camera, particularly when it is held in front of the face. Waist-level viewfinders, useful for low-angle shots, are better from this point of view – at least in some ways. Remember that the top of a photographer's head also presents a barrier to communication. Try to avoid these situations as much as possible. Lower the camera or look up, smile at the subject and chatter about something of mutual interest – relate to the human being in front of you. You, the photographer, must also relax and try to remain objective. The glow of warmth you might feel in your heart when photographing someone special will not be reflected in the images.

The expression of the boy in the foreground reveals his spontaneous reaction to a light-hearted gesture. The background figure adds depth and balance to the image.
Nikon F4 with 20–35mm f/2.8 Nikkor AFD, Kodachrome 200, 1/125sec at f/4

This candid image, captured with a telephoto lens, is devoid of all communication. The hat also depersonalizes the rice worker by shielding the face from view.
Nikon F4 with 300mm f/4 Nikkor AFD, Kodachrome 64, 1/250sec at f/8

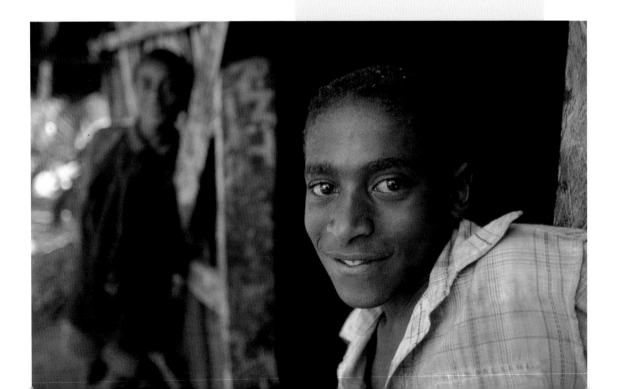

When travelling, subjects are rarely under the control of the photographer and opportunities must be grasped as they arise. Learn how to approach people without the advantage of a common language, show genuine interest and get involved. Ordinary people are basically the same the world over. They love their families and share similar hopes and fears. At this level it is possible to relate to strangers anywhere.

EXPRESSION: THE RIGHT MOMENT

Highly sophisticated languages that might be regarded as the ultimate tools of communication have been developed by human beings.
They make possible the exchange of complex information and ideas, but are less effective when it comes to expressing emotions, which are often better and more rapidly conveyed by subtle changes of expression.

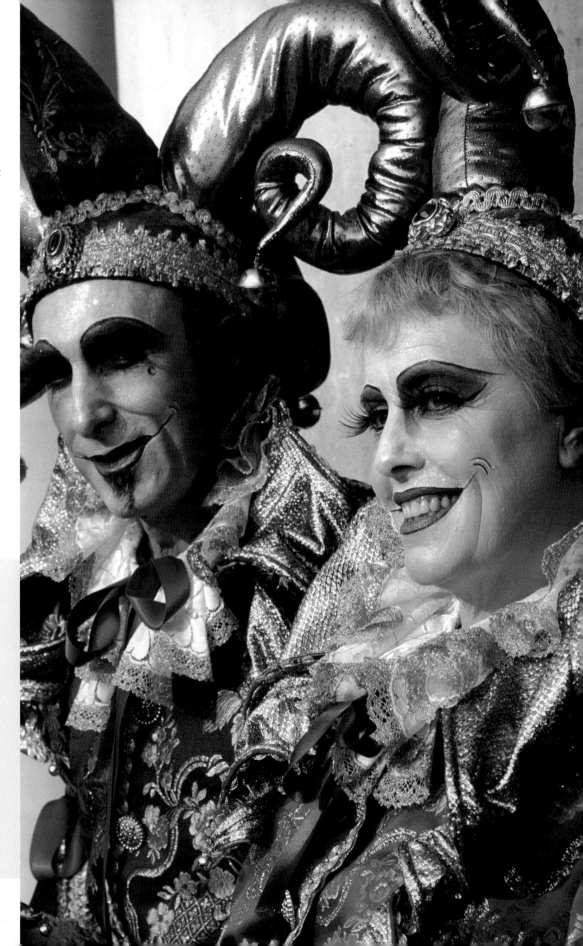

Exotic costumes invite attention and therefore serve to break the ice. The expressions on the faces of these artists revealed that they wanted to be photographed and would therefore be easy to approach.
Nikon F5 with 105mm f/2.8 Micro Nikkor AFD, Fujichrome Sensia 200, 1/250sec at f/8

The human face is a highly developed organ of expression. It has more muscles, and hence a more varied repertoire, than that of any other creature in the world. Indeed, we are capable of producing thousands of different expressions and use hundreds in everyday life. This very personal form of communication enables us to convey our innermost feelings by momentarily tightening a particular set of muscles. As social animals we are also accomplished at interpreting the expressions and gestures of others. Facial movements tell us a great deal, so sensitivity to every nuance is beneficial and well developed.

Despite their ephemeral nature, or perhaps because of it, expressions can make or break a photograph. The problem for photographers is principally one of timing. Even now, after a lifetime of photographing people, I am surprised by the fleeting nature of facial movement. Sequences of images captured at split-second intervals reveal marvellous expressions visible only in a single frame. Transient smiles, wide eyes and lifted eyebrows that go almost unnoticed have the potential to transform the mundane into something special. The preparedness and alertness of the photographer are consequently

so crucial that it is worth practising framing and focusing until it becomes a single fluid movement.

This shot was taken from within the perimeter fence of an airfield in the remote highlands of Papua New Guinea. The expressions reveal a little of the local attitude to comparatively wealthy foreigners.
Nikon F4 with 20–35mm f/2.8 Nikkor AFD, Kodachrome 200, 1/250sec at f/11

But I have also photographed people who seem impassive, or who might be unable to change their expressions. (An unfortunate medical condition associated with the cranial nerves, known as Möbius' Syndrome, leaves the sufferer incapable of facial movement.)

Capturing fleeting expressions may seem daunting, and it can be, but there are things we can do to make life easier. Reactions can be elicited from subjects in many different ways, and may consequently become a little more predictable. Things are perhaps at their worst in the sterile environment of a studio where subjects may feel tense, exposed and inhibited. Music, humour and simple conversation are standard tools used to establish a rapport. Other situations, such as weddings, require different techniques. Experienced photographers have numerous approaches up their sleeves, and must learn to adopt those best suited to the mood of the occasion.

In the broader world the photographer can no longer call the shots, and external factors are more likely to intervene. When photographing people on market stalls it is unlikely that you will have their attention for very long. Brief exchanges may be possible but mostly you will have to work in an opportunistic way. Customers need to be served, and in the process may walk in front of your camera and ruin your shot. However, events over which you have no control are part of this environment, and can be used advantageously. Distractions, even when brief, may cause your presence to be forgotten and expressions and angles of view to change – be ready.

This storyteller was difficult to follow with a camera as he strode boldly around to emphasize the highlights of his tale. Nevertheless, it was vital to capture the best of his fleeting expressions.
Nikon F4 with 135mm f/2 DC Nikkor AFD, Kodachrome 64, 1/125sec at f/5.6

Of course, some people are more expressive than others. Those with bubbly personalities are a delight in front of the camera. The emotions are close to the surface and reactions may be exaggerated or unexpected; their faces are mobile and their communication is generally animated.

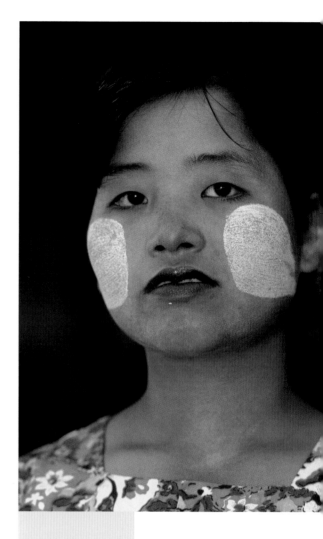

Some faces are naturally less expressive. There is eye contact in this image, but unfortunately little evidence of meaningful communication.
Nikon F4 with 135mm f/2 DC Nikkor AFD, Kodachrome 200, 1/250sec at f/5.6

EYES AND ENGAGEMENT

Eyes are the gateway to personality and their magnetism can transform an image. They change in appearance more rapidly than any other part of the face, and must be watched carefully. If the eyes are averted and the look is not positive, the result may be furtive. A spontaneous smile is enchanting because we sense the subject's joy; a scowl is disturbing because it conveys disapproval. If the eyes are unfocused, the subject appears lost in private thought. A glance over the shoulder may seem casual, as in a chance encounter, and often creates an impression of innocence or mischief.

The child's eyes are the centre of interest in this monochromatic image. Without their doleful appeal, the image would fail.
Nikon F4 with 135mm f/2 DC Nikkor AFD, Kodachrome 200, 1/60sec at f/4

CASE STUDY

DIRECT EYE CONTACT

The human eye is unusual in that a large area of contrasting sclera, the white of the eye, is visible. This increases the impact of direct eye contact, particularly when the eyes widen in surprise or perhaps in response to a romantic encounter. A direct gaze conveys a powerful message but its meaning may have to be interpreted with knowledge of the relationship between those involved – it could be love, curiosity, amazement or fear.

Eye contact is highly personal and more acceptable in some parts of the world than others. In the western world, direct contact is maintained only intermittently for periods of a few seconds to avoid staring.

This is taken to extremes in inner-city areas, where 'eyeballing' someone may be regarded as confrontational. In other cultures it is acceptable and normal to maintain unbroken eye contact for much longer periods.

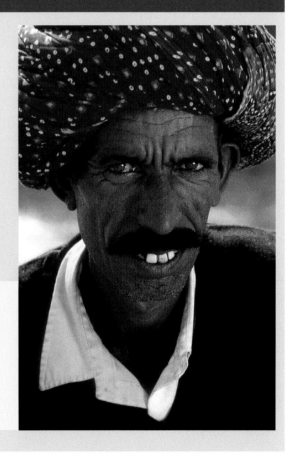

The eyes have an irresistible magnetism. When captured at the critical moment, they communicate all sorts of messages and emotions.
Nikon F4 with 135mm f/2 DC Nikkor AFD, Kodachrome 200, 1/250sec at f/8

Vitality, love of life and pure delight are all apparent here, communicated by expression, demeanour and good light.
Nikon F5 with 85mm f/1.8 Nikkor AFD, Fujichrome Sensia 100, 1/250sec at f/8

A simple widening or redirecting of the eyes can fundamentally alter an image. A subject who looks into the lens communicates not only with the photographer, but also with those who view the image. Engaging with your subject is therefore a powerful technique, but involvement is not always easy to achieve. Approaching a complete stranger in a foreign country can be daunting, particularly where there are cultural divisions and language barriers. Over the years, I have acquired my own ways of dealing with this using non-verbal communication, humanity and a self-effacing sense of humour. On many occasions I have spent half an hour 'conversing' with a subject with whom I shared not a single common word, getting by with smiles, gestures and humility. The effort has been repaid handsomely by the engagement apparent in the resulting images.

VITALITY

To bring an image to life we must be clear about what we want to portray, and then realize it in a simple and direct manner. If a woman loves riding she might be photographed grooming her horse, perhaps with the sun behind her to highlight her hair. If we can also capture a windswept look and a twinkle in her eye, the image will provide evidence of her vitality and love of outdoor life.

The subject's physical characteristics can also be used to bring life to an image. Be sure to capture features such as sparkling eyes, glowing skin or a good figure because they are direct indicators of good health and vitality. It is not necessary to flatter subjects to the extent that they become different people, but as photographers we should aim to do them justice.

Of course, vitality is not the exclusive preserve of the young. Enthusiasm, spirit and even image awareness can be found in people of all generations. Distinctive clothes, bright colours, attitudes and mischievous eyes all make some statement about a subject's exuberance and lead an image in the right direction.

MOOD: AN EXTRA DIMENSION

The mood of an image is the predominant feeling with which it leaves us. It is truly an extra dimension that can be used to establish a reality and meaning far beyond that of a simple likeness. We may be uplifted, inspired, depressed or left with unanswered questions. I recall a period spent in the killing fields of Cambodia, in South East Asia, where, between 1975 and 1979, two million people were executed by the Khmer

CASE STUDY

IMAGES WITH VITALITY

It is all too easy to produce dull, wooden images where the subject looks bored. People are alive and active, so dynamic images, perhaps including strong light and vibrant colours, are likely to have greater impact and immediacy. Aim to capture the spirit of the subject, perhaps through movement, mischief or sense of humour. Dynamic or unbalanced compositions, such as those featuring movement or off-centre subjects, help by producing spontaneity and tension.

It is hardly necessary to explain that this shot was grabbed from a passing celebration. The vitality conveyed by the girl's expression says it all.
Nikon F5 with 105mm f/2.8 Micro Nikkor AFD, Fujichrome Sensia 200, 1/250sec at f/11

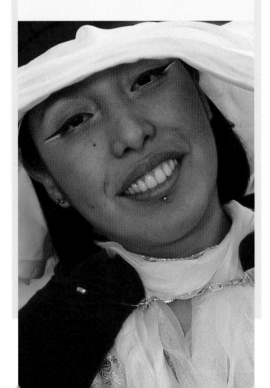

Rouge regime. Images of death and insanity left me intensely depressed, but captured something of the scale of the tragedy.

Mood is partly a physical attribute incorporated into an image. Expression, visible and implied circumstances, colour, focus and the atmosphere imposed by the prevailing light all offer a degree of control. However, it is also a product of our personal reactions and attitudes, and thus an elusive and subjective quality attracting a different interpretation from every viewer.

The key to communicating our vision effectively is to understand how others are likely to react to our work. Photographers bring their own background, experience and style to subjects, and cannot avoid doing so. Their personal marks are inevitably embedded within images of any depth. Those who view images also do so in the light of their own attitudes and experience. The challenge for the photographer is therefore to find common ground.

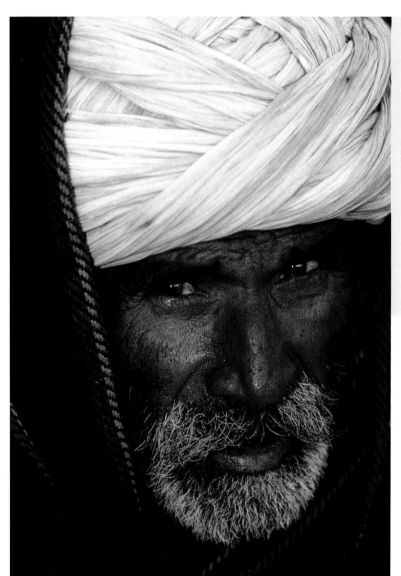

The intense expression on the man's face, framed and concentrated by his turban and blanket, gives this portrait a moody reflective feel.
Nikon F4 with 135mm f/2 DC Nikkor AFD, Kodachrome 200, 1/250sec at f/8

CASE STUDY

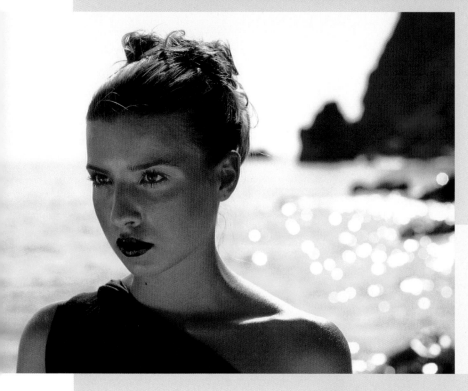

DIRECTING A MODEL'S GAZE

Both the direction and focus of the eyes affect mood. An intense, focused look directed at the camera gives a purposeful feeling to an image. If a model is asked to stare through earthly objects to infinity, the eyes acquire a determined laser-like appearance. Averted, defocused or glazed eyes encourage a relaxed or dreamy mood. Eyes turned sharply to the side, or up or down, reveal more of the sclera and hence appear larger and more emotional.

Eyes focused at infinity have a laser-like intensity. Their penetrating stare grabs the viewer's attention and sets the mood of the image.

Nikon F5 with 85mm f/1.8 Nikkor AFD, Fujichrome Astia 100, 1/250sec at f/16

This woman's happy, mischievous smile surely reveals something of her lively character.

Nikon F4 with 20–35mm f/2.8 Nikkor AFD, Kodachrome 200, 1/125sec at f/5.6

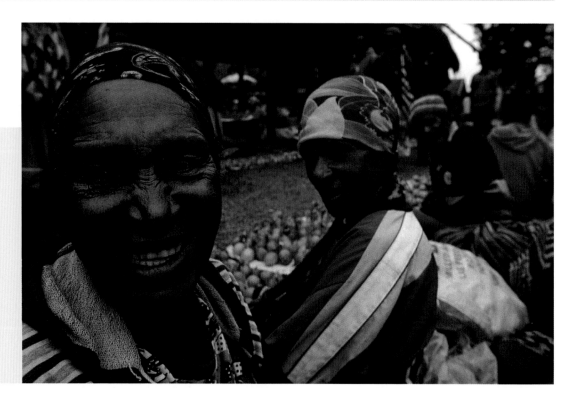

It is worth learning to look at your own images some time after they are captured and noting what associations and emotions they arouse. If they provoke little reaction, or are similar in nature, it is time to break out. A narrow track may be restricting your creativity. Try something new, something crazy. Act on impulse and break some rules.

Colour and light

The colour content of an image has a significant bearing upon mood. Strong, strident colours are obvious and invigorating, and tend to demand attention. Bold colour combinations also attract, but clashes that might be regarded as poor taste may repel. Pastel colours are soft, soothing and subtle and generate a feeling of calm.

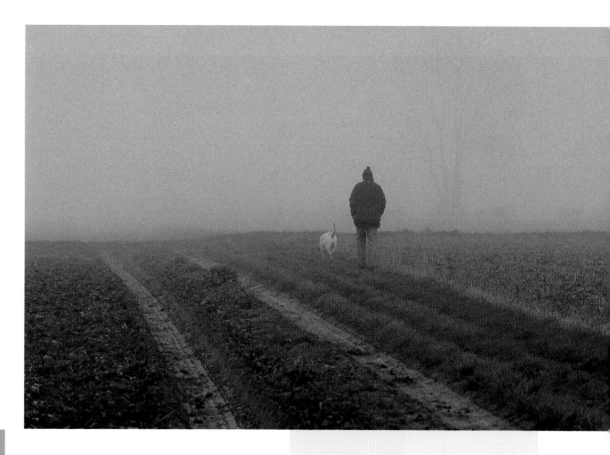

Desaturated hues and lack of contrast lead directly to a sombre, lonely feeling in this image.

Nikon F5 with 50mm f/1.4 Nikkor AFD, Kodachrome 200, 1/60sec at f/5.6

CHECKLIST

Creating mood:

- Consider the strength and direction of light
- Soften focus to isolate a subject or suppress detail
- Use soft colours to create a feeling of calm
- Create energy and draw attention with bold colours
- Control the direction and focus of the eyes
- Establish the story behind the picture
- Consider the inclusion of broader environmental elements
- Find common ground with viewers

Similar hues and saturations reduce contrast and seem to merge easily together. Monochromatic images, where a single colour dominates and contrast and definition are lacking, often evoke emotional responses. A scene showing a man walking his dog in thick fog consequently has a sombre, lonely feel. Colour casts, such as those created by appropriate coloured filters, may also work well.

Soft and differential focus convey mood by suppressing detail throughout the image or in the defocused areas. They reduce contrast and merge defocused areas of colour until they become abstract. Slight overexposure also softens colours and creates a degree of mystery that can be attractively romantic. However, bear in mind that all these techniques can be overused.

Prevailing light also imposes mood. The face of an elderly man, wrinkled by experience, may be thrown into wonderfully expressive and atmospheric relief by sidelighting. Alternatively, muted colours and large areas of shadow tones might bring serenity and solemnity to the same subject. At sunrise or sunset the light is warm and gentle and lends itself to reflective portraits. However, for the soft complexion of a young girl, pastel colours and soft light provide an appropriate fragility and gentleness that is more flattering.

READ ON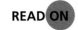

The direction of light

p.65

Framing and

environment

p.104

Wideangle and

environmental work

p.121

Strong light is bright and cheerful, particularly when combined with lively colours, and can be used to highlight exuberance and vitality. But when used as backlighting it emphasizes a person's outline and conceals detail, form and even the face. Images of this type rely on strong shapes, but are distinctive and intriguing.

The contribution of environment

People express their personalities not only through their appearance and behaviour, but also in their personal environment. The home in which someone has lived for many years is perhaps the most obvious example of this. Furnishings and contents reveal the tastes and interests of the occupant, and provide an ideal environment in which to capture the subject's character. My own home has become more like a museum as the years have passed and the valueless but treasured paraphernalia gathered in the far corners of the world has accumulated.

The environmental aspects of someone's life should be approached with tact and sensitivity. Personal possessions may be much more than decorative objects – they may be irreplaceable memories of past experiences. When working in the home of your subject think carefully about the impact of your presence and that of cumbersome and intrusive photographic equipment.

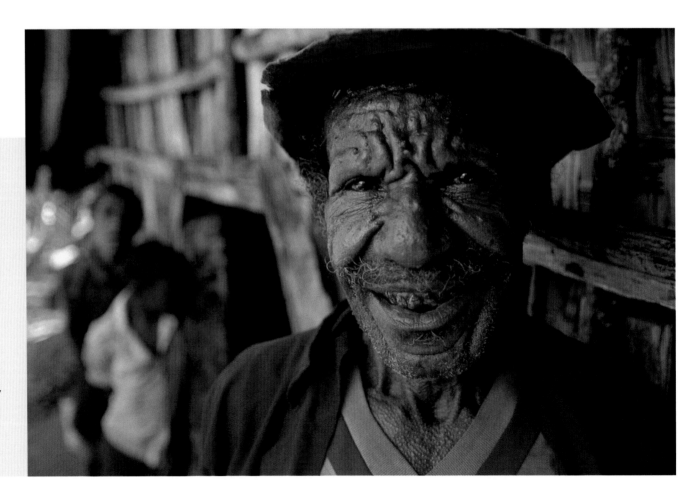

Sidelighting has emphasized not only this man's perplexed expression but also the form and texture of his extraordinary face. Flatter, frontal lighting would have been much less effective.
Nikon F4 with 20–35mm f/2.8 Nikkor AFD, Kodachrome 200, 1/125sec at f/4

Remember that too much supplementary lighting is likely to kill the comfortable atmosphere of a room, so flash should be used sparingly and balanced with ambient light wherever possible.

Broader environmental elements can also be used to convey mood. Depressing streets and run-down industrial areas imply a hard, monotonous existence. Dirty surroundings, smoke or fog may add to a feeling of drudgery and depression. Atmospheres of this type can be emphasized in low-key images dominated by dark tones, or alternatively relieved by a lighter high-key approach.

CASE STUDY

CHOOSING WHAT TO SHOW

Different photographers will inevitably approach the same subject in quite different ways. One might see a girl as a fashion model and portray her as a carefree, impulsive buyer of clothes. To another she might be a sultry beauty and hence shown in a quite different light. However, mood is not always achieved in such a direct manner, and may be more effectively conveyed by what is not shown. For example, poverty or the results of famine might be used to make a social or political comment. This does not mean that the portrayal must in itself be shocking. We may choose to leave much to the imagination and, in so doing, encourage viewers to draw upon their own resources. The ultimate objective when photographing people is to reach out to a feeling or situation. The real story is what lies behind a haunted look or fixed stare, and mood provides additional evidence.

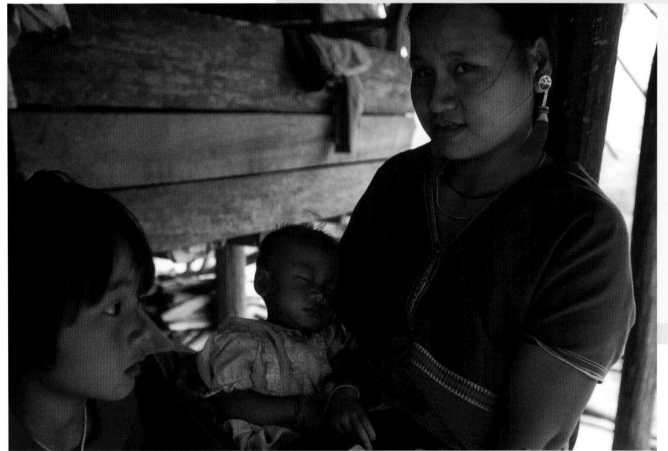

The warmth of the family's surroundings, and the environmental detail captured by a wideangle lens, communicate love, unity, poverty and hardship.
Nikon F4 with 20–35mm f/2.8 Nikkor AFD, Kodachrome 200, 1/60sec at f/4

THEMES

THEMES

SPORT & ACTION

THEMES

THEMES

The essential ingredients of good sports images are action, effort and stress. Movement can be stopped by the use of fast shutter speeds, leaving the subject crisp, sharp and frozen at the peak of the action. This can be a very effective way of showing extraordinary physical effort or unusual body positions. Action can alternatively be portrayed by using a slow shutter speed. The degree of blurring will depend not only on the period of exposure but also the speed and direction of movement. Experience soon reveals the most successful techniques.

This scramble rider was caught at the peak of the action with the ground carefully excluded from the frame. This emphasizes the height of his trajectory.
Nikon F5 with 135mm f/2 DC Nikkor AFD, Fujichrome Sensia 400, 1/2000sec at f/8

The action of the bowls player is frozen at the critical moment of delivery. Positioning the camera to include the scoreboard has provided additional context for the image.
Nikon F5 with 300mm f/4 Nikkor AFD, Fujichrome Sensia 200, 1/500sec at f/8

For most photographers, sports images must be obtained during a competitive event from the best vantage point available. This editorial approach is essentially opportunistic, and relies upon an ability to seize the critical moment. When photographing an unfamiliar sport, it is worth watching for a while before shooting away. This helps to identify the peak of the action, when concentration and effort are at a maximum or the achievement of an objective is on the verge of realization. However, some commercial photographers use a more calculated approach, where competitors are hired to repeat their actions until the critical moment is finally captured.

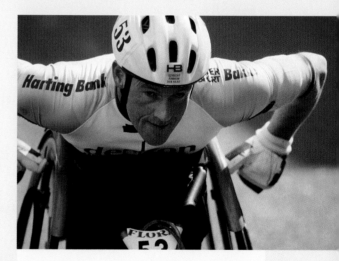

I captured this hand-held shot from a press vehicle travelling at 20mph in front of the leading competitors in the London Marathon. Concentration and effort are etched onto the face of this wheelchair contestant.
Nikon F5 with 300mm f/4 Nikkor AFD, Kodachrome 200, 1/500sec at f/8

THEMES

THEMES

COSTUMES & MASKS

THEMES

THEMES

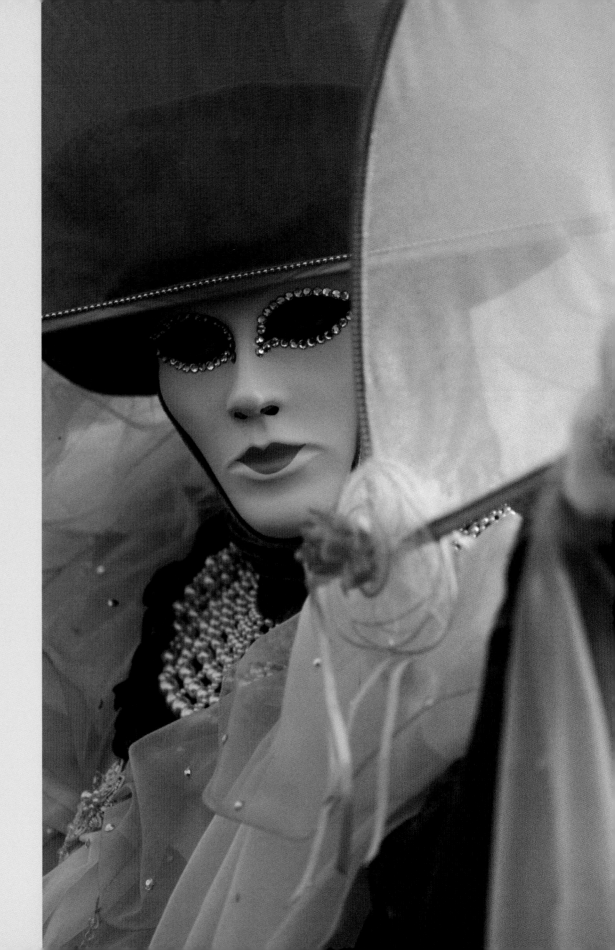

Costumes and masks take many forms and serve many purposes. They have been used for centuries not only to conceal the identity of the wearer but also to project the image of another person, animal or unearthly being.

In Africa, Asia, South America and Oceania, elaborate and exotic creations are still widely used to entertain, exercise power and maintain tribal identities.

Subjects dressed in unusual costumes adopt roles or disguises. If the costumes are exotic it is obvious that they are overstated and unreal, and the wearers are released from the constraints of normal behaviour. Masks that cover the face take matters a step further. They conceal and dehumanize the subject by removing the feedback of moods and expressions. This blocks communication and leaves the viewer unsure of how to relate to the masked person. Free rein is then given to the imaginations of the artists, and extravagant poses and actions are encouraged.

This is a liberating experience for a photographer. No longer is it necessary for subjects to appear normal or real – anything is possible. Look at the shapes and colours of the costumes and masks, and experiment with wild behaviour, exaggerated gestures, unusual camera angles and so on. Dramatic, selective or coloured lighting also works well, particularly with masks, so this is a subject that might be transferred to the controlled environment of the studio.

Sunset is a good time to photograph the masqueraders at Venice Carnival. I selected this golden mask in good time, and ensured that I was in position and ready as the sun set. Such conditions do not last long.

Nikon F5 with 300mm f/4 Nikkor AFD, Fujichrome Sensia 200, 1/250sec at f/8

The limited range of hues in this simple image adds to its illusory nature. The slightly different positions of the two identical subjects add to the magic. All I had to do was find the right light and background.

Nikon F5 with 105mm f/2.8 Micro Nikkor AFD, Fujichrome Sensia 200, 1/500sec at f/8

Costumes and masks depersonalize subjects and encourage unusual poses and actions.

Nikon F5 with 105mm f/2.8 Micro Nikkor AFD, Fujichrome Sensia 200, 1/250sec at f/5.6

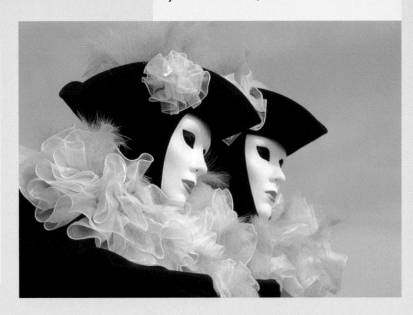

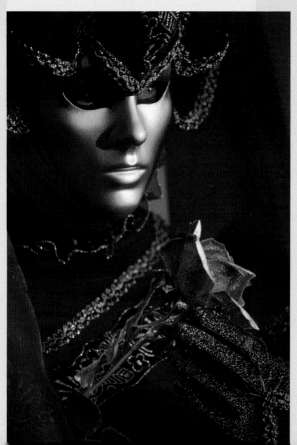

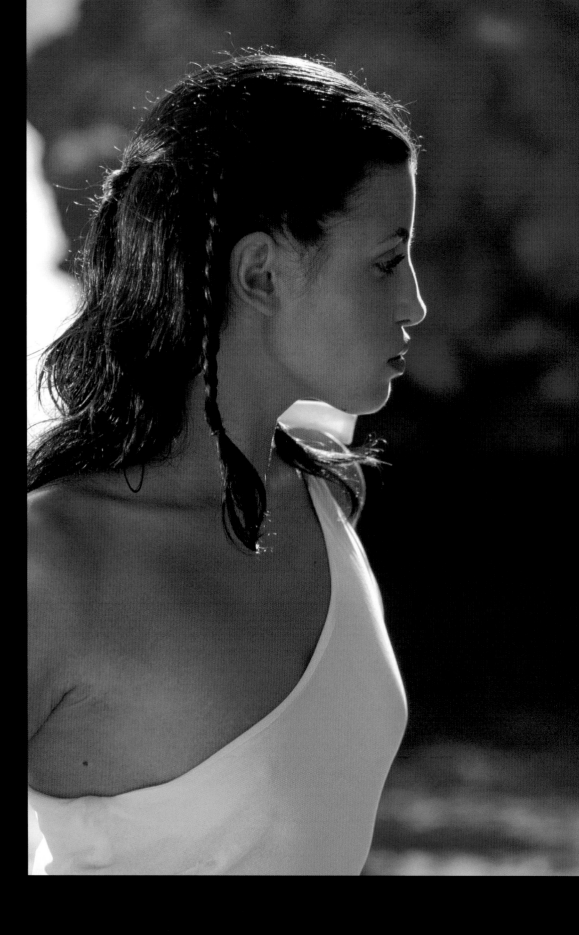

IMAGE DESIGN

Successful images work because they are captured in beautiful light, their elements fit together in a satisfying manner, and ultimately they inform us about the subject. Unfortunately, the attractive attributes that make an image special rarely appear by chance, and there are many aspects of design to be measured and carefully arranged. These include light, shape, pattern, texture, tone, atmosphere and meaning.

The rim lighting and bold yellow triangle are strong elements of design in this simple profile.
Nikon F5 with 85mm f/1.8 Nikkor AFD, Fujichrome Astia 100, 1/250sec at f/8

SEEING PICTURES

Producing a really good two-dimensional representation of form and depth is one of the greatest challenges in photographing people. A photograph is merely a sheet of paper and has no depth, but must nevertheless preserve the illusion of a third dimension if it is to be lifelike. Lighting is the key here, because visual experience allows us to relate tonal gradation in the flat image to the different ways in which surfaces respond to illumination in the real world. Areas of deeply contrasting light and shade emphasize depth, form and texture.

However, the gentle curves of the human body are normally best illuminated by diffused light that produces subtle effects. In black & white images, shape, line, form, texture and tone are the principal elements of composition and must be fully utilized to retain depth. In colour images, brighter hues tend to advance, so brightness and saturation may become significant.

The edges of a photograph, as perceived through the viewfinder, also have to be accommodated. Such boundaries do not exist in the environment, but all the elements included in an image have to lie comfortably within these strict limits. A couple of simple techniques help to develop the basic visual perception required. First, we can learn to see and analyse shape in a deliberate manner, independent of its human context. Partially closing the eyes helps to identify the principal shapes and elements in a scene. This diminishes the finer qualities of the light and reduces detail and colour saturation.

Peering through a rectangular frame, perhaps formed by the thumb and first finger of two hands, can enhance this effect. Alternatively, just close down the lens aperture using depth-of-field preview and look through the viewfinder.

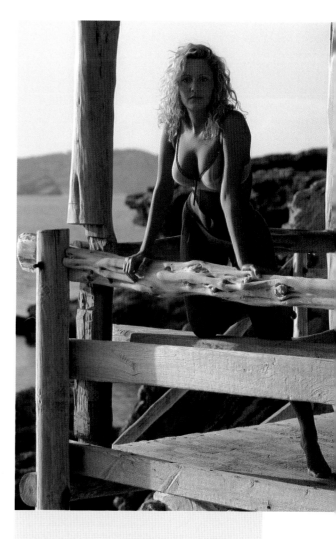

Sidelighting has given form to the model's body. Her outstretched limbs emphasize her slim figure and strengthen the diagonal element of the composition.
Nikon F5 with 135mm f/2 DC Nikkor AFD, Kodachrome 200, 1/250sec at f/8

EQUIPMENT

VIEWFINDERS

When you view a subject using a reflex camera, the image you see in the viewfinder is gathered through the lens. Although it should be noted that a viewfinder's field of view is sometimes slightly less than that of the attached lens, this system generally gives an extremely accurate view of the image that will be captured. Twin-lens reflex, rangefinder and some compact cameras, on the other hand, use separate optical systems to view and to capture a scene, which can cause a problem when composing an image, as shown below. This so-called 'parallax error' is at its worst when a camera is used close up, and can lead to heads being cut off. Framing lines are sometimes marked in viewfinders to relieve the problem.

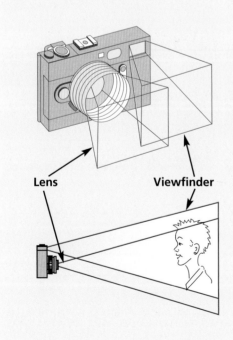

Lens **Viewfinder**

The ability to see form in an analytical manner is a little more difficult to acquire, although it is basically only the three-dimensional equivalent of analysing shape. As we have seen, key elements are how surfaces are illuminated and how they absorb or reflect light. Highlights, dark shadows and the infinite tonal gradations between the two extremes must be observed. Also, look at lines and curves, and consider whether they encourage the eye to explore the depth of the image.

The perception of colour was discussed in Chapter 4, but it is worth noting here that it is an integral part of seeing pictures. Colours alter balance, create the illusion of form, and suggest shapes and directions. Advancing, strident colours draw the eye, leap out of the picture and subordinate quieter hues. Consequently, they are significant in the same way as the physical shapes of objects.

Strong lines and colours have created graphic background detail. The dominant shapes are echoed to some extent by the geometry of the performer's body. **Nikon F5 with 300mm f/4 Nikkor AFD, Fujichrome Sensia 200, 1/250sec at f/8**

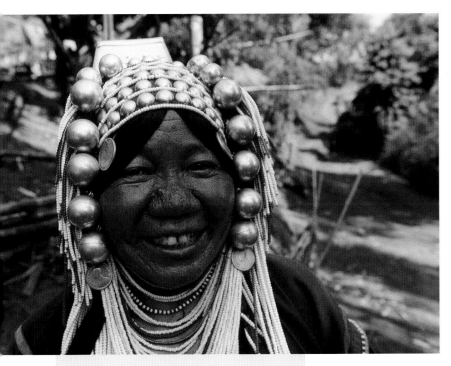

An important step in learning to perceive an image is to know your lenses and their limitations. In particular, understanding how they change perception increases control of image design. Telephoto lenses compress depth and enlarge the subject. Distant objects may look closer to the foreground than they really are, reducing uninteresting intervening spaces. Depth of field is restricted, so differential focus can be used as an image design tool. Wideangle lenses increase the impression of depth and scale, but diminish the size of the subject. To achieve a reasonable reproduction ratio the photographer must therefore work close to the subject, perhaps within touching distance. This implies a considerable degree of involvement, but often results in entirely fresh perception.

READ ON

Focus and depth of field

p.57

Human perception of

colour

p.75

The lines created by the background track and shadows seem to thrust this Akhar tribeswoman, photographed in Northern Thailand, towards the camera. The use of a 20mm lens at close range has further emphasized the exceptional breadth of her nose.

Nikon F4 with 20–35mm f/2.8 Nikkor AFD, Kodachrome 200, 1/250sec at f/5.6

Camera lenses, microphones and lights all lead the eye to Natalie Imbruglia performing on stage. The limited depth of field of a telephoto lens has also lifted the subject out of the cluttered background.

Nikon F5 with 300mm f/4 Nikkor AFD, Fujichrome Astia 100, 1/250sec at f/5.6

MAKING IMAGES

The process of 'taking a photograph' is very straightforward provided we require nothing more than a record with little creative merit. The ability to 'make an image' is what qualifies us as photographers. This is not just semantics; it is a fundamentally different approach. Taking a photograph implies that we accept what is available, perhaps just choosing which part of a scene to reproduce. There is virtually no creative input, and consequently little satisfaction. Making an image suggests that there is work to be done by the photographer – the image has to be designed before it can be captured, and therein lays the creativity.

CASE STUDY

FRAMING: LANDSCAPE OR PORTRAIT

One of the first considerations when making an image is the proportion and orientation of the frame. Compositions suggested by the square frame of some medium-format cameras might be quite different from those suited to the 3:2 aspect ratio of 35mm film or the various digital formats. Where the frame is not square, the choice between landscape (i.e. horizontal) and portrait (i.e. vertical) orientation must also be made. The human form simply portrayed invites the use of portrait format, but be sure to consider other, less conventional options when framing, including square and diagonal.

The horizontal format can work well even with head-and-shoulders portraits. This man's costume and painted face seemed to suggest a composition of this type.

Nikon F4 with 105mm f/2.8 Micro Nikkor AFD, Kodachrome 200, 1/250sec at f/8

Nelson's Column in London's Trafalgar Square, foreshortened by the low viewpoint, is an obvious candidate for vertical format.

Nikon F4 with 20–35mm f/2.8 Nikkor AFD, Fujichrome Sensia 100, 1/250sec at f/11

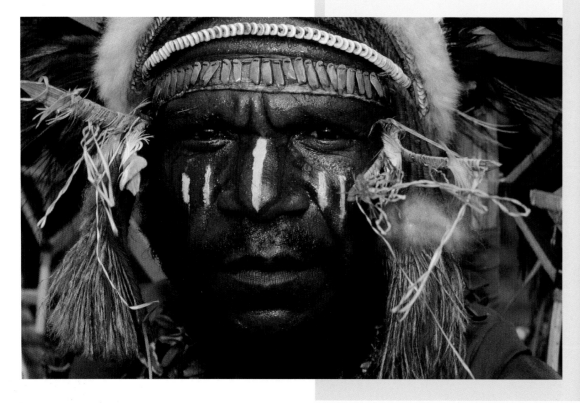

READ ON

Hyperfocal focusing

p.57

The girl's arms have created interesting shapes and a strong diagonal line that cuts boldly across the horizontal and vertical background detail.
Nikon F5 with 85mm f/1.8 Nikkor AFD, Fujichrome Astia 100, 1/250sec at f/11

To make sure the overall form of the subject is pleasing, force the eye to regard the human figure as a shape. If the geometry is uninteresting, change it in whatever way is appropriate or possible. Try simple movements of the head and limbs, look for diagonal lines and, if necessary, rearrange the overall shape of the body. Also consider whether perspective, illumination, colour and contrast are such that the illusion of depth will be maintained in the image. If the scene has marked contrast, measure the highlights and shadows using spot metering and, when required, compensate using fill-in flash.

Once satisfied with the subject, concentrate on the background. Consider its colour, contrast and detail. Quite small changes of camera angle or subject position can produce significant improvements. Also address depth of field and how it is best utilized. A large aperture might transform unwanted detail into abstract shapes. A lens set to the hyperfocal distance, or a suitably small aperture, will render background detail sharp and perhaps environmentally interesting.

Control of design must be learnt by experience. Mistakes have to be made and acknowledged before images are successfully created. Eventually, many elements of design become second nature and the incidence of good images increases. Use plenty of film and keep only the most pleasing images.

FRAMING AND ENVIRONMENT

A tour of photographic clubs and a few evenings spent listening to some club judges might well convince you that framing and composition were matters for well-established rules. Unfortunately, life is not that simple, and, while useful as a guide, rules and conventions should not stifle creativity. Any part of the body can be placed anywhere in an image; cropping can be done in any way you like. The only requirement is that it works. Don't be afraid to try new angles, go another way, or even fail altogether – experimentation opens doors and that counts for a great deal.

A good starting point is to try to use the whole of the picture area in a balanced manner. Move around the subject to see how composition changes, and don't be afraid to go in close when the background is intrusive or adds nothing to the image. Crop tightly around the centre of interest and feel free to exclude parts of the body. However, take care when cutting off limbs close to joints – the result may look awkward. Slide film encourages good discipline as composition work has to be done in-camera. If an image is later printed, use a mask cut from thin card to visualize how any cropping might look.

When working outdoors, the picture may include a jumble of unwanted and uncontrollable detail, particularly in the background. It therefore pays to know a little about the environment and to think before plunging in. Stand back and take a broad look at the surroundings. Identify the most interesting elements and those that may support your vision. A good guiding principle it to show enough of the environment to add something to the composition, but not so much that focus on the subject is lost.

CASE STUDY

THE RULE OF THIRDS

The rule of thirds calls for the principal elements in an image to be placed at intersections of the pairs of lines, horizontal and vertical, which divide the frame into nine equal areas. This can be inhibiting, but cannot be completely disregarded, and an examination of good images soon shows that it has some merit. Place the eyes of a subject in the centre of the frame and the result is restful but dull; put them one-third down from the top of the frame and the composition becomes less symmetrical and more interesting. Position them one-third from the top and also one-third across the frame and the image becomes strongly asymmetrical; it begins to acquire tension and may need a counter-weight of some sort to achieve visual balance.

I waited for a couple of hours for a water-seller to walk past this mosque doorway. The rule of thirds seemed to offer the best approach to composition.

Nikon F5 with 85mm f/1.8 Nikkor AFD, Kodachrome 200, 1/250sec at f/5.6

FRAMES WITHIN FRAMES

When deciding how to frame your subject, think carefully about what will lead the eye to the centre of interest. Strong lines, implied directions and selective lighting are useful for this purpose. A person in a landscape will attract greater attention than other objects of similar size, but the sweeping diagonal line of a path or fence leading to the location of the figure will further strengthen the composition. Another worthwhile technique is to use a second frame within the frame of the viewfinder – this isolates and draws attention to the subject. Windows and doors are the simplest examples of internal frames, though certainly not the only ones. Natural vignettes provided by foliage, or even lines implied by composition, are also effective. In the case of close-ups of a subject's face or eyes, frames may be suggested by hairlines, hats, beards and items of clothing – it is not essential that the face is completely surrounded. Finally, make sure that whatever effect is used is not excessively contrived.

A final thought on framing relates to the use of space – an important and often overlooked consideration. Areas that are more or less empty are an acceptable part of an image provided they serve some purpose in the overall design. Indeed, they may be desirable or necessary to achieve scale or balance.

The angular position of the dancer, and the strong diagonal lines suggested by her arms and legs, more or less dictate the framing for this shot. The distribution of empty space is an important element of composition in images of this type.

Nikon F5 with 85mm f/1.8 Nikkor AFD, Ilford Delta 100, X sync at f/8

I managed just two shots of this workman as I walked around the temples of Angkor in Cambodia. The frame-within-a frame composition allowed the beautiful stonework of the walls to be included.

Nikon F4 with 135mm f/2 DC Nikkor AFD, Kodachrome 200, 1/250sec at f/5.6

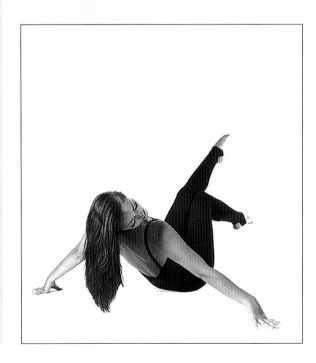

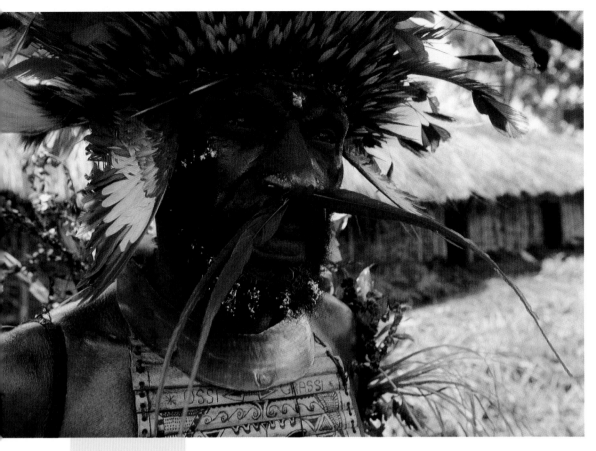

The aim here was to capture the dignity of this proud tribesman of Papua New Guinea's highlands. However, in circumstances such as these, where the cultural gulf is vast, work should be undertaken with great caution.
Nikon F4 with 20–35mm f/2.8 Nikkor AFD, Kodachrome 200, 1/125sec at f/11

bring to bear your background, culture, experience and beliefs. Artistic freedom sends electricity surging through the body every time a camera is used. Go wherever ideas lead you, and do whatever you wish. This very individual approach stamps a recognizable style upon work. As time passes, and understanding of a particular field increases, so the style will develop. Ultimately, interpretative involvement and personal joy come through in the images.

How you choose to portray a subject is a personal matter, and in work of any depth the portrayal and the photographer will be inseparable. For example, when photographing an elderly man in desperate circumstances you might choose to highlight the dignity of old age, or encourage charitable donations in support of a relevant cause. Inevitably, personal perceptions and interpretations will be reflected in both images.

PERSONAL STYLE AND INTERPRETATION

Few professional photographers have complete freedom of choice when selecting subjects. They are bound by the requirements of a particular business or assignment, and probably have a mortgage to pay. It is therefore a real luxury, and one that I am fortunate to share, to be able to photograph whomever you choose – at least among the tolerant and willing. This may be self-indulgent, but is nevertheless fertile ground for developing a personal style.

Doing what you really love is the best way to bring maximum commitment, enthusiasm and energy to your work. It also encourages you to reveal something of yourself, as you are free to

Some years ago I did a portfolio of images in Papua New Guinea. My subjects were members of volatile primitive tribes living in inaccessible highland regions of the country. Work of this type is not without risk, but I decided to concentrate on gritty close-up shots of highly decorated faces – tribal identities that will surely soon disappear. My objective was to reveal the dignity and humanity of the people through the brutal reality of their hard lives. The images were honest but unforgiving, and included characteristics such as torn clothing and neglected teeth. The processing lab saw them in a different light, perhaps closer to formal portraits, and wanted to retouch and tidy up the rougher edges. The two approaches were equally valid but quite different.

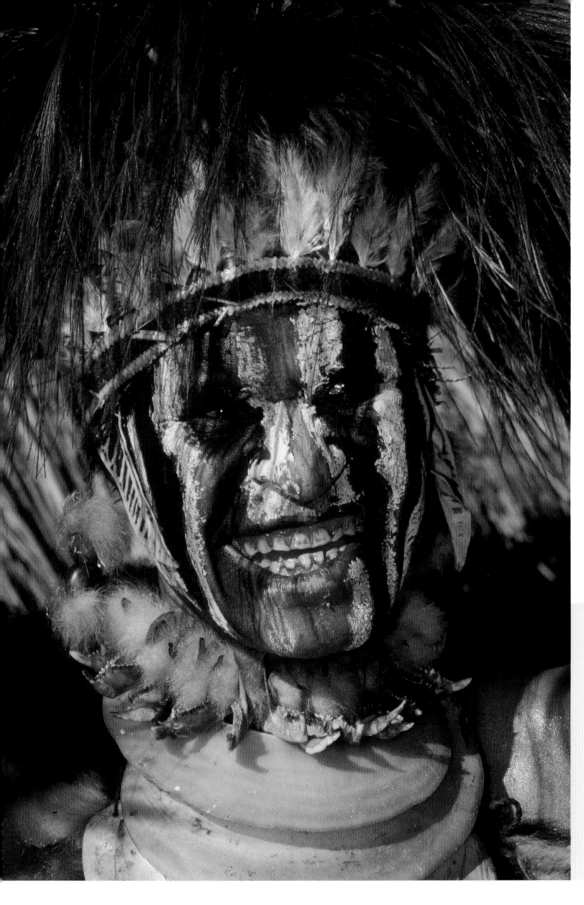

Eventually, as style and personal interests develop, others come to recognize the mark of your work. This is possibly the final piece in the jigsaw of context. Over the years I seem to have acquired a dubious reputation as a photographer with an 'in yer face, warts and all' style. It may be justified.

VISION AND SIMPLICITY

For work to progress it is necessary to have an overall vision and reasonable clarity of purpose. Successful photographers understand the impact of an image; they visualize a message as the image is composed and decide how it should be interpreted and conveyed to the viewer. Simple images suggest the most powerful messages and are more likely to be understood when viewers reinterpret the visual information in the light of their personal values and beliefs. Only by developing such vision can we hope to produce an image that might, for example, come to represent a particular crisis or war.

Exotic subjects of this nature invite close examination and 'in yer face' work – although people should, as ever, be approached with sensitivity.
Nikon F4 with 105mm f/2.8 Micro Nikkor AFD, Kodachrome 200, 1/250sec at f/8

KEEPING IT SIMPLE

In general, it is wise to avoid unnecessarily complicated compositions. A simple shape or angle, or a telling look, is sufficient basis for a successful image.

Keep the design as straightforward as possible and, when everything is optimized, pause for an appropriate expression before releasing the shutter.

Simple messages are often the most effective. It is not difficult to imagine the thoughts occupying the mind of this young mother as she awaits the arrival of her second baby.
Nikon F5 with 50mm f/1.4 Nikkor AFD, Fujichrome Sensia 200, X sync at f/8

A broader type of vision derives from clarity of purpose. Images accumulate as projects come and go, and it can eventually become difficult to see a clear direction. Those who view images inevitably detect uncertainty of photographic purpose arising in the mind of a photographer. Indeed, an image or photographic project without an identifiable visual message will probably fail. It will confuse those who view it, just as a poorly composed letter leaves readers unsure of what the writer intended. Without vision, clarity of purpose and the ability to interpret a subject, we are lost.

It is all too easy to get stuck in a rut and follow the same unadventurous path, always framing similar pictures in the same way. At such times it is worth reviewing past work and asking how things might develop. Look for unexplored areas and identify consistent successes and failures. Ask what you saw in failed images and how the subject might be approached more successfully. Objectivity is fundamental because exercises of this nature can be painful as well as stimulating and refreshing.

I have been through such reviews on numerous occasions, usually because of pressure exerted by forthcoming events. My first exhibition was selected from images acquired years earlier, and brought me face to face with unseen aspects of my work. Consequent recognition of personal strengths and weaknesses proved to be the catalyst for beneficial change.

SPECIAL QUALITIES

A good portrait brings us uncannily close to a real human being. Its impact and immediacy are such that little seems to stand between the observer and the subject. So what are the hard-to-define special qualities that elevate the finest images to such levels? Photographers talk about pizzazz, zing and the X-factor, but what does this really mean in terms of photographing people? A definitive statement would undoubtedly be useful, but in practice there are too many different subjects, styles and techniques to consider.

However, whilst accepting that any effort in this direction will be incomplete and imperfect, there is no reason to evade the matter. So, in no particular order, a few suggestions follow.

Beautiful light is virtually a prerequisite for a stunning image. Those extraordinary warm colours that pass so quickly at sunset are impossible to describe in words. Bathe a model in light of this quality and the skin becomes incandescent. Use backlighting and the body is rimmed with gold. Alternatively, go out at dawn when the air is cool and moist, and capture the spring-like freshness of a young complexion.

It is almost true, but not absolutely, that for an image to be really special it must incorporate beautiful light. Other factors intervene, of course, but where beautiful light prevails good images are never far away.
Nikon F5 with 135mm f/2 DC Nikkor AFD, Kodachrome 200, 1/250sec at f/8

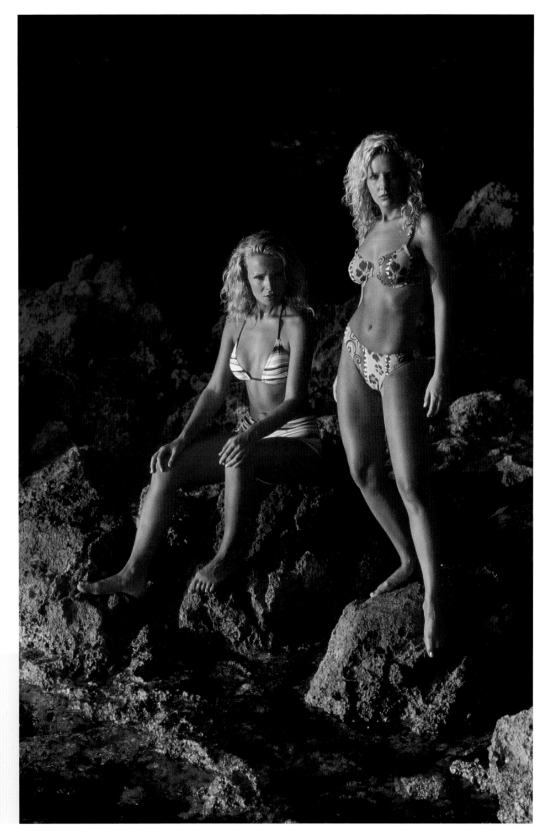

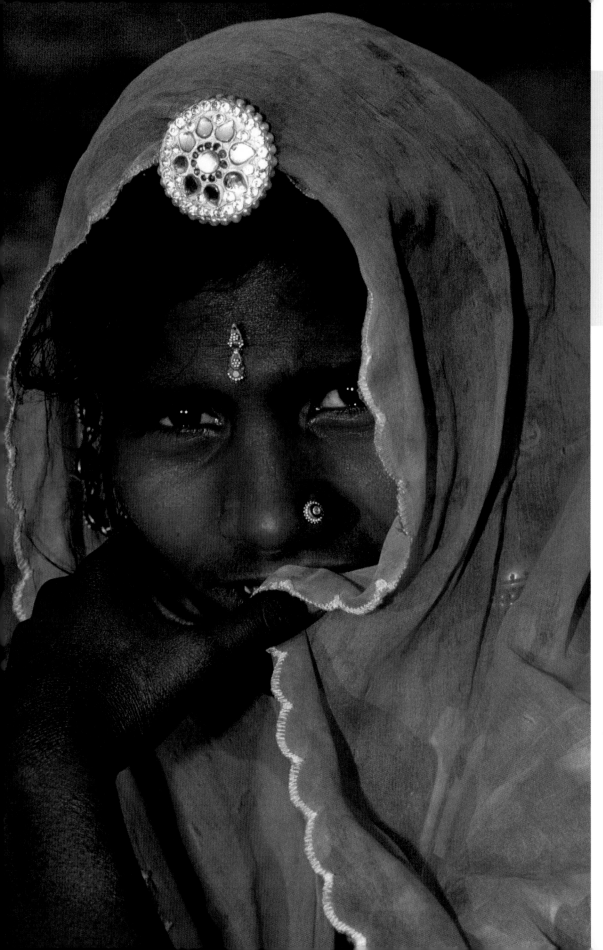

The low angle of the warm light in this monochromatic image has revealed beautiful skin texture.
Nikon F4 with 135mm f/2 DC Nikkor AFD, Kodachrome 200, 1/125sec at f/5.6

Form and texture are revealed by directional light, perhaps striking a surface at a low angle. This produces sharp contrast between light and shade. Sure winners are intimate skin texture, wrinkles, callused hands, rippling muscles and exquisite beauty shown in fine detail.

The illusion of image depth is also a product of contrast and directional light, but may be enhanced by careful use of perspective, line, shape and colour. Telephoto lenses and differential focus can be used to emphasize the separation of foreground and background.

Atmosphere and mood add emotion and meaning to an image. Lighting that conceals detail creates mystery, and backlit smoke and dust add intimacy. Soft focus, muted colours and reduced contrast give a feeling of tranquillity, and strong light and vibrant colours are cheerful.

Eyes certainly deserve a mention. Wide, round eyes, or those with a particularly interesting shape or direction, add magnetism to a portrait. Introduce emotions such as love, fear, joy or despair and you have an X-factor. If the eyes are

sparkling, moist, intense or focused like lasers that is also a plus. Vitality results from lively or mischievous eyes, from intensity, from action or movement, and from the presence of bright, saturated colours. A feeling of expectation and immediacy can be produced when a subject seems about to move, and this is emphasized by dynamic composition.

Asymmetrical equilibrium is achieved when an appropriately placed but subordinate secondary element balances the weight or impact of an off-centre subject. The result is a sort of tension felt throughout the image.

Unusual positioning in the frame, particularly of the subject's eyes, may produce an unexpected quality as attention is drawn away to a corner or edge. When combined with strong lines and shapes, and implied lines such as the diagonal gaze of eyes directed to the corner of the frame, a powerful and dynamic composition is possible. Other lines, such as those suggested by the body, or a particular limb, can be used to create simple geometric shapes.

Finally, communication encourages the viewer to feel in contact with the real subject. It is enhanced by direct eye contact, expression, a feeling of involvement, the portrayal of mood or atmosphere, and the interpretation of a message or deeper meaning.

Off-centre subjects often benefit from the tension or balance provided by a smaller or more distant secondary subject. Here it was just a matter of waiting for the right moment as the child in the background approached the camera. **Nikon F4 with 20–35mm f/2.8 Nikkor AFD, Kodachrome 200, 1/250sec at f/8**

ON LOCATION

ON LOCATION

STUDIOS

ON LOCATION

ON LOCATION

GENERAL CONSIDERATIONS

The controlled and private studio environment opens up a new dimension in photographing people, providing the only environment in which total control over lighting, background and props is possible. This is a major advantage in the sense that everything can be set up to achieve precisely the effect required. Test shots can even be made prior to the arrival of the subject.

It is important to involve models in the image design process. Talk before the session, explain ideas carefully and be sure to listen to suggestions.
Nikon F5 with 105mm f/2.8 Micro Nikkor AFD, Fujichrome Sensia 100, X sync f/8

The model's symmetrical pose and the division of the picture area by the trestle encourage the eye to explore the image. The rough woodwork also contrasts with the girl's smooth skin and provides a frame for her face.
Nikon F5 with f/2.8 105mm Micro Nikkor AFD lens, Fujichrome RTP Tungsten 64T, 1/40sec at f/5.6

This might sound ideal, but in practice a lot of expertise is required to get the best results. In some circumstances, for instance when working with a professional model, control extends to make-up, clothing and personal accessories. Almost any type of image is then possible, but work undertaken in this relatively sterile environment is usually identifiable as such.

EQUIPMENT AND TECHNIQUE

The expenses incurred when establishing a studio are also considerable. Suitable cameras, lenses and accessories must be purchased, and specialized lighting, props and background equipment set up. When the cost of these items is added to that of maintaining suitable accommodation, a studio becomes a significant investment. Creative control of lighting is an art form in its own right. Subject and background are usually lit using several carefully balanced independent heads. Other equipment is used for highlighting hair and adding special effects.

LIGHTING

There are essentially two types of lighting: tungsten photoflood and studio flash. Photofloods are the least expensive approach as they are basically just powerful versions of domestic lamps. They have the advantage that the combined effect of a number of lights is easily observed. Unfortunately, they also produce lots of heat and glare, and can make the working environment uncomfortable. Studio flash units are large and very powerful mains-powered flash heads, usually suspended from rails or mounted on stands. Better units have integral modelling lamps that facilitate set-up by simulating the effects of the flash. They are manually adjusted and can be equipped with a range of devices to control the direction, colour, focus and softness of the light.

Umbrella reflectors are available in white, silver and gold and are used to direct diffused light onto a subject. Softboxes of various sizes, which fit over flash heads, produce even softer light. They are fabric boxes with highly reflective silver linings designed to direct light through a screen of diffusing material. Large softboxes used close to a subject produce the softest light. Snoots, or cones, direct a soft-edged circular beam of light onto a subject, typically to highlight hair or produce a halo effect in a portrait.

PRO TIP

The artificial nature of studio work can prove intimidating for both photographers and subjects. The photographer has more opportunity to become familiar with the environment, but may not feel relaxed when dealing with subjects. Although this is very much a personal matter, it is an important part of photographic technique. As much as possible should also be done to encourage a subject to relax. People generally appreciate firm but considerate direction and an understanding of what is expected of them. Aim to minimize time spent adjusting equipment, and project confidence wherever possible.

This shot was acquired as part of a dynamic sequence where the model was encouraged to change position every time the shutter was released. The white background was several metres behind the model and required overexposure by one stop.
Nikon F5 with 85mm Nikkor AFD, Fujichrome Provia 100, X synch at f/5.6

This model was illuminated using a single 2kW tungsten light, allowing adjustments to be observed until the desired effect was achieved. However, a source of this power generates a lot of heat and the model may soon become uncomfortable. **Nikon F5 with f/2.8 105mm Micro Nikkor AFD lens, Fujichrome RTP Tungsten 64T, 1/60sec at f/4**

Music can help to ease tension and all the normal considerations of safety and comfort should be incorporated into studio management. Models, professional or otherwise, will be more familiar with working procedures, but still need privacy, changing and toilet facilities, and somewhere to relax.

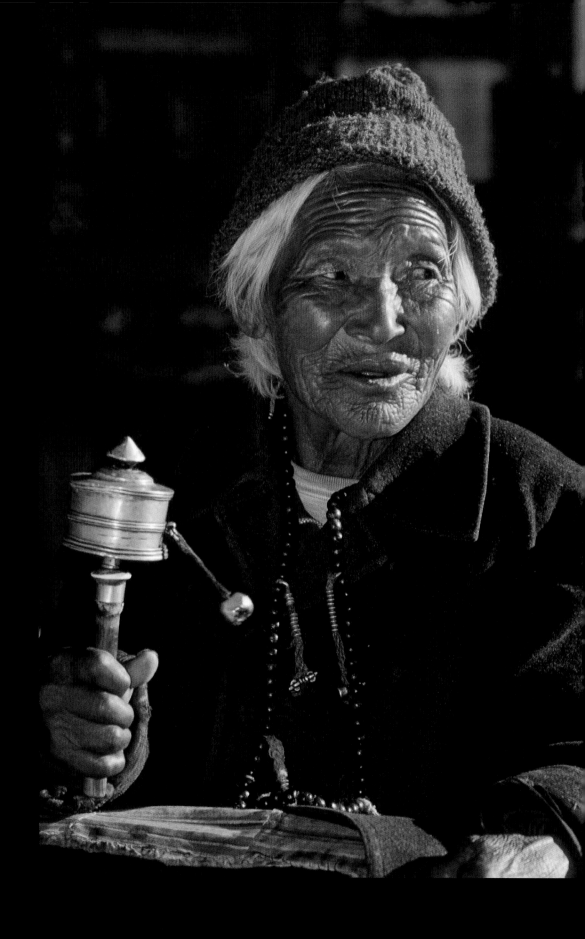

APPROACHES

There are numerous basic approaches to photographing people, and all have their merits. However, the chosen style should suit not only the subject but also the purpose for which the image is created. Much therefore depends upon the artistic inclinations of the photographer.

CANDID PHOTOGRAPHY

The literal meaning of the word candid is 'honest or unrehearsed', so candid photographs need not necessarily be captured without the knowledge of the subject. They can be obtained in more or less any situation where a photographer is prepared to use a camera. Indeed, personal sensitivity and respect for others may be the only limitations. Many people adopt a surreptitious approach because it requires no involvement, but similar pictures can be obtained with the agreement of the subjects. For example, photography might be undertaken at a sports club, where your presence is agreed but soon forgotten.

INFORMAL IMAGES

Informal images are spontaneous and also convey a degree of honesty; the subjects realize that a photographer is at work, but continue with their normal activities. Family holiday photographs are a good example of this casual approach.

FORMAL IMAGES

Formal images are created by agreement and staged to give a particular impression. An appropriate location is found or set up, and the subject is posed in a suitable manner. Bear in mind that most people will feel self-conscious because they will not be accustomed to this approach. Expect the images to look as formal as the situation in which they were created.

BIG HEADS

Big heads are so called because only the head and shoulders of the subject are shown in the image. The eyes usually provide the centre of interest, and expression and mood are key considerations. Short telephoto lenses are ideal. The longer ones in this range compress perspective and give more space between camera and subject.

This shot was taken in Bhutan's Bumthang Valley. It is candid in the sense that it is totally honest, but the woman became aware of the camera shortly after the shutter was released.
Nikon F4 with 135mm f/2 DC Nikkor AFD, Kodachrome 200, 1/200 at f/8

The formal approach to portraiture requires planning and preparation. I discussed ideas with this model several days prior to the studio session so that suitable preparations could be made.
Nikon F5 with 105mm f/2.8 Micro Nikkor AFD, Fujichrome Provia 100, X sync at f/8

CASE STUDY

PROFILES

Profiles, which rely on shape and strong features, are less personal – communication is lost and eye contact is impossible. Light tones suggest a happy, outgoing personality, whereas darker images imply a more serious, introspective character. When framing this type of shot, leave space in front of the face to give the image balance, and move around to see how features change shape. Focus on the nearer eye, or possibly the bridge of the nose, and make sure depth of field is sufficient to keep key features sharp. Camera orientation can be vertical or horizontal – both work well with an off-centre subject.

Full profiles eliminate communication with the viewer and are therefore less personal in nature. This Burmese woman was not aware that she had been photographed.
Nikon F4 with 135mm f/2 DC Nikkor AFD, Kodachrome 200, 1/250sec at f/4

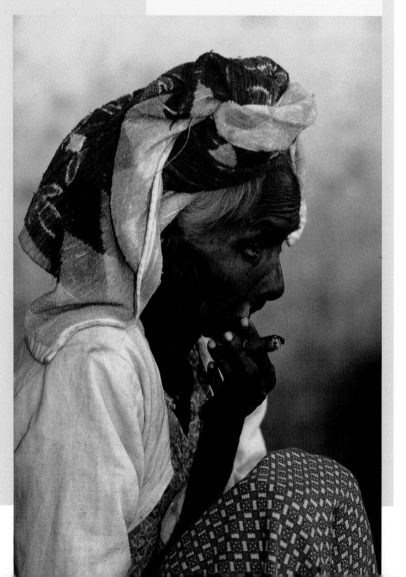

Some photographers dismiss head-and-shoulders shots as easy on the basis that there is no requirement to control the environment. This is valid to a point, but really good examples are difficult to capture. The main challenges are finding suitable light and novel compositions. Move around the subject to find the most flattering and interesting angles. It is not essential for the person's head to fill the frame, so explore ways of placing the subject off-centre and using space asymmetrically. Compositions of this type tend to be more interesting than standard centred shots.

Full-face

Shots of this type show a frontal view of the face, or close to it, and are perhaps the most searching disclosure of personality. They are intimate images created at close range with the subject's knowledge, and as such they invite engagement and communication. Where possible, position the subject in diffused light and use a reflector or a touch of fill-in flash to control contrast and put highlights in the eyes. Red-eye is not normally a problem provided the flash head is positioned at least 4in (10cm) from the lens.

Half profiles

Half profiles, where the subject turns slightly to one side, have greater depth than standard full-face shots, but depth of field may be limited when working in poor light. The best approach is to focus on the eyes and control depth of field carefully. Remember that too much out-of-focus shoulder in the foreground may prove to be an unwanted distraction.

Full-face head-and-shoulders portraits are relatively easy
to compose, but good examples require beautiful light,
a great deal of care and something a little special.
**Nikon F4 with 135mm f/2 DC Nikkor AFD,
Kodachrome 200, 1/200sec at f/5.6**

Half profiles, positions between full face and full profile,
invite a wide range of compositions. A degree of
communication and greater depth can be incorporated.
**Nikon F4 with 135mm f/2 DC Nikkor AFD,
Kodachrome 64, 1/125sec at f/4**

READ ON

Reproduction ratio

p.59

Using perspective

p.157

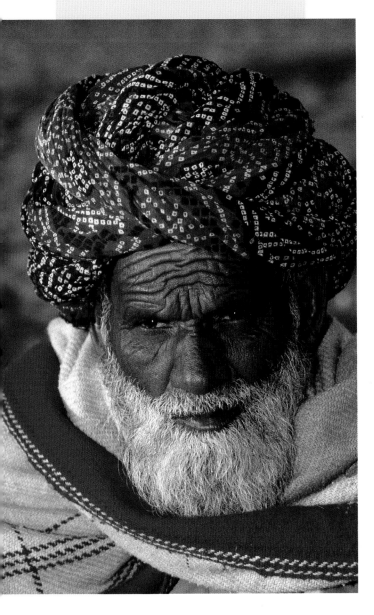

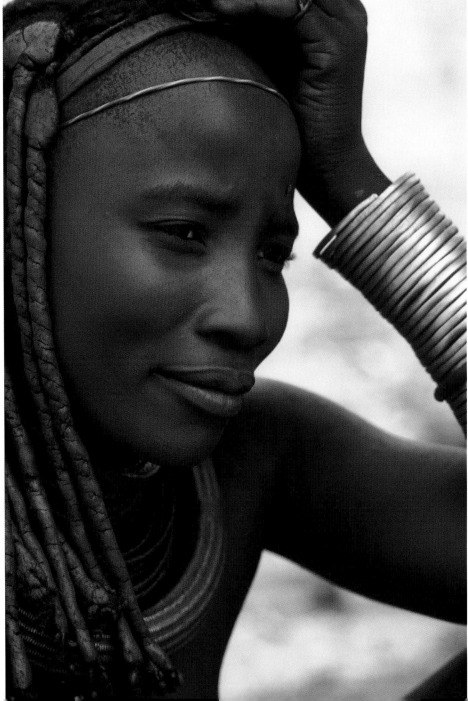

FULL-LENGTH AND PART-LENGTH SHOTS

Images become less intimate as the camera is moved back from a subject, but the biggest challenge with half-length and full-length shots is dealing with limbs. Hands can be very expressive but may need to be kept occupied to avoid them becoming untidy. Arms and legs may also look awkward if they extend out of the frame.
In general cut them off between joints rather than at elbows or knees. In full-length shots legs must be arranged in a comfortable manner. Try asymmetrical and bold positions, as the straight up and down look is usually dull. Tightly cropped full-length figures tend to look uncomfortable in the frame.

For a natural feel, the camera is ideally positioned a little more than half way up the part of the body in the frame. If it is much higher or lower the subject appears demure or dominant. When using flash, keep the flash head well away from the lens. The red-eye phenomenon becomes more apparent at a distance of several metres, so use red-eye reduction if possible.

Full-length shots require care with the positioning of limbs. It is all too easy for arms and legs to appear tense or awkward. Professional models are often very good at arranging their limbs.
Nikon F5 with 85mm f/1.8 Nikkor AFD, Fujichrome Astia 100, 1/60sec at f/5.6

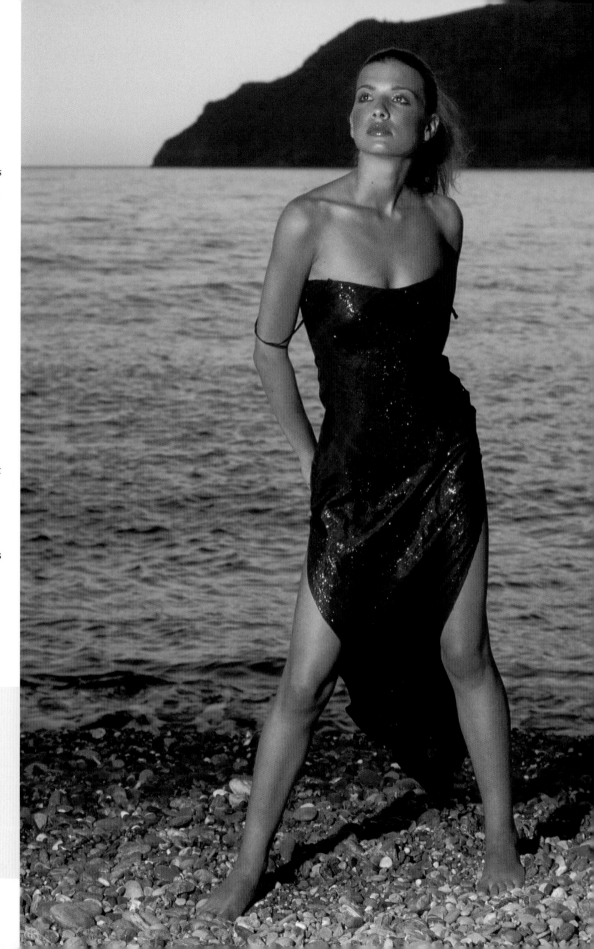

Short telephoto lenses are normal for part-length shots, although others can be used. Depth of field increases with focused distance and is usually sufficient with large apertures. Backgrounds should be chosen carefully because significant areas may be visible and unwanted detail may creep in. Include some of the environment if it is interesting; if not, drop it out of focus.

WIDEANGLE AND ENVIRONMENTAL WORK

Wideangle lenses are useful when portraying people in the context of their environment. The camera must be close to the subject to give a worthwhile reproduction ratio – perhaps within

3ft (1m). Perspective is accentuated under these circumstances, and care must be taken to ensure that facial features do not become grotesque. Depth relationships of different planes in a scene are clearly shown, and relationships between objects appear to change. Also, vertical lines converge if the camera is moved away from the horizontal. The extent to which such effects are acceptable is largely a matter of taste.

The broad field of view of a wideangle lens reveals great swathes of the surroundings, so depth of field, composition and exposure must be carefully considered. When using a 17mm lens focused at 3ft (1m) and set to an aperture of f/16, depth of field extends from about 20in

(50cm) to infinity. Background detail is rendered sharp and must be interesting and appropriate if it is to provide context. Off-centre subject placement leaves lots of empty space, so a small or distant secondary subject may be needed to restore visual balance.

READ ON

The red-eye

phenomenon

p.21

Eyes and engagement

p.87

Approaching full-length shots from somewhere just above waist height gives a natural feel to the image.

Nikon F4 with 50mm f/1.4 Nikkor AFD, Kodachrome 200, 1/250sec at f/8

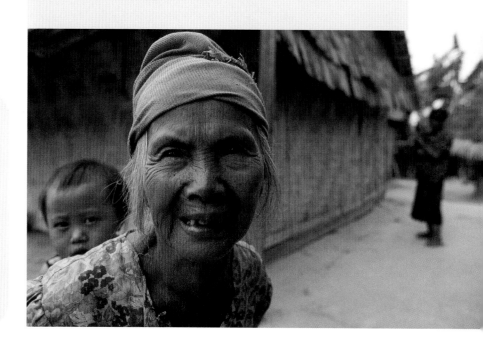

This woman of the Hmong tribe walked passed me in a small village street in Laos. The wideangle lens that happened to be on the camera was ideal because it showed something of the environment and made focusing quick and easy.

Nikon F4 with 20–35mm f/2.8 Nikkor AFD, Kodachrome 200, 1/250sec at f/5.6

CASE STUDY

METERING FOR WIDEANGLE SHOTS

Determining exposure for a wide field of view is not entirely straightforward. Contrast between the subject and other parts of the image, such as the sky or a dark corner, may well exceed the latitude of any film or sensor. If so, it must be reduced by changing composition, using fill or diffusing the light. Centre-weighted measurements are obviously a poor compromise where the subject is off-centre. Averaged or multisegment measurements combined with some fill may prove adequate. Alternatively, take spot measurements from key areas of highlight and shadow, use fill and bracket the exposures.

This little girl was absorbed in feeding pigeons and completely oblivious to everything else.

Nikon F5 with 300mm f/4 Nikkor AFD, Fujichrome Sensia 200, 1/250sec at f/8

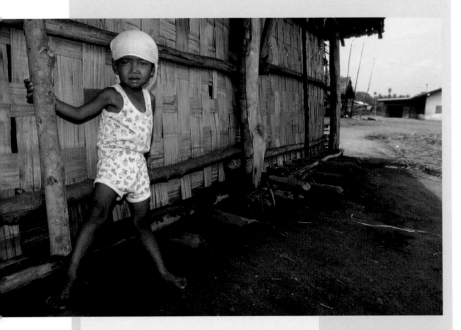

Contrast between the shaded subject and the area of bright sky made a compromise exposure necessary here. Although fill-in flash has been used the bright area of sky still creates a distraction for the eye.

Nikon F4 with 20–35mm f/2.8 Nikkor AFD, Kodachrome 200, 1/125sec at f/8

WORKING WITH CHILDREN

Be prepared to spend time relating to children before trying to photograph them. Attention spans are short, and moods and expressions change rapidly. The best opportunities may arise when your subjects forget about you altogether and begin playing in an uninhibited manner. When working outdoors try using a medium zoom lens, perhaps 70–210mm (on 35mm), that lets you keep your distance but still fill the frame with interest. Indoors, where space is restricted, something shorter is more appropriate.

There are a few points to be aware of when choosing your approach. Small children appear diminutive from a high viewpoint, so this is very much an adult's perspective. Better opportunities may be obtained by getting down to the level of the children. The floor is a good place to start, although the occasional sticky finger in the middle of a lens may have to be accepted.

Children are best approached at their own level.
Don't be afraid to get down on the ground with them.
Nikon F5 with 85mm f/1.8 Nikkor AFD, Fujichrome
Sensia 100, 1/125sec at f/8

CASE STUDY

IMAGES OF CHILDREN

Laws are different in every country, and we must not assume the Western obsession with the hazards of images of children is universally shared or understood – it is not. However, in Western Europe and the USA, extreme but understandable sensitivity exists. Photographers therefore typically adopt guidelines such as:

- getting parental permission for planned shoots and work undertaken in private locations (e.g. studios);
- having a parent or responsible adult present where the subject is under 16 (and perhaps under 18);
- getting written permission to publish images of children; and
- being careful to avoid situations that could be interpreted as indecent (e.g. where a child is changing on a beach).

In public places the situation is, and must be, somewhat more relaxed. The use of a camera, in an openly responsible and proper manner, is generally acceptable. In most cases, decent public-place images may be published without permission (although France is emerging as a country where tighter privacy laws may apply). Indeed, newspapers all over the world publish images of young people without necessarily obtaining permission.

Teenagers are likely to be self-conscious and awkward in front of a camera, but keen to project a particular image. If this becomes a problem, try working with groups of friends. The individuals draw confidence from each other and eventually become more relaxed, so may be easier to handle than when they are alone. Be prepared to adopt their collective mood and take an interest in whatever they are doing.

PHOTOGRAPHING BABIES

Baby pictures are priceless to the parents. The early years pass quickly so a few really good shots soon become treasured possessions. Nevertheless, photographing babies is challenging because direct cooperation is of course impossible – if the child decides to wave a leg in the air, that is what will happen. This is all part of the fun and of what makes babies so appealing. The secret is to get close and take as many pictures as time will allow.

This girl enjoyed practising her trampoline skills, and was quite willing to perform for the camera.
Nikon F5 with 85mm f/1.8 Nikkor AFD, Fujichrome Provia 100, 1/500sec at f/5.6

A suitable backdrop to conceal distracting objects is a major priority. If you intend to work in colour, think about colour casts. Light reflected from a backdrop or coloured clothing may turn the infant a sickly shade. Such casts can be avoided by using white clothing and neutral backgrounds.

Once the environment is acceptable, get in as close as the lens will allow and start shooting. Enlist Mum and Dad or whoever is closest to the child – a favourite toy can be used to catch the infant's attention and get a smile. Look for eye contact and be ready to grab it. Remember that you are the one who is intimidated, not the baby. The child doesn't care how close you get or how many shots you waste, and Mum will know how to handle expressions, moods and tantrums. Don't worry about a few fretful tears – crying can be just as photogenic as laughing. Try including Mum's face and shoulder, Dad's huge hand holding a tiny foot, or something similar. Also, look for distinctive behaviour from the subject, such as a foot going into the mouth. Ultimately you should just go for it because babies tire quickly and get grumpy when hungry. As a result, this sort of session can run off the rails at any moment.

Get in close to babies, but be prepared to feel intimidated!
Nikon F5 with 105mm f/2.8 Micro Nikkor AFD, Fujichrome Astia 100, X sync at f/8

In this instance, opportunities were restricted because the baby was just three months old and raised his head for short periods only. The strength of this image lies in the baby's questioning expression and in the implied diagonal line of Mum's gaze.

Nikon F5 with 105mm f/2.8 Micro Nikkor AFD, Fujichrome Astia, X sync at f/8

CASE STUDY

LIGHTING OPTIONS

Flash equipped with a softbox or bounced off a white ceiling may seem the obvious approach when photographing infants, providing enough light to work with a small aperture and good depth of field. However, it can also upset a baby. It may be better to place your subject close to a window where there is good indirect illumination. Here, the daylight will be diffused, the shadows soft and the atmosphere moody. A window that receives no direct sunlight is ideal, although a similar effect can be achieved by covering any window with a net curtain. The aim is to find conditions that permit a shutter speed faster than 1/30sec and an aperture small enough to achieve sufficient depth of field.

Film speed obviously has a bearing upon this, and digital cameras provide extra flexibility by allowing the ISO rating to be adjusted on a shot-by-shot basis.

Speed is essential when working with babies because they soon become tired of your ideas. In this case the child was on a table in a studio, where lighting could be set up in advance. Two 'catchers' were ready to restrict crawling ambitions.

Nikon F5 with 105mm f/2.8 Micro Nikkor AFD, Fujichrome Sensia 200, X sync at f/16

CLOSE-UPS

Successful images can be created while excluding part of the subject's face, or even the head and shoulders. There is no absolute requirement for the subject to be recognizable – evocative images can also be obtained by concentrating on small parts of the body.

To do this sort of work it is necessary to be very close to the subject. Since portraiture lenses commonly have a minimum focused distance of about 20–32in (50–80cm) and a maximum reproduction ratio of perhaps 1:8, some type of close-up lens or accessory must be used. Supplementary close-up lenses, bellows and extension rings all allow closer approach to the subject and larger reproduction ratios, but a macro lens gives the highest image quality. Lenses of this type are designed specifically for close-up work. They focus down to about 8 or 12in (20 or 30cm) and can normally achieve reproduction ratios of 1:2 or 1:1. This means that the subject can be reproduced at near life-size on film.

Close-ups of parts of the body can be captured using nothing more than light from a window. In this case the walls of the room were covered with dark drapes to minimize reflected light.
Nikon F5 with 85mm f/1.8 Nikkor AFD, Kodak T-Max 400, 1/60sec at f/2.8

EQUIPMENT

CLOSE-UP EQUIPMENT

Macro lenses

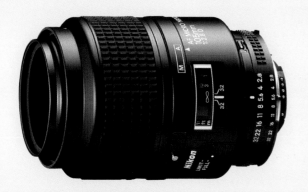

Macro lenses are the most practical option for close-up people photography. They allow close focusing and large image magnification (reproduction ratio), and many retain the versatility to perform as general purpose lenses. True macro lenses produce a 1:1 reproduction ratio or greater, but a maximum reproduction ratio of 1:2 and a small minimum aperture such as f/32 are typical.

Supplementary close-up lenses

These easy-to-use and relatively cheap attachments screw into the front thread of a lens and give a simple and convenient increase in reproduction ratio. TTL autoexposure control remains effective. Some image quality will be sacrificed.

Extension rings

These rings fit between camera body and lens to increase the distance between lens and film plane. They are light, robust and relatively inexpensive. A set of three different widths used in various combinations provides a wide range of reproduction ratios. Auto extension rings retain automatic diaphragm control and meter coupling.

Bellows

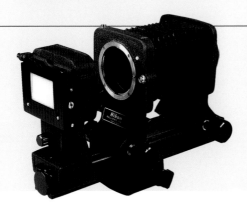

These fit between camera body and lens, and provide continuous adjustment of reproduction ratio over a larger range than extension rings. Automatic diaphragm control and meter coupling may be retained. Bellows have very limited application when photographing people but might, for example, be used to photograph an eye.

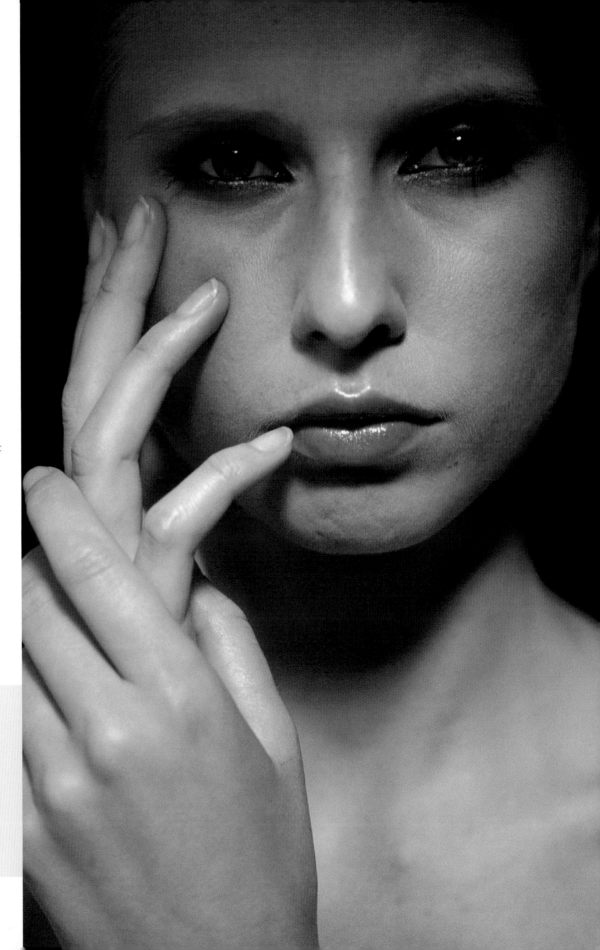

I use a Micro Nikkor 105mm f/2.8 lens that can also be used as a normal short telephoto, but, as with any close-up configuration, precise control of depth of field is important. Use a tripod to keep the camera stable, and select a slow shutter speed. This will allow the aperture to be closed down as far as possible, perhaps to f/22 or even f/32, and maximizes depth of field. Ask models to hold their breath momentarily when using shutter speeds slower than about 1/15sec, and remember that reciprocity characteristics may become a consideration when exposing film for more than one second.

Using a camera so close to somebody is a personal business. You are well within personal space, the invisible area of privacy that surrounds every human being, and an inexperienced subject may feel uncomfortable. Spend some time explaining what is intended. This helps the model to relax and understand what results to expect. The images can be quite powerful because perspective is accentuated under such circumstances. The impact is even greater when they are enlarged and printed, since parts of the body may then be magnified to many times life-size.

Extreme close-ups have special appeal but require careful attention to detail. Depth of field can be limited and focusing must be very precise.
Nikon F5 with 105mm f/2.8 Micro Nikkor AFD, Fujichrome Astia 100, 1/60 sec at f/4

GROUPS

Photographing a number of people together is as much about direction and stage management as it is about cameras and lenses. The principal challenge is getting everyone ready at the same time and coordinating all the positions, looks and expressions. People inevitably have their own views about the arrangement of the group, and someone will be distracted, make a joke or blink at the critical moment. Be sure to acquire additional safety shots. Call for attention with some authority only when everything is ready, but don't expect concentration to persist for more than a couple of minutes. If direction is not sufficiently robust the group may feel collectively in charge, and control will be lost.

In general, try to steer a course between issuing military orders and being too jovial. Wedding photography is probably the ideal training ground in this instance.

A good starting point is to find a location that provides an attractive background and a focal point, such as a gate or fallen tree, around which the group can assemble. Then consider the group structure, bearing in mind the interactions and relationships of the individuals. Careful planning is required when three or more people are involved – a row of figures lined up across the frame is simply not interesting. Try varying the depth and height of the composition by arranging people according to size and seating

Formal groups need firm direction from the photographer. A good location and beautiful light add a great deal to the image. Thanks to Belstead Brook Hotel, Ipswich, UK, for access to their garden.

Nikon F5 with 85mm f/1.8 Nikkor AFD, Fujichrome Sensia 100, 1/60sec at f/8

children at the front. Build pyramids of people, for example where children flank a dominant adult figure, then merge several of these building blocks into a larger pyramid.

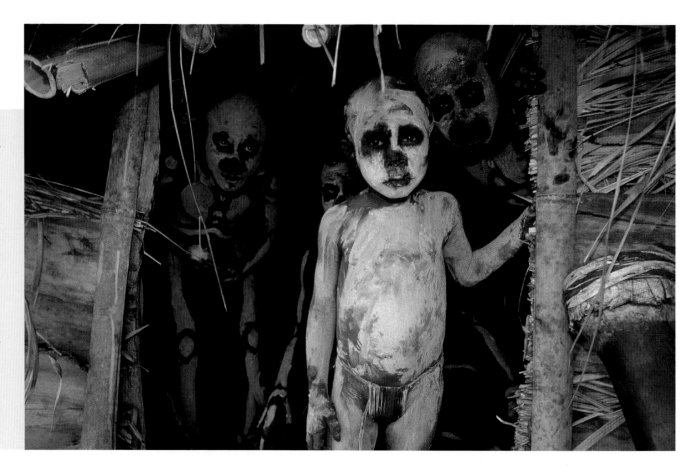

Where no control is possible it is just a matter of recognizing the best opportunities. The skeleton-like tribal image of these people in Papua New Guinea is created by chalk-and-charcoal body painting.
Nikon F4 with 105mm f/2.8 Micro Nikkor AFD, Kodachrome 200, 1/125sec at f/8

Lighting is less critical for a group than for individual portraits because each face is less significant in the image. Nevertheless, it is still a key consideration for the overall image. Use diffused light to reduce contrast, and beware of shadows cast by one group member onto another. Lens selection will depend upon the group's size and location, but a standard or short telephoto makes a good start. Remember that depth of field extends approximately one-third before and two-thirds beyond the focused distance, so focus one-third into the depth of the group.

If you have no control over the group, an opportunistic approach is the only option. Ideally, position yourself somewhere between the group and the main event – the band, the food or whatever it may be. You will then get at least some attention. If the direction of the light makes this impractical, seek out a compromise position to one side.

Approach

Lens	Candid	Environmental	Big heads	Part length	Full length	Interiors	Outdoors	Groups	Close-ups
Wideangle		●				●	●	●	
Standard			●	●	●	●		●	
Short telephoto			●	●	●	●		●	
Medium telephoto	●		●	●	●		●		
Long telephoto	●						●		
Macro			●						●

While it is possible to create a particular image with various lenses, some will be more suitable than others. This chart illustrates some of the most useful lenses for handling the different approaches covered in this chapter.

Large demonstrations, such as this anti-war march in London, often include unified groups advocating a particular point of view. In this case the clear area in front of the banner provided a convenient space in which to operate.

Nikon F4 with 20–35mm f/2.8 Nikkor AFD, Fujichrome Sensia 100, 1/250sec at f/11

LARGE GATHERINGS

Very large groups of people and crowds are rarely under the control of a photographer. Lighting is almost irrelevant because nothing much can be changed. It is just a matter of finding your spot and doing what you can. An elevated position helps to show depth and more of the people in the crowd, but may not be achievable. However, the largest events usually have a stage or focal point that provides opportunities. At pop concerts, for example, the most animated and enthusiastic fans are at the front, so get among them if you can. Watch your camera, because quite a bit of water flies around.

If a group is moving, as in the case of a public demonstration or parade, try walking backwards with the flow of the crowd. Use a lookout to watch for hazards, and remain sensitive to the purpose of the event. Alternatively, ride on a vehicle, or find a convenient corner or doorway and let the world flow past.

When photographing a section of a large crowd, it is difficult to achieve a clean cut-off at the edge of the frame. Disembodied arms and legs creep in everywhere, and may look untidy. An integrated group can sometimes be isolated, but don't rely on it. This raises the issue of whether people should be cut in half at the frame's edge. The purists say this is undesirable, but it can result in some visual tension – perhaps a feeling of action or pent-up emotion. If so, it may make the image.

THEMES

THEMES

ROMANCE & NOSTALGIA

THEMES

THEMES

A romantic atmosphere can be conveyed in numerous ways, but the most effective portrayals have strong elements of softness, tranquillity and mystery. Soft focus or diffused lighting, pastel colours, reduced contrast, smooth curves and an air of innocence all create an impression of gentleness. In particular, the lines formed by a subject's body should be elegant and flowing, so avoid sharp angular positions and shapes that suggest any form of tension. Sunshine and a predominance of lighter shades work well because they imply happiness and relaxation. Diffused window light can be successful, but strong directional lighting should be avoided.

Working in a tranquil setting can further emphasize a romantic atmosphere. For example, a young girl in a long flowing dress might be shown walking in a field of wild flowers where one could imagine finding peace on a warm spring day. Calm water and reflections produce similar feelings of relaxation. Mystery can be created by merging colours into a monochromatic mist, and by partially concealing detail that the viewer would like to see.

All the trappings of modern life have been carefully eliminated from this image. The print was toned to add to the feeling of a bygone era.
Nikon F5 with 135mm f/2 DC Nikkor AFD, Fujichrome Provia 100, 1/250sec at f/5.6

This shot was captured through a soft-focus filter and was overexposed by two-thirds of a stop. The gentle lines, muted colours and reduced contrast enhance the impression of softness and romance.
Nikon F5 with 105mm f/2.8 Micro Nikkor AFD, Fujichrome Sensia 100, 1/250sec at f/11

Many of us have warm, idealized memories of the past. To some extent this nostalgic vision can be recreated by careful choice of subject, surroundings and colour. A subject dressed in old-fashioned clothes and photographed near a thatched house or a dilapidated farmyard cart encourages the viewer to recall a bygone era. Of course the surroundings must be appropriately devoid of power lines, cars and modern gadgetry. Black & white images of this type hint at an era prior to the introduction of colour. They can also be toned, perhaps using sepia, to emphasize the feeling of age.

THEMES

THEMES

PEOPLE AT WORK & PLAY

THEMES

THEMES

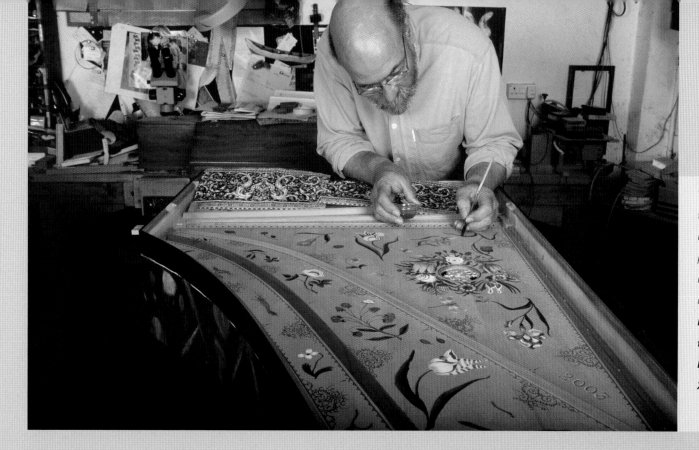

The cluttered interior of this workshop, captured using a wideangle lens, provides a glimpse of the reality of the instrument-maker's art.
Nikon F5 with 20–35mm f/2.8 Nikkor AFD, Fujichrome Provia 100, X sync at f/11

People are often more confident when photographed in familiar surroundings, or when involved in a favourite pastime. They feel in charge because they know more about their activity and environment than an onlooker. The immediate activities of the subjects and the circumstances in which they take place are key ingredients. The pursuit itself is only part of the story and may mean little if seen in isolation.

Well-composed images inform the viewer about what the subjects are doing, and include details such as dress requirements and equipment. However, don't lose sight of what participation involves at a human level, the type of people involved, and so on. Consider using a wideangle lens and look for views that show the broad picture.

By using a tripod and a slow shutter speed, the sparks produced by the welding torch have been recorded as curved traces of light. A small flashgun was placed on the ground in front of the welder to reduce contrast.
Nikon F5 with 105mm f/2.8 Micro Nikkor AFD, Fujichrome Astia 100, 1/15sec at f/8, tripod

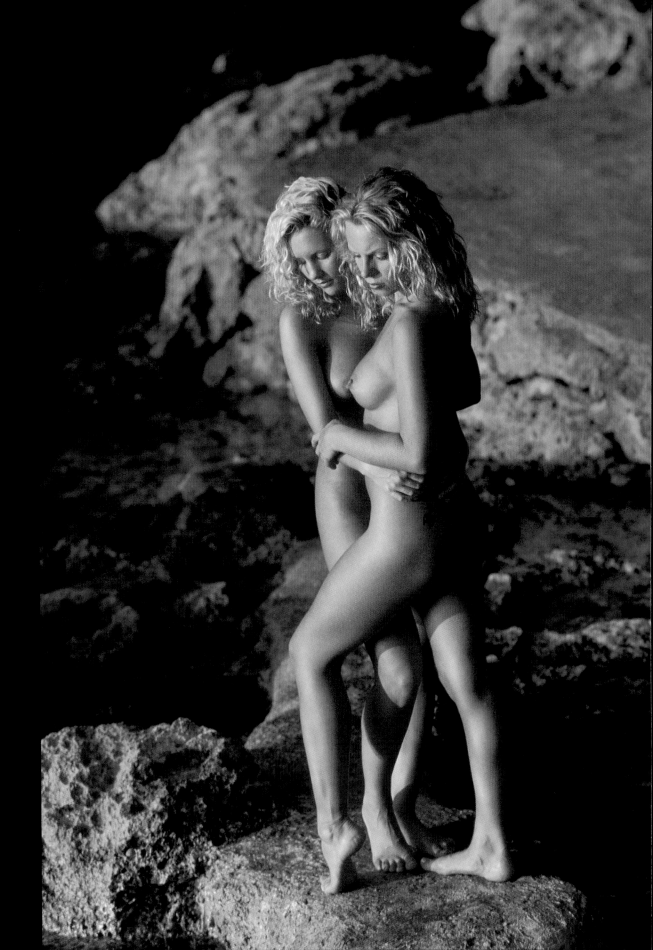

THE NUDE

Giving expression to the human form,

whether in natural or artificial light, is

perhaps the greatest challenge in the

photography of people. Technique, lighting,

environment and sensitivity are all critical in

any worthwhile interpretation.

Since the Renaissance the nude has become well established as a form of artistic expression, but also inextricably linked with morality and the upholding of standards. Modern times have seen art students drawing from life models as an objective exercise in the study of shape, form and tonal gradation. Today, nudity surrounds us – on newsstands, in cinemas, and on television and the stage.

A photograph arguably brings us closer to reality than any other depiction of the human form, and so into more intimate contact with the body of the model. Notions of artistic licence can no longer offset lingering self-consciousness. A conventional photograph is a statement of fact, a frozen instant of time, and there is no escape from its revelation. Some models find this difficult to handle and are justifiably afraid that their nude images may fall into unscrupulous hands and be misused.

HISTORY AND ETHICS

A visit to any major art gallery quickly reveals that the portrayal of the nude figure goes back a long way. Indeed simplified drawings of unclothed people have been found in prehistoric art dating back millennia. However, attitudes have changed substantially over the centuries. The early Christian world regarded depictions of the naked form as sinful and used drapery to conceal its natural shape. Ancient Greek artists were more enlightened and preferred to emphasize the lines of the body. They developed an idealized concept of beauty based upon physical measurement and classic proportions, and reconciled the sensuousness of the athletic male nude with rational order.

The two sun-tanned models seem to be illuminated from within as they stand in the oblique light at the entrance of a large cave.
Nikon F5 with 85mm f/1.8 Nikkor AFD, Kodachrome 200, 1/250sec at f/5.6

CASE STUDY

MODELS: AMATEUR OR PROFESSIONAL?

We all feel vulnerable when naked and inevitably even more exposed when facing a photographer. For this reason it is worth developing an open, trusting relationship with the model before embarking on anything too ambitious. Initially, it may seem tempting to work with friends, relatives or amateur models. However, their reluctance to pose naked, perhaps because of lack of confidence in their ability or appearance, may reveal itself in images as insecurity or self-consciousness. Professional figure models may therefore provide a better introduction to nude work. They are expensive to hire, but tend to be relaxed, confident and skilled at taking direction and adopting graceful poses.

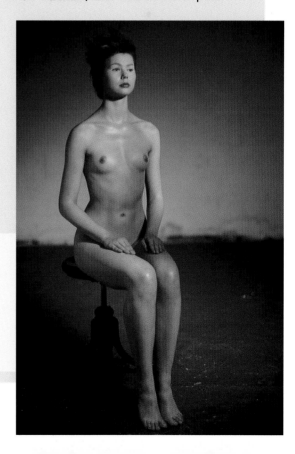

Professional figure models project confidence and are familiar with the studio environment. A good model will work with the photographer to develop ideas.
Nikon F5 with 85mm f/1.8 Nikkor AFD, Fujichrome RTP Tungsten 64T, 1/30sec at f/5.6

The line that separates fine art from simple exposure is surprisingly narrow. The nude figure is always sensual and erotic and small changes of position, expression and lighting can transform beauty into banality or even vulgarity. Consequently, it is extremely easy to get things wrong. Good nude images are possible only when the talents of the photographer and model are properly combined. The photographer needs a great deal of skill and judgement, and must search for inherent beauty and grace rather than simple clinical exposure.

Even professional models – most of whom are female – are unlikely to have perfect bodies. Individual strengths and weaknesses must therefore be identified and revealed while concealing imperfections. The model should be encouraged to contribute creatively and concentrate on subtle and graceful movements. She will need confidence, natural talent, and a rounded body with unblemished skin.

Any environment used for nude photography must be private and suitably warm – probably warmer than the photographer would like. Ideally, it should include a private changing room with good lighting and mirrors, a toilet and an area for refreshment and relaxation. Photographic studios and domestic interiors are commonly used for this sort of work, but all sorts of other locations can be found. The photographer should remain sensitive and tactful, and the model should be afforded appropriate consideration. Music chosen by the model breaks silences and helps to establish a relaxed atmosphere.

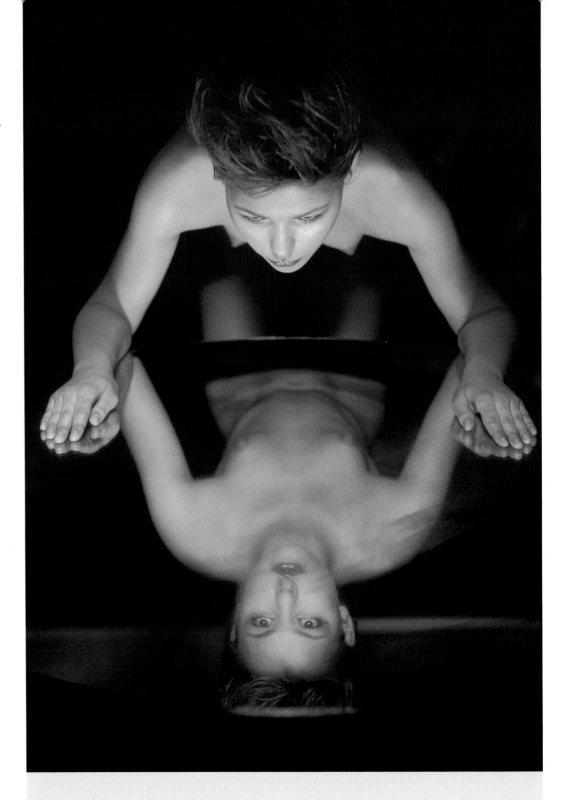

Small changes made to the position of the model can make or break an image. This shot took some time to set up and was captured using a single tungsten light.

Nikon F5 with 85mm f/1.8 Nikkor AFD, Fujichrome RTP Tungsten 64T, 1/30sec at f/5.6

CASE STUDY

WORKING IN MONOCHROME

Black & white images, and monochromatic images in general, depend to a large extent upon the distribution of tones to convey the impression of depth. They cannot record a figure as the eye sees it since they are abstractions taken from the coloured reality of the world. Nevertheless, the removal or reduction of colour information can have a significant and beneficial effect upon our perception of a subject.

Colours alter the mood of an image in a significant way. Warm reds and golden tones give a feeling quite different from cooler blues and greens, and strong colours distract the eye. Consequently, when colour is removed the brain's interpretation of what the eye sees is subtly altered – perhaps to the extent that the centre of interest changes. To achieve an adequate understanding of a monochromatic image the eye must extract more from the limited information available. We therefore concentrate to a greater extent upon shape, form, pattern and tonal gradation, and sensitivity to these aspects is enhanced.

Images of the nude depend heavily upon more or less the same fundamental aspects: shape, form, tonal gradation and texture. Indeed, photographers go to great lengths to create or find soft directional light that reveals these essential elements. Monochromatic media are consequently well suited to nude work.

Black & white photographs also have the advantage that numerous darkroom processes can be used to transform them after they have been captured. Tones can be changed more than is possible with colour, contrast can be increased or decreased, and various grades of paper can be used to produce quite different effects. Image-manipulation software is changing this situation to some extent, but the underlying creative truth remains.

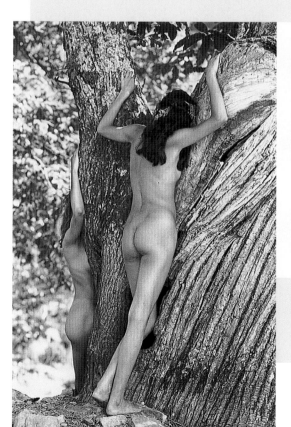

The objective here was to merge the models into the tree. Their poses reflect the shape of the trunk, and the roughness of the bark contrasts with their smooth skins.

Nikon F5 with 85mm f/1.8 Nikkor AFD, Ilford Delta 100, 125sec at f/8

Directional light emphasizes the form of the body. Tungsten lighting was used so that the modelling could be seen and adjusted as the model was positioned.

Nikon F4 with 85mm f/1.8 Nikkor AFD, Kodak T-Max 100, 1/30sec at f/5.6

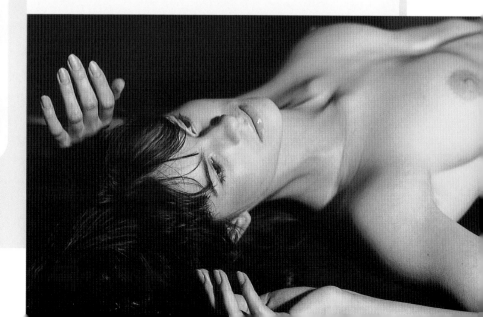

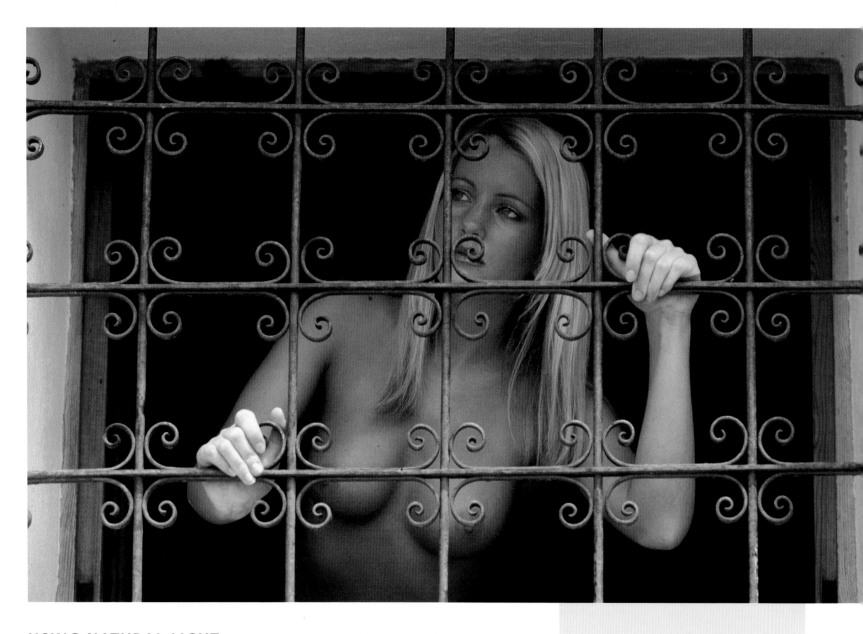

USING NATURAL LIGHT

Natural light is probably the best and most appealing for nude work, just as it is for many other types of portraiture. The easiest starting point is to work indoors and reasonably close to a window where the light is indirect, diffused and directional. Light levels decrease significantly as distance from the window increases, so move the model around the room and observe how highlights, shadows and tonal gradation change.

Bear in mind that regions of deep shadow create mystery by concealing detail, and can be more atmospheric and suggestive than fully lit areas of the body. Exposure latitude is likely to be a problem very close to a window, particularly if working in colour without any secondary light source. A second window on the far side of the room might provide enough light to fill shadows, otherwise use a suitable reflector placed close to the model.

The illumination at this window fell off sharply inside the room, so it was important to keep the model close to the grill.

Nikon F5 with 135mm f/2 DC Nikkor AFD, Kodachrome 200, 1/250sec at f/5.6

Natural light has many changeable moods that we cannot control. Nevertheless, we can learn to work in a flexible manner and use the prevailing circumstances to our advantage. Strong directional light such as that found on a sunny day can be used to produce striking highlights and shadows, although the location and pose of the model must be arranged so that attractive shapes are formed. Exposure must also be handled carefully to ensure that detail is retained in all areas, and that the latitude of the film or sensor is fully utilized. Alternatively, diffuse the light or limit contrast with substantial fill for shadows.

If fill-in flash is employed it is worth fitting the head with a small softbox and a warm flash filter such as an 81A. This produces a softer, more flattering light and warms the model's skin tones.

READ ON

Filters

p.20

Exposure latitude

p.49

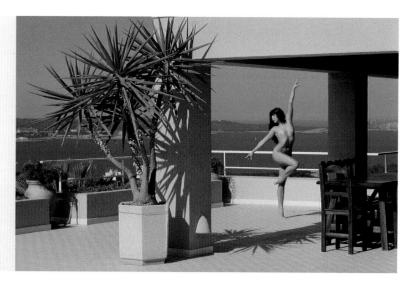

The orientation of this dancer was chosen to preserve modelling without casting unsightly shadows in the direct sunlight.
Nikon F5 with 85mm f/1.8 Nikkor AFD, Kodachrome 200, 1/250sec at f/16

CASE STUDY

USING CAST SHADOWS

Interesting shadows are sometimes cast on floors and walls. These effects can be beautiful in their own right, so use them as features of an image wherever possible. Shadows seen as straight lines on a plane surface emphasize form and are transformed into intriguing curves as they rake the torso or limbs of a model.

Natural window light cast this attractive shadow on the bare floor. The lines created by the frame have been disturbed by the shape of the model's body.
Nikon F4 with 50mm f/1.4 Nikkor AFD, Kodak T-Max 100, 1/30sec at f/4

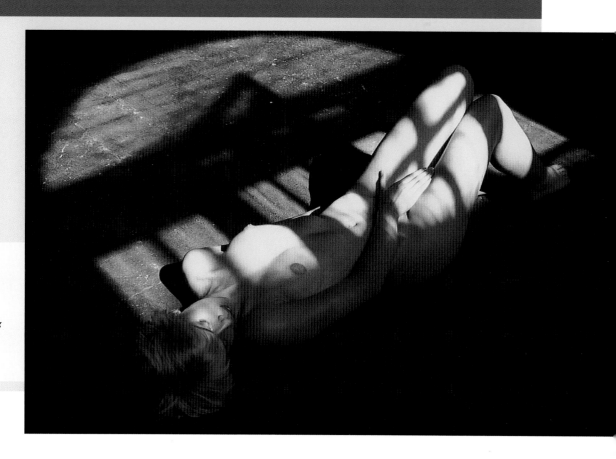

SIMPLICITY

Simple approaches to nude photography are often the most rewarding. This is not unique to this field of work, but it is perhaps more true here than in other areas. Simple lighting, ideas, settings and props can all mean more rather than less in terms of the success of an image.

We have seen that simple lighting, such as window light, can provide beautifully soft directional illumination for the figure.

Even when used in isolation, without secondary sources or reflectors, it can provide everything needed. Alternatively, the soft illumination of the setting sun can be very effective. It bathes a model in warm light and the skin glows, particularly when tanned.

Simple ideas are also powerful. Have a few concepts clear in your mind before a photographic session begins – two or three are generally sufficient as a starting point. Work on

them with the model, changing and developing the original concepts until something worthwhile is achieved.

This dome was part of a ruined farmhouse in Spain. All that was necessary was to choose the best time of day for the shot. The model was quite happy lying in the sun and did not want to move.
Nikon F5 with 85mm f/1.8 Nikkor AFD, Fujichrome Astia 100, 1/250sec at f/11

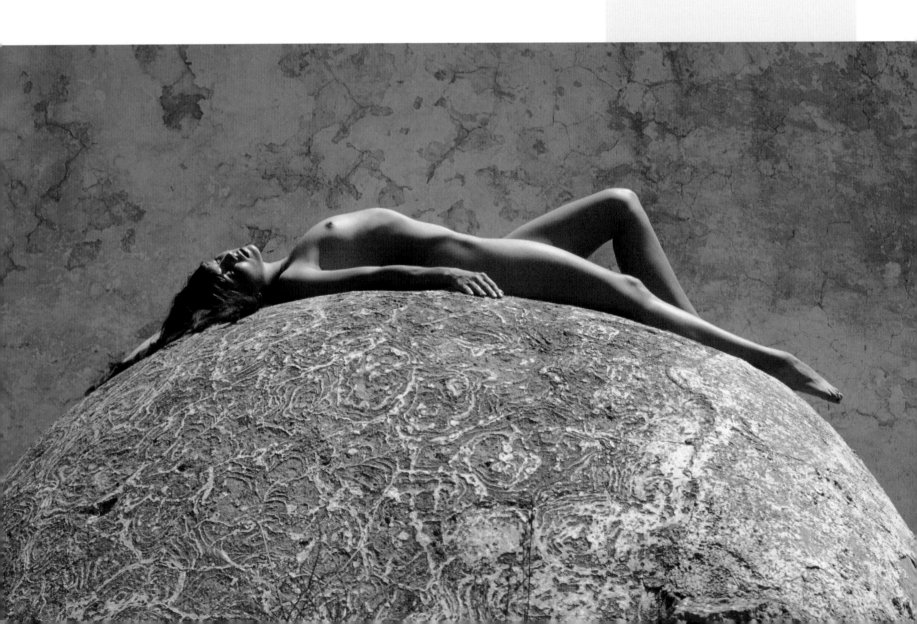

CASE STUDY

CHOOSING THE BACKGROUND

Settings and backgrounds can be as simple or elaborate as circumstances permit, but should disclose appropriate context for the image. Colour has a significant effect upon atmosphere and can be used to provide contrast or comfort for the naked form. Environmental detail may be necessary to set the mood, but too much subordinate information serves only to distract the eye.

A bland environment such as a bare wall or unfurnished room immediately focuses attention on the figure – its stark unwelcoming atmosphere strikes an interesting contrast with human softness and vulnerability. A comfortably furnished bedroom, on the other hand, suggests a more relaxing and intimate atmosphere. Finally, a background shape that mimics the geometry of a model's pose adds depth and

emphasizes the graceful lines of the body. It is worth looking for lines and curves in the environment which suggest positions a model might reasonably adopt.

This image was created by encouraging the model to adopt the shape of her surroundings.
Nikon F5 with 20–35mm f/2.8 Nikkor AFD, Fujichrome Astia 100, 1/250sec at f/8

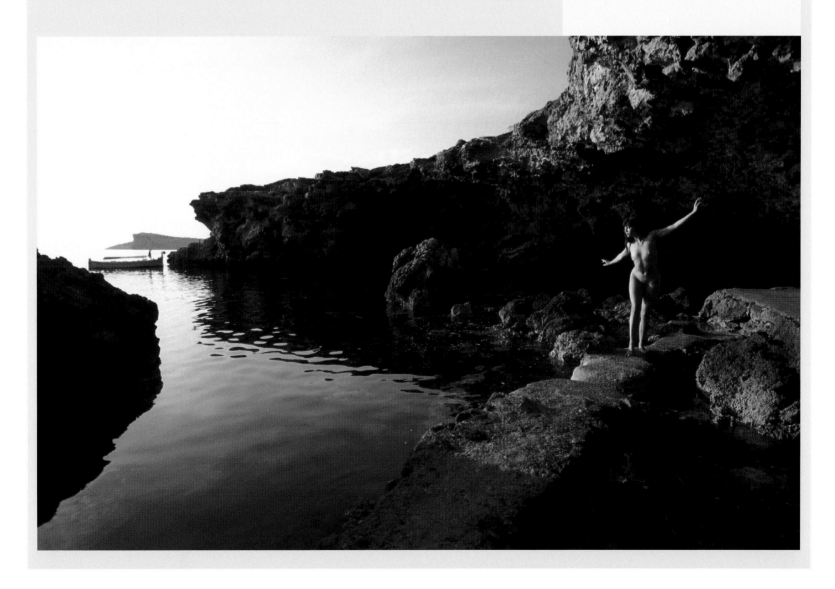

EQUIPMENT

PROPS

Context is further implied by judicious use of props, but the items chosen should be sympathetic to the feeling of the image.

It is worth having a range of things available, but they do not need to be elaborate. The simplest bits and pieces are often the most effective. For example, a personal touch such as a piece of jewellery decreases anonymity and might be used to suggest a pensive or romantic atmosphere. It is also interesting to use the model as the background with focus maintained upon a simple foreground prop.

The key to this shot was a narrow beam of light directed onto the wineglass from behind and to the right of the model. Exposure was set for the background to reduce the model to a silhouette.
Nikon F5 with 85mm f/1.8 Nikkor AFD, Fujichrome Astia 100, X sync f/5.6

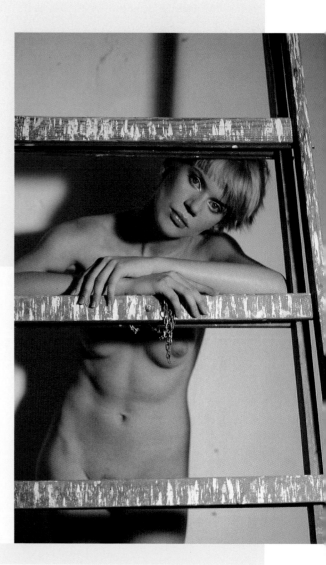

Simple objects often make very effective props. This decorator's trestle frames the model and contrasts with the gentler outline of her figure.
Nikon F5 with 85mm f/1.8 Nikkor AFD, Fujichrome RTP Tungsten 64T, 1/30sec at f/5.6

FORM AND GEOMETRY

Form is most readily captured using a largely
abstract approach to the nude. Instead of
portraying the model as an unique personality,
the aim is to create abstract but recognizable
images composed almost exclusively of texture
and graceful curves. Working close to the model
with a short telephoto lens, and concentrating on
the clean and supple natural lines of a particular
part of the body, can achieve this. The face and
identity of the model are normally excluded from
the frame to further enhance the depersonalized
and abstract nature of the image. This also
removes any possibility of the image becoming
unnecessarily erotic as a consequence of any
facial expressions.

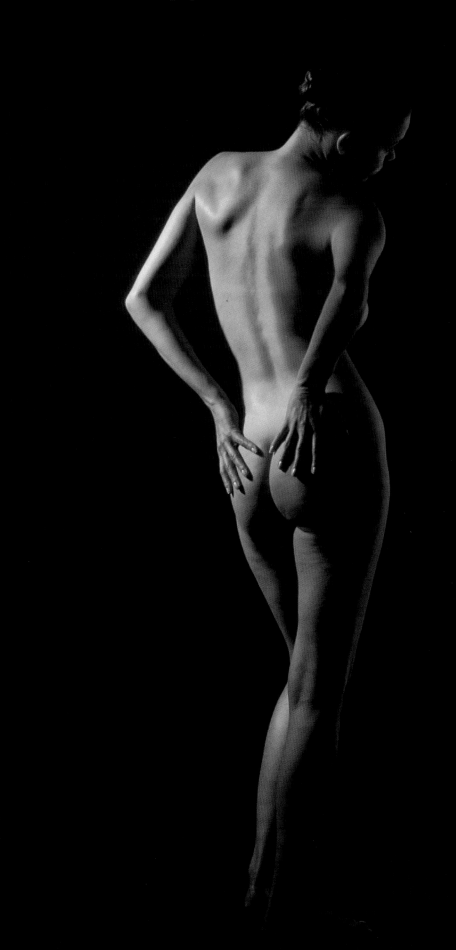

*Although the model's
face is partially visible,
the lighting concentrates
attention on her back
and figure.*
**Nikon F5 with 85mm
f/1.8 Nikkor AFD,
Fujichrome RTP
Tungsten 64T, 1/30sec
at f/4**

Choose a slim model with graceful movement and an understated but rounded figure. Prior to a session, ask her to ensure that her skin is free of the pressure marks left by straps or underwear, which might otherwise remain visible for many hours. Show her examples of the sorts of images you have in mind, and encourage her to relax and move naturally. Explaining that the images are anonymous may help to ease any initial self-consciousness. Privacy, comfort and a relaxed atmosphere are again important. Inherent tension reveals itself through stiff, awkward poses so use music and encourage the model to breathe deeply. This helps relaxation and also flattens

the stomach. However, gently tightened or stretched limbs maintained in relaxed positions do help to emphasize form. It is worthwhile asking the model to vary the tension in the muscles of a particular limb or surface.

Lighting and control of tonal range are key concerns. Soft, directional light from a window creates beautiful relief as it skates over the figure, the tones deepening as the surface turns away from the light. Contrast between light and shade can be controlled by reflectors or by the proximity of light-coloured walls, but limiting tonal range and suppressing surface detail

emphasizes shape at the expense of form. Bathing in oil or water increases the amount of light reflected from the body and exposes the granular nature of the skin. Cold water, if the model is willing, tightens skin and produces an invigorating and refreshing look. If a background is required in part of the frame, use plain walls or fabrics of neutral colour that do not distract the eye.

The human-geometry approach to the naked figure reduces the subject to a series of curving outlines and strong angular shapes. The aim is to produce simple graphic images that focus on the

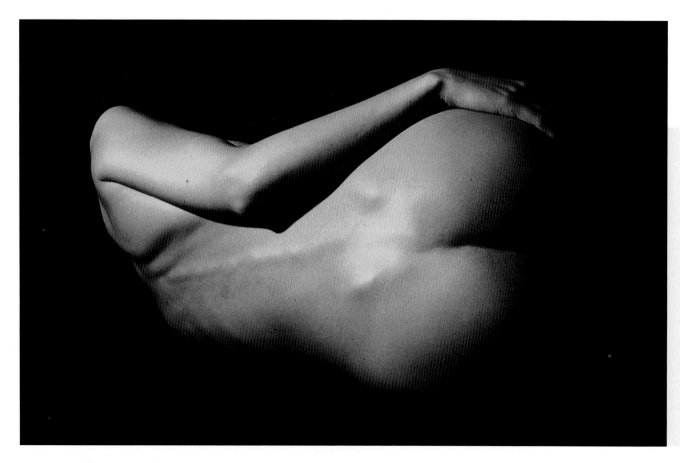

As more of the body is concealed, so interest focuses increasingly upon shape and form. The body of a model is still recognizable here, but the image is approaching the point where it would become abstract.
Nikon F4 with 85mm f/1.8 Nikkor AFD, Kodak T-Max 100, 1/30sec at f/5.6

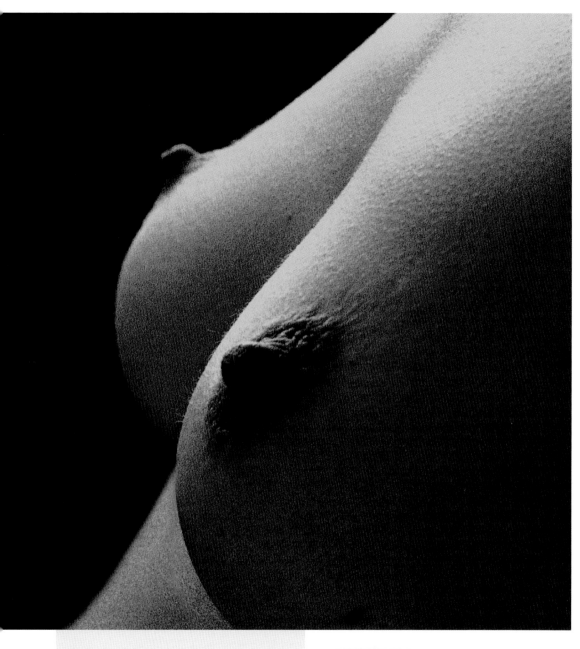

structure of the body. The face can be excluded from the frame to focus attention on the figure, or partly concealed to suggest shyness. Position the figure so that light falls from above and behind the body, producing highlights that emphasize natural shapes and structural geometry. Dense shadows can be partially filled or used to frame and isolate shapes and natural angles. Shape can also be emphasized by casting graphic shadows onto the floor or background.

Images of this type can be photographed in a studio, where precise and complete control of lighting is possible, or in directional natural light. Domestic environments need to be handled with great care, as furnishings and other details inevitably add personal touches to the images. The result may then be rather too voyeuristic and lose focus on geometric aspects. Backgrounds should provide tonal or colour contrast, and avoid any elements that might distract. Coarse fabrics introduce a textural contrast for the smooth skin of a model. Monochromatic images consisting of flesh tones, tans and warm browns have particular impact and appeal.

Soft directional light from a window beyond the model is sufficient here to reveal the form of her breasts. Care was taken to ensure that light was not reflected back into the shadows from the walls of the room.
Nikon F5 with 105mm f/2.8 Micro Nikkor AFD, Kodak T-Max 400, 1/30sec at f/8

Strong lines and shapes created by the limbs encourage the eye to explore the geometry of the model's body. The image has been depersonalized by excluding the face.
Nikon F4 with 85mm f/1.8 Nikkor AFD, Kodak T-Max 100, 1/30sec at f/5.6

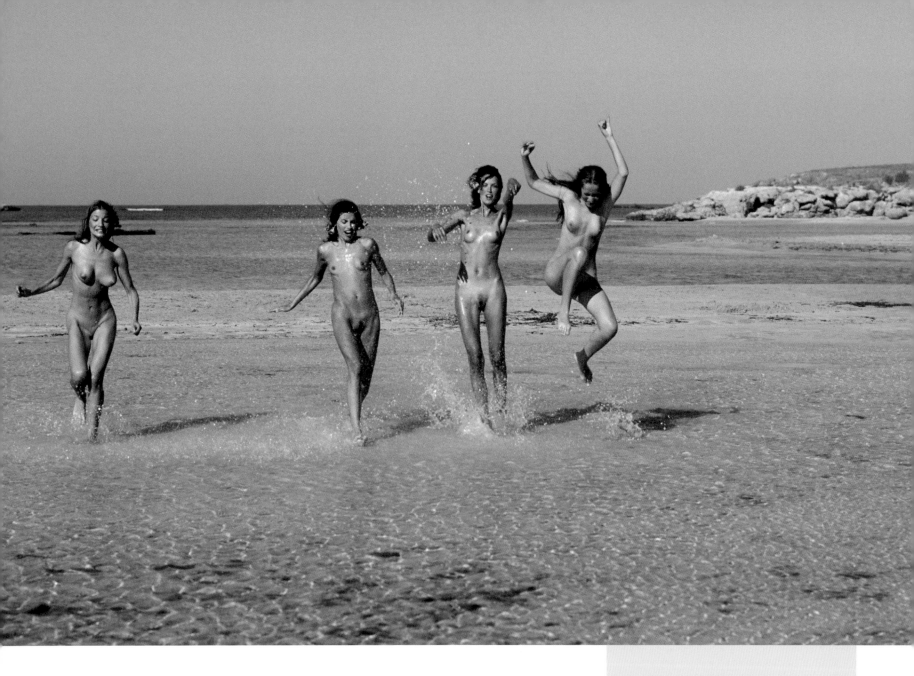

WORKING OUTDOORS

Additional difficulties encountered when working outdoors are the weather and lack of privacy. Temperate climates, cold skin and goose pimples are tough on models as well as images. Mediterranean and subtropical conditions are certainly more accommodating and pleasant from most points of view. Warm summer mornings are generally a good time to work: the light is wonderfully soft and oblique, the air is fresh and most people are still in bed. But make sure the models have suitable garments to wear when relaxing – it is surprisingly cold walking around naked. The golden glows of evening are also rewarding, but it may be more difficult to find privacy at this time of day.

This sort of shot is best done early in the day when the air is fresh and the beaches are quiet. Four nude models soon attract attention.

Nikon F5 with 50mm f/1.4 Nikkor AFD, Fujichrome Astia 100, 1/1000sec at f/8

The softness of the girl's body is the only relief from the cold hardness of the grey coastal rocks. The tones of the seaweed and the light-coloured boulder help to balance the composition.
Nikon F5 with 85mm f/1.8 Nikkor AFD, Fujichrome Astia 100, 1/125sec at f/5.6

A suitable location should be selected well before the session, and with the feelings of the models in mind. Some will disregard onlookers, but others may become tense and distracted.

I have worked with outdoor nudes mainly on Mediterranean islands where the models are able to relax and local people are remarkably tolerant. Nevertheless the local culture, and those who may be offended by public nudity, should always be respected.

Many different approaches can be adopted when photographing nudes outdoors, but the most successful images achieve a good relationship between model and environment. Rocks can be used to suggest shapes, and their rough surfaces contrast well with human softness. Water offers the possibilities of freshness, reflections and partial concealment, and ruined buildings with broken windows and flaking paint suggest remoteness and vulnerability. The broad landscape itself is also a rewarding canvas. A small figure in a vast, stark or cold landscape again suggests vulnerability and frailty. A more harmonious relationship suggested by similar tones, and comparable shapes and lines, results in a much warmer atmosphere. With care, and appropriate use of sympathetic shapes and contrasting textures, a body can be blended into a landscape as a tree fits into a wood.

READ ON

Getting organized
p.30

The quality of natural light
p.63

Reflections
p.161

ON LOCATION

ON LOCATION

GRAND SETTINGS

ON LOCATION

ON LOCATION

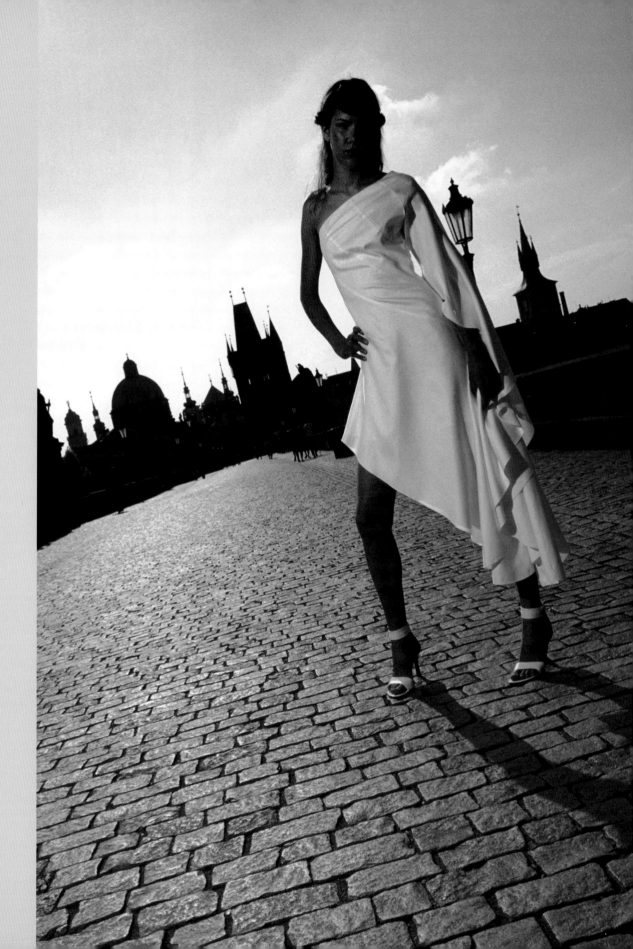

GENERAL CONSIDERATIONS

Although simple settings work well, it is also possible to use grand or large-scale locations. These might be scenic wonders, or man-made structures such as imposing buildings. A person adds scale to landscapes and structures, or might be used to emphasize the desolate or hostile nature of the surroundings. The subject can also be positioned so as to conceal an unwanted object.

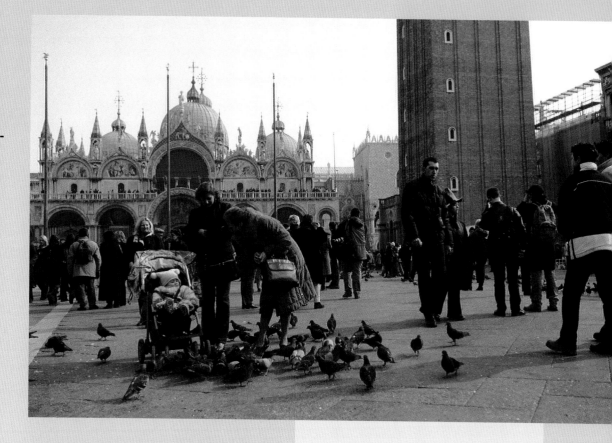

Charles Bridge is the busy tourist centre of Prague, but early in the morning there is hardly a soul to be seen. The model was therefore booked for 0630. The shot was taken with flash against the light to capture the drama of the silhouetted architecture.

Nikon F5 with 20–35mm f/2.8 Nikkor AFD, Fujichrome Astia 100, 1/125sec at f/11

EQUIPMENT AND TECHNIQUE

Subjects photographed in landscapes, or close to imposing structures, should be positioned in a sympathetic manner at a location to which the eye will be drawn. The human figure is instantly recognizable even when relatively small in the frame, but composition is strengthened by elements that guide the eye to the centre of interest. This can be achieved not only by using lines suggested by the landscape or architecture but also by differences in colour and tone. Strong colours and dark tones can be used to lead the eye deeper into an image, as can depth of field and differential focusing.

Look for a cameo within a crowd, and use the mass of people as a frame for the image. This family group, surrounded by pigeons and backed by grand architecture, tells a simple story.

Nikon F5 with 20–35mm f/2.8 Nikkor AFD, Fujichrome Sensia 200, 1/250sec at f/8

LIGHTING

While it is obviously not possible to control completely the lighting of a large location, we can choose the best of what nature offers. Observe how the light changes with the weather and time of day, and if possible work at the optimum time. Harsh and flat frontal light is rarely interesting, so consider using sidelighting or working at sunrise or sunset. Much depends upon what you are trying to achieve, and on practical matters such as access to the site and the availability of the subjects.

A group of Bhutanese monks is dwarfed by the extraordinary architecture of Punakha Dzong. The angles are unconventional, but seem to work.
Nikon F4 with 135mm f/2 DC Nikkor AFD, Kodachrome 200, 1/125sec at f/8

This shot was captured on an island in the River Vltava in the heart of Prague, and was designed to incorporate the grandeur of this beautiful old city.
Nikon F5 with 20–35mm f/2.8 Nikkor AFD, Fujichrome Astia 100, 1/125sec at f/11

Venice Carnival offers unique opportunities to photograph people amid extraordinary architecture. Here, I chose the huge columns and veined wall as a backdrop before asking the masquerader to position herself appropriately.
Nikon F5 with 85mm f/1.8 Nikkor AFD, Fujichrome Sensia 200, 1/250sec at f/11

PRO TIP

The secret when using a grand location is to find elements that relate the subject to the setting. Try to identify defining characteristics and separate them from other detail. These might help to create a strong sense of individuality linked in some way to the subject. It is not necessary to show every feature of a large backdrop. It might be better to strip detail down to the bare bones by careful selection of lens focal length or depth of field. Vary the camera position and observe how balance and background features change. There is a balance to be struck between including so much that the message of the image is lost, and going so close that the subject is isolated from the surroundings.

09 THE UNCONVENTIONAL

Millions of photographs of people are taken every year. Most show the face and upper part of the subject's body or a simple full-length view, but there is absolutely no need to follow this convention. Indeed, there is every reason to try other approaches. One of the attractions of photography is its ability to surprise. The medium has the potential to deliver stunning results and is limited only by the imagination of the photographer.

UNUSUAL ANGLES

Conventional wisdom is that portraits are best captured from about eye level. This is how we see each other in everyday life, and the advice is basically sound from that point of view. However, imaginative images can be obtained from any angle. For example, the camera can look up from close to the ground, or look down from a raised position. Looking up to a subject gives him or her apparent height and dominance, and consequently an air of authority. Looking down from an elevated viewpoint renders the subject vulnerable or even threatened.

Try shooting up from beneath the chin of a reclining figure or, using a wideangle lens, from between the feet of a seated subject. The back of the head is definitely worth investigating, particularly if your subject has an unusual hairstyle or perhaps a bald patch. Hands clasped behind the head add appeal, although may become the centre of interest, and the diamond created by the arms makes an interesting frame.

I met this man in Greece. Although the shot is conventional in style, and taken from eye level, the subject's unusual appearance catches the eye.
Nikon F4 with 105mm f/2.8 Micro Nikkor AFD, Fujichrome Velvia 50, 1/125sec at f/5.6

CASE STUDY

USING PERSPECTIVE

When angles of view are acute, perspective becomes important. Images created from low down, particularly with wideangle lenses, tend to show large feet but small arms and head. Those shot from an elevated position show a large head with disproportionately small limbs, adding impact and focusing attention on the face. These are not distortions created by the lens, but an accurate representation of a subject seen in a particular manner.
The parts of the body that are closest to the camera simply appear to be the largest. It is worth training your eye to notice these effects through the viewfinder, as they can be used to direct attention to particular features.

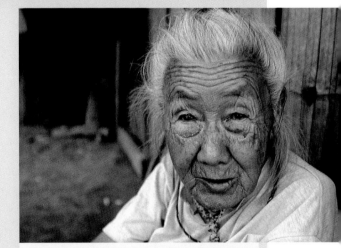

The camera was positioned very close to this woman's face. The wideangle lens and reasonably high viewpoint have together emphasized the size of her head relative to the rest of her body.
Nikon F4 with 20–35mm f/2.8 Nikkor AFD, Kodachrome 200, 1/125sec at f/2.8

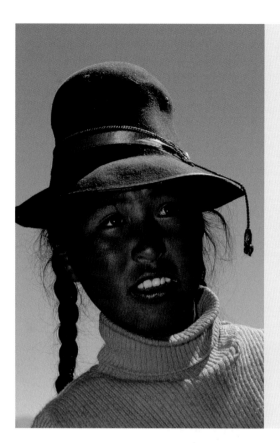

This Andean Aymara girl lived on a crowded floating island built from totora reeds. No suitable background was available, so I knelt down to replace unwanted clutter with blue sky.
Nikon F4 with 105mm f/2.8 Micro Nikkor AFD, Kodachrome 200, 1/250sec at f/8

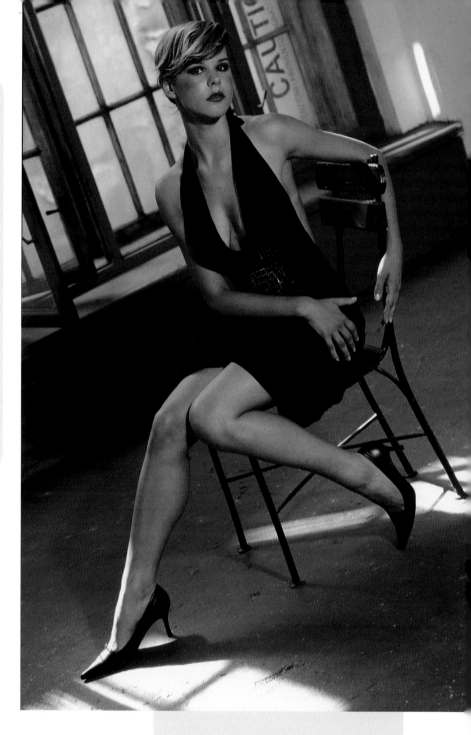

Unconventional angles can be used to advantage. When tilting the camera away from the horizontal or vertical, it is usually best to do it boldly.
Nikon F5 with 85mm f/1.8 Nikkor AFD, Fujichrome Sensia 100, 1/125sec at f/11

All sorts of circumstances can lead to the choice of unusual viewpoints. Unwanted backgrounds can be reduced or eliminated by gaining a little height and looking down on the subject. If we shoot upwards the foreground reduces and the sky becomes the backdrop. Alternatively, an image can be transformed by moving around the subject so that light strikes from different angles. Front lighting reveals detail and colour but can be uninteresting. Viewed against the light, and exposing for background highlights, the same subject becomes a silhouette. Colour is then sacrificed in favour of shadows and strength of outline. Colours and shapes in backgrounds can also be manipulated by changing viewpoint. Contrasting colours might, for instance, be replaced with colour harmony by taking a couple of steps to one side.

Unusual camera orientations can also be exploited. For example, tilt your camera to capture a diagonal cut through the scene. This will give the image a quite different and less formal feeling. Once again, the key is experimentation.

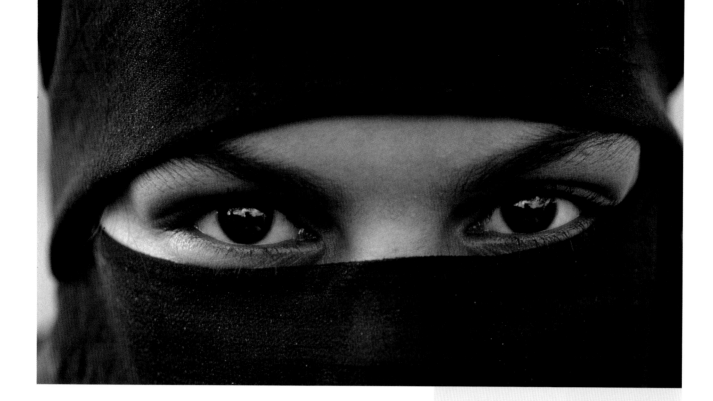

READ ON

Communicating with

subjects

p.83

Seeing pictures

p.99

Approaches

p.116

ISOLATING PARTS OF THE BODY

Eyes, hands, legs and feet, seen in isolation, often say a great deal about people and their way of life, and consequently make interesting subjects. This gives rise to a quite different approach to photographing people.

Even when considered in isolation, eyes make a fascinating subject. Shots framed so tightly that only the eyes are visible usually grab attention, but those that also convey emotion have the most impact. Framing and composition for images of this type are not as easy as one might think. Wherever the cut-off occurs on the face it can seem uncomfortably placed. One solution is to choose a subject wearing an item of clothing that frames the eyes, such as a scarf or veil. This creates a softer and more acceptable boundary than the clean rectangle defined by a viewfinder. Compositions of this type may be more successful if the subject's head is tilted to one side so that the eyes are on different levels.

Eyes can make an interesting photograph in their own right, but need careful framing. Here, the frame provided by the girl's clothing has worked well.
Nikon F5 with 105mm f/2.8 Micro Nikkor AFD, Kodachrome 200, 1/250sec at f/5.6

CASE STUDY

CLOSE-UPS: EYES

Close-ups of eyes composed in camera tend to work better than enlargements obtained from more distant shots – images are more likely to have the desired impact when seen and captured as originally visualized. The short minimum focusing distance of a macro lens is therefore an advantage. If you are close enough to a subject for the eyes to fill the frame comfortably in landscape format, depth of field will be minimal and dependent upon aperture only. At f/2.8 it is less than five millimetres, and at f/22 it is approximately 30mm. It is usually the case that both eyes should be in sharp focus, although under some circumstances one may be allowed to go soft. Focusing should therefore be very precise, and depth of field must be carefully controlled.

Hands are a key indicator of personality and consequently invite curiosity. Who do they belong to and what sort of life does their owner lead? Hands are also extremely versatile and can be presented to the camera in countless different ways.

Nikon F5 with 105mm f/2.8 Micro Nikkor AFD,
Fujichrome Sensia 200, X sync at f/22

Exposing the hip and asking the dancer to stand on her points have both helped to increase the apparent length of her legs.

Nikon F5 with 85mm
f/1.8 Nikkor AFD,
Ilford Delta 100,
X sync at f/8

Legs and feet

Legs seen in isolation are subjects in their own right – indeed whole books have been written about them. The muscular thighs and calves of an athlete, or the graceful and geometric poses of a dancer, provide sufficient interest to attract the eye. With good composition, an uncluttered background, and directional lighting to provide modelling, simple ideas such as these can be very successful.

Here the model's feet have been given additional context by including the shadow of her body.

Nikon F5 with 85mm f/1.8 Nikkor AFD, Fujichrome
Astia 100, 1/250sec at f/16

Hands

The hands of a rugged farm worker will be quite different in appearance from those of an office worker or a child. Those of an elderly subject may be deeply wrinkled and make the viewer want to see more of their owner. Capture the hands clasped, perhaps with the fingers intertwined, or simply holding a small object. Directional light is important because it highlights texture. Hands can also be photographed as a frame for the face. One way to do this is to position someone behind a screen, and ask him or her to look through a restricted opening held ajar by relaxed hands. Venetian blinds or an old tarpaulin are good for this purpose, but many other approaches are possible.

Feet are of interest in a more intimate way. The compound curves and the texture of the skin make us curious about their owner. Are these the feet of a man or a woman? How old are they and what sort of life have they led? Feet can be photographed in a straightforward manner and portrayed as the parts of the body that make contact with the ground, or seen as a sculptural abstraction rich in form, texture and outline. The latter approach needs directional light, and is probably best tackled in a studio where lighting is fully controlled and precise.

REFLECTIONS

Highly reflective surfaces of various types can be used to capture unusual pictures. Mirrors are the most obvious source of reflections but there are many others. Windows, particularly those of modern office buildings, are prime targets for this sort of work. Water and wet roads are also surfaces worth considering.

This model was photographed in numerous positions around the mirror tabletop, but I particularly liked this restful pose.

Nikon F5 with 105mm f/2.8 Micro Nikkor AFD, Fujichrome RTP Tungsten 64T, 1/30sec at f/4

A simple approach is to seat your subject in front of a mirror and position the camera to include in the frame both the subject and the reflected image. If the camera is visible through the viewfinder, it must be moved. Bear in mind with all mirror shots that the reflected image is as far behind the mirror as the subject is in front of it. If only the reflection is to be sharp, focus the lens at the distance from the camera to the mirror and back to the subject. When using an autofocus system, focus directly on the reflected image rather than the edge of the mirror. If both the subject and the reflected image are to be in focus, the focused distance must be chosen in conjunction with aperture to achieve the necessary depth of field.

A small mirror held in the subject's hand may be used to frame a reflected image of the face only. The hand and arm of the subject can be included in the frame to lead the eye to the mirror. If only the mirror and the reflection are included, the mirror takes on the appearance of a framed picture.

Water is perhaps the most varied source of reflections. Its surface is easily disturbed and produces fascinating distortions and colours. Always look for reflections when photographing people near water, and remember that it may be necessary to get down low before the full extent of a reflection becomes visible. Refreshingly different images can be captured from the surface of a lake or swimming pool, or even a humble pool of rainwater in the street. A simple shot of a figure on a riverbank can also be transformed simply by lowering the camera to incorporate the inverted image in the water.

Another approach is to walk the streets of your local town during heavy rainfall. Images of pedestrians are reflected from wet pavements and roads, and make good atmospheric subjects. Streetlights and brightly-lit shop windows add further colour and excitement. Choose distinctive silhouettes of couples or individuals and try to isolate them from the crowd. Use a fast film and carry a plastic bag as protection for your camera.

Water breaks up reflections in the most attractive manner. This Burmese Intha fisherman was perched precariously on the prow of his unstable craft. The slightest movement of the boat produced fresh ripples.
Nikon F4 with 135mm f/2 DC Nikkor AFD, Kodachrome 200, 1/250sec at f/11

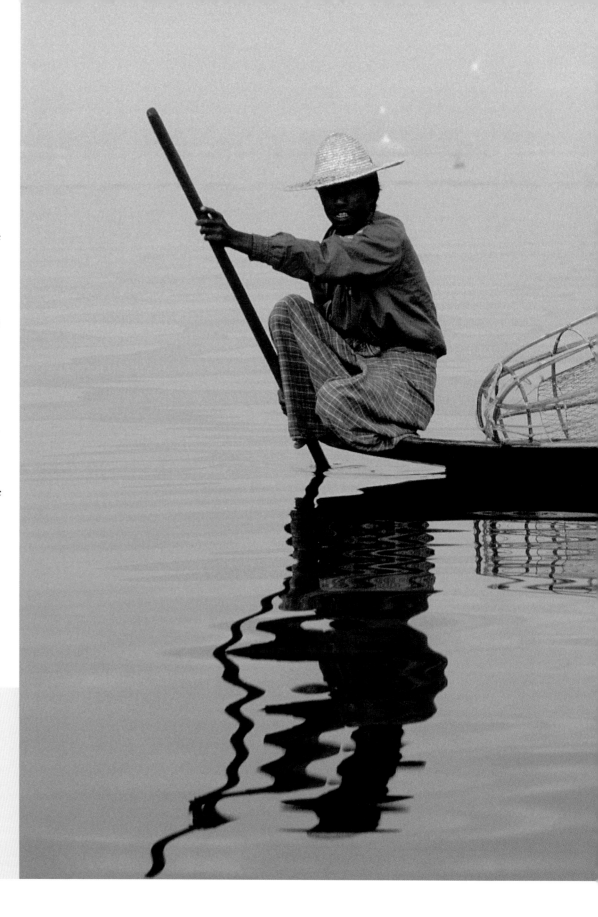

USING MOVEMENT

When photographing moving subjects it is all too easy to default to a shutter speed of 1/1000sec or faster to freeze the action. This is a perfectly good technique, but very different and more dynamic images can be obtained using much slower speeds. The two simplest alternatives are to blur the subject while keeping the background sharp, or maintain subject sharpness by panning the camera and letting the background flow. Shutter speeds must be chosen to suit the speed of movement and create the desired effect. The camera can be moved horizontally, vertically, diagonally, or even rotated. The direction of movement of the subject, however, has considerable bearing upon the amount of movement relative to the camera and hence the nature of the final image. Movement towards and away from the camera will produce less blurring than movement across the plane of the film or sensor.

Another technique is to blur everything by using a slow shutter speed and moving the camera relative to both background and subject during exposure. Here the results are more difficult to predict, so try a range of shutter speeds. The precise setting will largely be determined by the speed of the subject and the direction of movement.

The gyrations of this nightclub dancer were captured using a tripod-mounted camera and a slow shutter speed. The film has preserved the eerie glow of the so-called ultra-violet light. Thanks to Club Pacha, Ibiza for access.
Nikon F5 with 135mm f/2 DC Nikkor AFD, Fujichrome Sensia 400, 1/15sec at f/2

The three fairground riders in the foreground are less blurred because they are moving towards the camera. Those in the background are blurred more because they are moving across the frame.
Nikon F5 with 105mm f/2.8 Micro Nikkor AFD, Kodachrome 200, 1/30sec at f/16

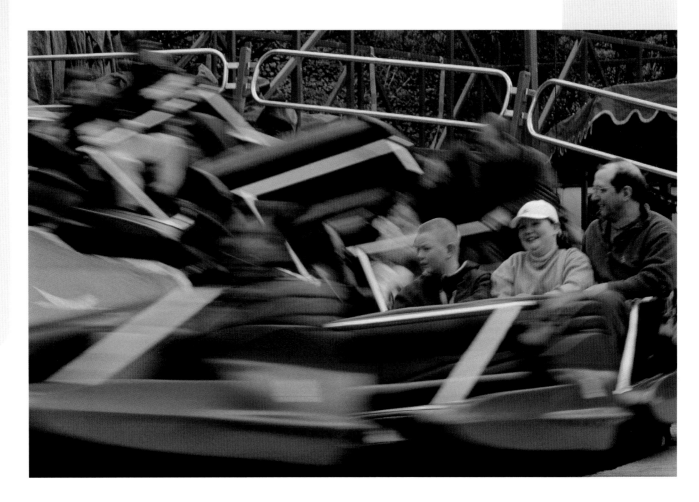

CASE STUDY

ZOOM BURSTS

It is also possible to create the impression of movement for stationary subjects. Load a camera with slow film, perhaps ISO 50, attach a zoom lens and set it up on a stable tripod. Position the subject, perhaps a child on a bicycle, in the centre of the frame. Focus on the child with the lens at maximum focal length and then zoom back to check the framing of the wider picture. Select a slow shutter speed and a small aperture – perhaps 1/15sec at f/8 or f/11. Release the shutter while moving the zoom from maximum to minimum focal length. The result should be a reasonably sharp subject at the centre of the image surrounded by a motion-like blur of converging streaks. A similar effect might be created in-camera using a radial zoom filter, or added later using image-manipulation software.

Despite appearances, this motorcyclist was stationary. The impression of rapid movement towards the camera was created by zooming the lens to a wider angle during the exposure.

Nikon F5 with 70–210mm f/4–5.6 Nikkor AFD, Fujichrome Velvia 50, 1/15sec at f/16

These camel traders were negotiating a deal as they watched the sun set. The camera was mounted on a tripod and pointed almost directly into the sun.
Nikon F4 with 300mm f/4 Nikkor AFD, Kodachrome 200, 1/60sec at f/4

LOW-LIGHT WORK

Low-light conditions occur indoors, on overcast and foggy days, during storms, and of course as darkness descends. It may seem natural to put your camera away under such circumstances, but don't be tempted to do so. Excellent photographic opportunities are created as colours darken and merge together, subtle tones dominate and the eye becomes more sensitive to small tonal gradations. It is important to have a lens with a maximum aperture of f/2.8, f/2 or f/1.4, and to use the wide apertures to full effect despite depth of field limitations. Slow shutter speeds, 1/4sec for example, can also be used provided your subject does not move and the camera is mounted on a tripod.

After dark there are still lots of possibilities. Illuminate a face with a match, a candle or an oil lamp and wonderfully warm and intimate images are possible. Use a fast film with good latitude in the range ISO 400–1600, and bear in mind the

READ ON

Exposure latitude
p.49

White balance
p.72

The light from the single match was the only illumination for this shot. The girl had natural auburn hair but the low colour temperature has added a distinct colour cast. To avoid flare, the lens had to be spotlessly clean.
Nikon F5 with 85mm f/1.8 Nikkor AFD, Fujichrome Provia 1600, 1/8sec at f4

CASE STUDY

SILHOUETTES

Silhouettes are created when strong backlighting is used to maximize contrast. This leaves the subject in deep shadow and removes surface detail. A difference of four or five stops between the background and the subject is normally required. Silhouettes are easy to set up but strong shapes are required to produce successful images. Props like a flamboyant hat or hairstyle, or a cigar and walking stick, may help.

Place the subject against an evenly illuminated white or light-coloured background, or a uniformly bright diffusing screen. If nothing else is available, use the sky or perhaps an orange sunset as a background. Make sure no light spills onto the foreground, and if necessary surround your subject with black drapes. Exposure must be set for the bright background, and no compensation should be made for the lower level of subject illumination.

By setting the exposure for the background, the man has been reduced almost to a silhouette. The shapes of his various accessories add considerably to the success of the image.
Nikon F5 with 105mm f/2.8 Micro Nikkor AFD, Fujichrome Sensia 200, 1/125sec at f/5.6

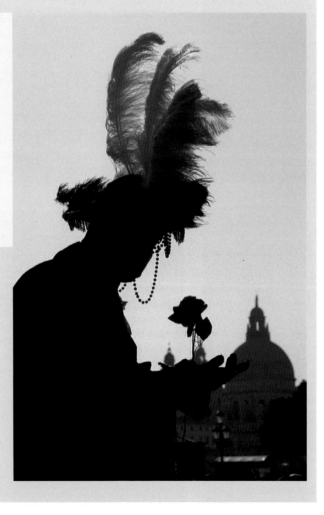

low colour temperature and extreme contrast. Also, remember that the film or camera's white balance should be appropriate for tungsten light, and blue colour-correction filters may be necessary to achieve anything approaching perceived colour. Detail at one end of the brightness scale will probably be lost. A digital camera used in conjunction with a low ISO setting may prove to be the best option.

GLIMPSES AND CONCEALMENT

Our impressions of the people we meet in everyday life are often based upon fleeting glimpses and unguarded moments. Glances exchanged in a crowd, or by the drivers of cars, may be brief and veiled in mystery. When we use a camera to penetrate barriers like these we feel we have entered the private world of our subjects. Faces photographed through soiled windows are a good example, and different effects can be obtained by selectively focusing on the subject or on the window itself.

The technique of concealment can be taken further by using the principle that what is hidden may be more interesting than what is visible. If a pretty girl peeps around a half-closed door, we want to see her whole face. Situations of this type can be captured in an opportunistic way, but can also be set up quite simply.

An obscuring foreground of foliage or flowers can be used to mask unwanted detail. However, what you show of your subject must catch the eye, and the surrounding environment should not be distracting. The viewer must be drawn to the centre of interest, perhaps via a line or shape in the image, and then want to know more.

Including the eyes of your subject can help to achieve this. Alternatively, use a large aperture and differential focus to lift the subject from the surroundings.

Images reflected from small mirrors also provide a basic concealment technique. The rear-view mirror of a car reflects only the eyes of the driver, but reveals sufficient information to arouse interest. A wideangle lens will show enough of the windshield or the interior of the car to provide context. A large aperture minimizes depth of field, and a wet or fogged windshield reduces background detail.

READ ON
Colour-conversion filters
p.73

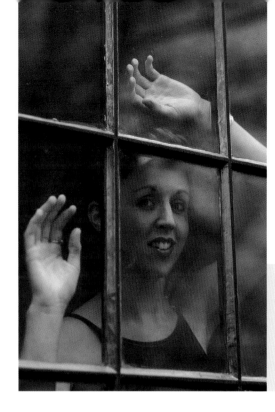

No polarizing filter was used here. The reflections from the glass were just sufficient to partly obscure the figure.
Nikon F5 with 105mm f/2.8 Micro Nikkor AFD, Kodachrome 200, 1/125sec at f/4

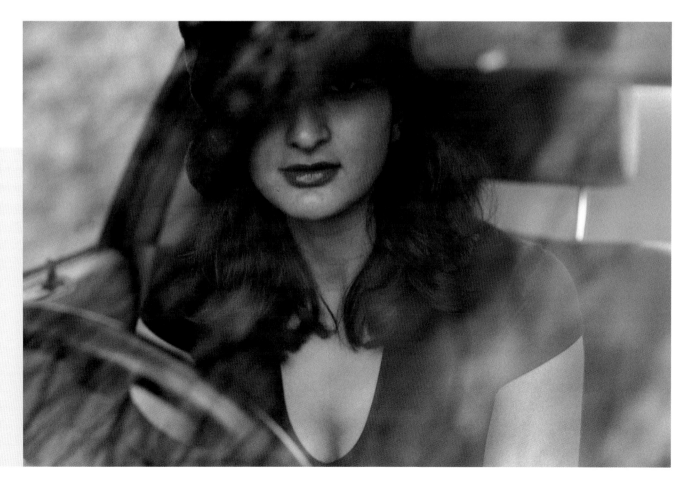

The polarizing filter used for this shot has removed most of the reflections from the car windshield to allow a glimpse of the driver. Without the filter the girl would not have been recognizable.
Nikon F5 with 85mm f/1.8 Nikkor AFD, Kodachrome 200, 1/250sec at f/5.6

EQUIPMENT

REMOTE RELEASES

Many cameras can be operated remotely using one or more of the following systems.

Self-timers

These are usually built into camera bodies, although accessory self-timers are also available. Self-timers release the shutter after a programmed delay – e.g. ten seconds.

Mechanical release mechanisms

Cable releases screw into a shutter release button and, with care, isolate the camera from hand movements. They are typically about 12in (30cm) in length, and are the cheapest and simplest remote release option. Other more sophisticated mechanical release systems are available for particular cameras.

Air releases

These systems use air pressure via a length of flexible tubing. They are cheap and can be up to 30ft (10m) in length.

Electrical release systems

The simplest types consist of a push button connected via a flexible electric cable to a socket on an electronic camera. They are relatively cheap, up to 10ft (3m) in length, and effectively isolate the camera from hand movement. More sophisticated models incorporate an electronic clock for programmed delays or timed exposures.

Infrared systems

These battery-powered systems rely on a line-of-sight infrared beam similar to a domestic television remote control. Maximum range is generally 30–300ft (10–100m). Systems of this type tend to be expensive, but can be useful for studio photography.

Interval timers

These electronic clocks provide sequences of shutter release signals at programmed intervals. They are intended for applications such as time-lapse photography but can be used for self-portraits. They are bulky and very expensive.

SELF-PORTRAITS

There are a number of ways in which self-portraits can be achieved. The simplest is to look directly into a clean mirror, raise a camera to your eye and release the shutter. Remember to focus on the reflection rather than the edge of the mirror. With care, good composition and a suitable background, this can be worthwhile.

Another approach is to set a camera up on a tripod and use a remote release concealed beneath a carpet or inside clothing. Camera alignment can be achieved by tacking small pieces of masking tape onto a wall or screen behind your proposed location so as to define the field of view. If a chair is required, position it well within these limits and set the focus by measurement. A small aperture provides sufficient depth of field to give a margin for error. Once satisfied, remove the tape before adopting a position and releasing the shutter. A self-timer can also be used, although it may not release the shutter at the ideal moment. Some cameras indicate the approach of shutter release with a light or beeper. Nevertheless, adopting the desired pose and expression at precisely the right moment can be challenging.

I do not enjoy doing self-portraits, and find it very difficult to appear natural as the shutter is released. This simple shot was made possible by using the camera's self-timer.
Nikon F5 with 135mm f/2 DC Nikkor AFD, Fujichrome Sensia 100, 1/60sec at f/8

◖ CASE STUDY

SOLARIZATION

Solarization is a false-colour technique that can work well with pictures of people, especially those with good contrast and sharpness. The effect is achieved by exposing a negative in the normal way in an enlarger, and then briefly and uniformly exposing the print to coloured light during the development process. This reverses some of the colours, particularly those in the highlight areas of the image. The colour and intensity of the light, and the length of exposure, have considerable effect upon the result. Solarization can also be achieved digitally using a U-shaped characteristic curve or a filter designed for the purpose. The process is readily variable and can be used to generate all sorts of results.

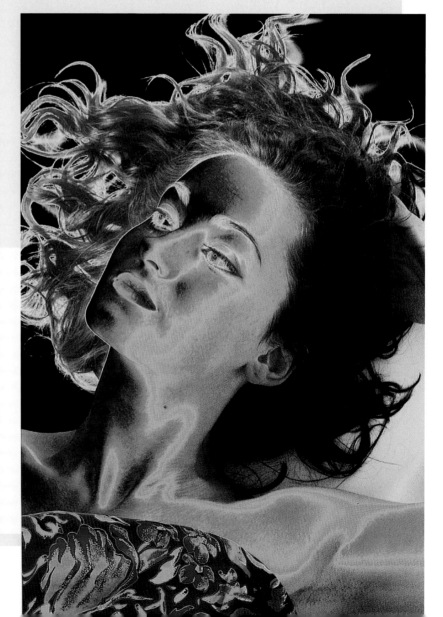

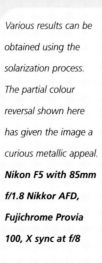

Various results can be obtained using the solarization process. The partial colour reversal shown here has given the image a curious metallic appeal.
Nikon F5 with 85mm f/1.8 Nikkor AFD, Fujichrome Provia 100, X sync at f/8

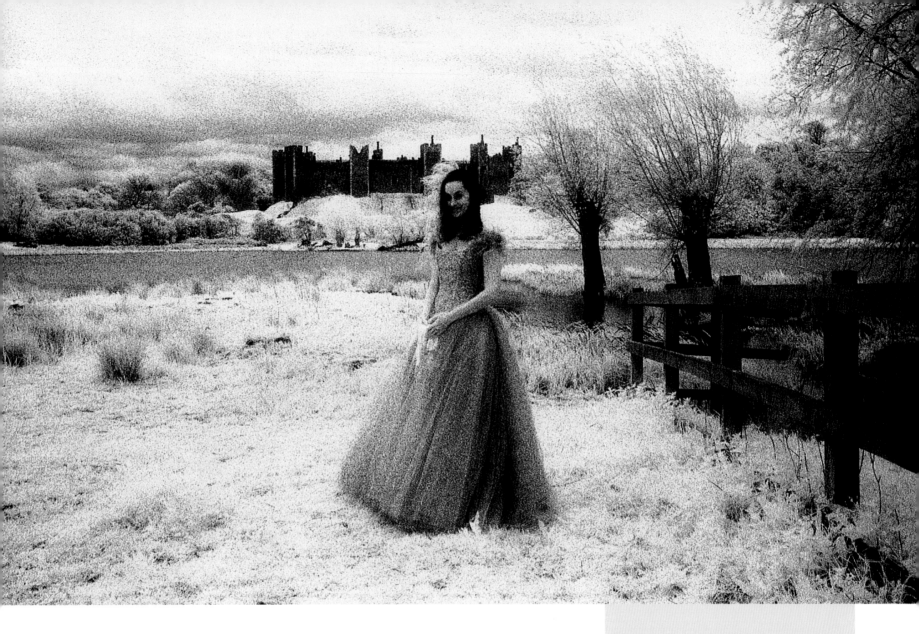

INFRARED

Standard cameras can be used for infrared photography provided the film advance, data back and autofocus systems do not incorporate infrared sensors. Infrared film, which is available in colour or black & white, is sensitive to some of the longer wavelengths of electromagnetic radiation not visible to the human eye or panchromatic film. We can therefore produce images influenced by wavelengths that we cannot otherwise see. This opens up new and exciting opportunities for photographing people.

Some basic rules must be observed when using black & white infrared film. In particular, it should be kept cool and must be loaded and unloaded in complete darkness – removing the film cassette from the canister or camera in daylight will cause fogging. Note also that infrared rays do not focus in the same way as visible light. Instead, focus in the normal manner, note the focused distance, and then turn the focusing ring manually until this distance aligns with the infrared focusing mark on the lens. Set the exposure initially to whatever your

Fresh foliage, old stone walls and timber fences all have great potential in infrared. The model chose the dress because she felt it was appropriate to the castle setting. An opaque infrared filter was used.

Nikon F5 with 50mm f/1.4 Nikkor AFD, Kodak High Speed Infrared, 1/250sec at f/8, infrared filter (IR72)

normal exposure meter indicates, and bracket widely using small or medium apertures. When exposing Kodak HIE infrared film at ISO 200 in direct sunlight, using a red filter, try bracketing around 1/125sec at f/8.

A person's skin is recorded as white if the subject is in direct light. Skin in shadow will be recorded as very dark. Hair and eyes record in broadly the same way as with panchromatic film, but only very dark shades of lipstick will be visible. Fresh green grass and foliage are recorded like

frost or snow. Consequently, it is possible to create unusual and even surreal images. The most evocative results are achieved using opaque infrared filters that absorb unwanted visible light, although a red filter (No.25) is a good alternative.

EQUIPMENT

COLOUR INFRARED FILM

Ektachrome EIR colour infrared film has only limited application for pictorial work, but is fun to experiment with and can be processed using standard E6 chemistry. It incorporates infrared-sensitive dye and delivers rather unpredictable false-colour images when exposed using a yellow filter. Unlike black & white infrared film, focusing adjustment is not necessary, but it must be loaded and unloaded in total darkness to avoid fogging. The film must be stored in a freezer and used fresh because its infrared characteristics degrade rapidly at room temperature.

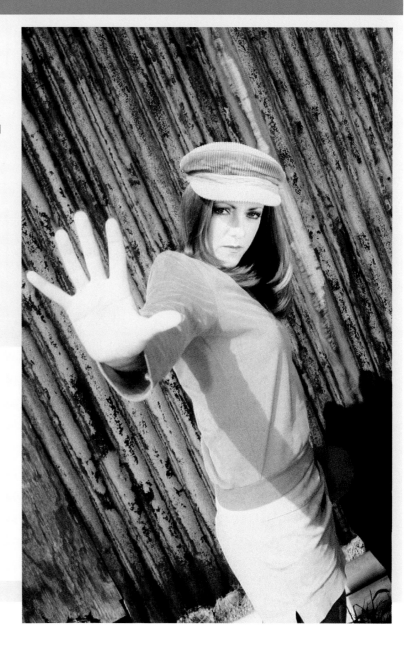

Colour infrared is somewhat unpredictable. The model wore a red top, green lipstick and blue hat and tights. She also dyed her hair dark red – and prayed that she would not meet anyone she knew! The corrugated iron was red with rust. I used a yellow filter.

Nikon F5 with 35mm f/2 Nikkor AFD, Ektachrome EIR 200, Infrared 1/250sec at f/11, yellow filter

THEMES

THEMES

ELDERLY PEOPLE

THEMES

THEMES

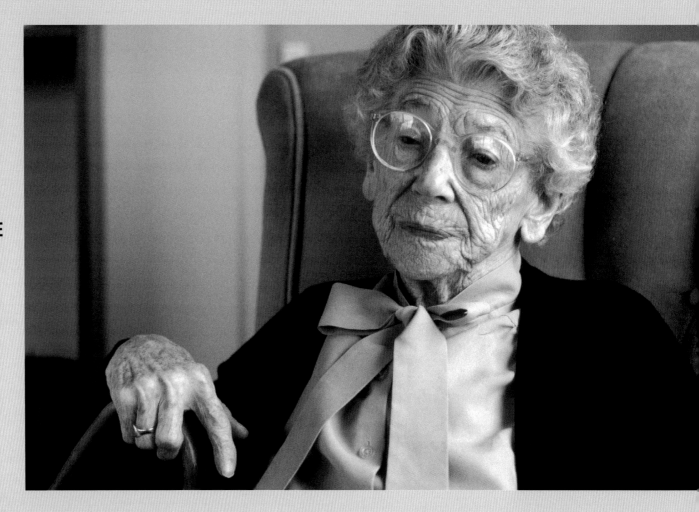

Personality and experience are likely to be more apparent in elderly people. Youthful beauty will have faded and been replaced by thinning hair, wrinkled skin and a face overflowing with character.

Images of men usually benefit from directional light and high contrast. These conditions emphasize strong lines and physical characteristics, and help to reveal the texture of aged skin. The golden hours that follow sunrise and precede sunset are wonderful times to work on character studies of this type. Women may prefer to be seen in a softer, more forgiving light where the physical effects of ageing are less obvious. Where this is the case, try using diffused front lighting that flattens and conceals imperfections.

Elderly people are generally less active than the young generation, and may need more support and consideration. For instance, an elderly man might prefer to be photographed in a comfortable chair, perhaps in the warmth and security of his own home. Under such circumstances, visit the location beforehand to look at the situation. An environment that surrounds him with the paraphernalia of his life might be very appropriate, but the light may be poor and the contrast high. If so, use high-speed film and reflectors or resort to balanced flash.

This lady was pleased to participate in a care-home photography project as she sat in her bedroom. I used natural light in conjunction with a white reflector to maintain the relaxed and peaceful atmosphere.
Nikon F5 with 85mm f/1.8 Nikkor AFD, Kodachrome 200, 1/30sec at f/4

Simple ambient-light portraits such as this one captured in a comfortable care home can take on deeper significance when the individual situations of elderly residents are considered.
Nikon F5 with 85mm f/1.8 Nikkor AFD, Kodachrome 200, 1/30sec at f/5.6

THEMES

THEMES

RELATIONSHIPS & ASSOCIATIONS

THEMES

THEMES

People are usually interested in the relationships of others, and are consequently sensitive to implied associations and circumstances. Personal relationships are most easily suggested in an image by the proximity, attitudes and expressions of the subjects. A couple embracing, with their heads close together, clearly share a warm or loving relationship. However, they could be lovers, siblings, mother and child or just good friends.

Other factors such as sex, relative age and demeanour provide further information, but we may have to turn to the surroundings for confirmation of their real relationship. The situations suggested by an airport and a bedroom would clearly be quite different.

Personal relationships, and associations with possessions or buildings, can also be implied by less obvious means. The way in which people are framed or visually aligned alters our interpretation of an image. Line, shape, eye contact and even colour can lead us to suspect an association of some type. Such devices can also be used to suggest relationships where none actually exists.

The location, presentation and demeanour of the model implies an association with the house – in fact, there is none.
Nikon F5 with 20–35mm f/2.8 Nikkor AFD, Fujichrome Sensia 100, 1/250sec at f/5.6

The expressions and relative positions of the two subjects invite questions about their relationship and the situation in which they are seen.
Nikon F5 with 85mm f/1.8 Nikkor AFD, Kodachrome 200, X sync at f/4

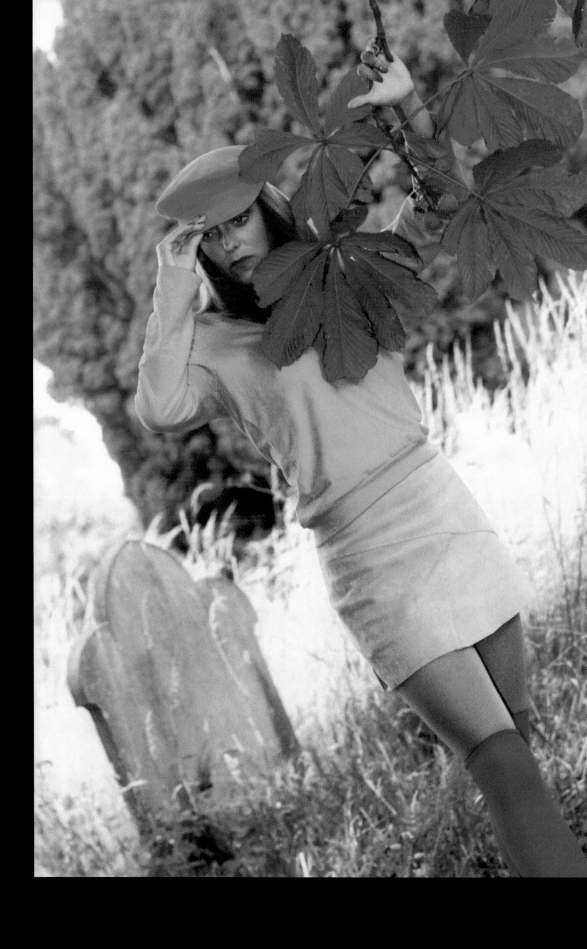

10 DIGITAL IMAGING

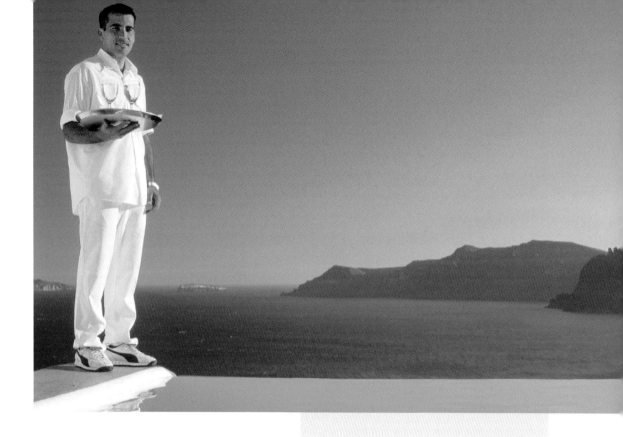

This image was shot on colour infrared film. The colours in this manipulated version are unchanged except for those of the gravestone, the model's hat and tights, and the flesh tones. The stone was selected and more or less desaturated to remove a red cast, and the hat and tights were made bluer. Finally, flesh tones were adjusted to look more natural.

Digital imaging makes use of electronic devices at some point during the capture and reproduction process. Digital cameras store the original image in an electronic memory from which it is later transferred to other media. However, it is also possible to work with film cameras, and then use scanners to digitize prints, transparencies or negatives.

GETTING STARTED

Before embarking on the digital route, think about what you want to achieve. Many people find pleasure in owning the latest photographic and electronic gadgets, but new technology does not necessarily lead to better images. If your objectives are at personal or club level, mid-range equipment will probably suffice. If you intend to contribute at the highest levels or work professionally, it may be worth purchasing the most sophisticated equipment. Before making decisions, consider budget implications versus additional capability, and ask whether you can reasonably manage without each item.

While it is of course possible to replace everything with the latest digital equivalent overnight, a more cautious approach to digital imaging might work better. If you have a significant archive of film-based images, the purchase of a high-resolution film scanner,

I wanted both the horizon and the edge of the infinity pool to be in level in this image, but the physical layout of the area made the ideal angle of view impossible (see original image on page 16). This manipulated version has been rotated to straighten the infinity pool, and the distant mountains then rotated in the opposite direction to achieve alignment.

a computer and colour printer is a good starting point. It is not necessary to have a digital camera, flatbed scanner, graphics tablet or internet connection from the outset.

In broad terms the advantages of the digital approach are fourfold. First, the images are stored electronically, as a series of numbers, and can therefore be manipulated on a computer. Almost any element of an image can be changed: colour, contrast, sharpness, size – even pictorial content.

Second, the duplication process merely generates copies of the numbers that define images. There is consequently no inherent degradation and perfect copies are possible. Third, when using a digital camera, results are viewable almost instantly (on an LCD screen), and unwanted images can be erased from the reusable electronic storage media. Fourth, images can be conveniently manipulated, transmitted and printed in a normal daylight environment.

Unfortunately, there are also a few drawbacks. Digital cameras can be slow to respond when first switched on, and some models exhibit a long shutter lag (the delay between pressing the button and the moment of exposure). They also tend to consume battery power at a high rate, and image resolution may fall short of what film can deliver. Finally, while the art of photographing people remains largely the same whether using traditional or electronic media, post-capture handling and manipulation techniques are quite different. This can result in a steep learning curve, particularly for those with little experience of personal computers and the associated paraphernalia.

Much depends upon expectations and how much you are prepared to pay. A good quality digital camera and accessories, together with a computer, image-manipulation software, storage devices and a photographic-quality colour printer, costs a great deal of money. If images are kept in electronic form this outlay may be partially offset by lower running costs – but printing costs are significant.

IMAGE FILES AND RESOLUTION

A pixel (picture element) is the smallest element produced or used by a device in the creation of an array constituting a digital image. In practice it is usually a tiny square of a precise single colour. The binary numbers (noughts and ones) that collectively define all the pixels of a digital image are assembled into a discrete file of information and stored in a standard format.

The size of an image file depends in part upon resolution. This is a measure of a system's ability to reproduce detail. For input devices, like cameras and scanners, it is usually expressed as the total number of usable pixels and points per inch (ppi) respectively. For output devices, such as printers, it is normally expressed as dots per inch (dpi). Resolution must be sufficient to preserve subject detail and avoid aliasing – the process by which smooth curves and other lines become jagged because the resolution of the image file is not high enough to represent a smooth curve.

FILE FORMATS

Various file formats can be used to store image data, although each was designed with particular criteria in mind. The Tagged Image File Format (TIFF) file is a flexible option typically used for applications where high-quality results are needed, such as magazine and book publishing. Since image files can be very large, however, compression techniques are sometimes used to reduce data-storage requirements. Some compression algorithms achieve huge reductions in file size with little loss of image quality. The commonly used Joint Photographic Expert Group (JPEG) format can reduce file sizes by up to 90% with minimal visible loss of image quality, but its use limits to some extent what can be achieved later with image-manipulation software.

EQUIPMENT

IMAGE SENSORS

Sensors of about 3000 pixels wide and 2000 pixels deep give a total of approximately six million pixels or six MegaPixels (6MP). Although substantially less than the 50–100MP equivalence claimed for ISO 100 35mm film, this is sufficient to produce good-quality A3 prints. More expensive digital SLRs feature larger sensor resolutions, and professional backs for medium-format cameras may achieve in excess of 20MP. A small image sensor, such as those found in basic digital compacts, might produce one million pixels, and are appropriate for prints up to about A6 size.

Many amateur photographers choose the convenience of the JPEG file format when using a digital camera, but other options should be considered. The RAW (NEF on Nikon cameras) format is the most flexible. It can essentially be thought of as unprocessed film since the data written to the storage card comes straight from the image sensor – no in-camera processing is performed. Shooting parameters can be adjusted freely using software supplied with the camera, although this can be time-consuming.

HARDWARE REQUIREMENTS

Computers accept digitized information, process it using an application program controlled by user commands, and store the results in files. There are basically two types of computer suitable for personal use: PCs and the Apple Macintoshes (known as Macs). Both are quite adequate for photographic purposes, but the vast majority of people use PCs with Windows operating systems. A huge range of compatible software is available for these systems and they are good for running several programs simultaneously. Macs are considered easier to use and are the accepted standard for creative work such as advertising and publishing. They also have sophisticated colour management that is important to photographers.

The processor is the brain of the computer, and performs all the calculations required to run software. Its speed and capability are therefore major considerations when choosing a computer. Pentium processors are widely used in PCs, and G4 and G5 processors in Macs.

Random-access memory is the fastest storage and retrieval system for instructions and data. Since digital-image manipulation creates large files it is desirable to have as much system RAM as possible. A hard drive, the principal long-term mass storage device, fills up very rapidly for similar reasons, so choose the largest capacity disk you can afford.

Monitors

A monitor provides a video display of what a computer is doing. For digital imaging, it should be capable of displaying millions of different colours. Various technologies are used to produce a monitor image, and all have their advantages and disadvantages.

Cathode ray tube (CRT) monitors are similar to domestic televisions and provide good image quality at a reasonable price. Increasingly popular are flat-screen thin-film transistor (TFT) monitors.

These are more expensive but flicker-free and less bulky. Examine the same image on various screens before making a purchase.

Printers

Ink-jet printers are cheap to buy and capable of producing good quality prints. The A3 models using six or more colours are probably the best buy for digital photography. Running costs, in terms of photographic quality paper and replacement ink cartridges, are significant.

Scanners

Flatbed scanners, usually A4 size, are useful for digitizing printed images. They can also be used in conjunction with an adaptor to scan transparencies and negatives. However, for film it is better to use a film scanner that produces professional quality scans. A good quality 35mm film scanner scans at 4,000 ppi and produces files of about 60MB.

CHECKLIST

Some suggestions for a basic digital-imaging system:

- A personal computer running at a minimum of 400MHz, with at least 256MB of RAM and 4GB hard-drive space
- A 17in monitor with a resolution of at least 1024 x 768 pixels
- Photographic-quality colour inkjet printer with a minimum resolution of 600dpi
- Image-manipulation software such as Adobe Photoshop
- A 35mm film scanner with a resolution of at least 2400 ppi, or a flatbed scanner with a resolution of at least 600 ppi, or a digital camera capable of producing images of 1280 x 960 pixels minimum

Peripherals

Graphics tablets are the electronic equivalent of pen and paper, and make possible the control of a computer with a pen-like stylus. They are available in various sizes, but A4 is ideal for photographic work. Additional storage devices, such as CD and DVD writers, are useful for archiving large image files that may then be removed from the computer's hard disk. External hard drives, which can be connected to your computer when needed and are available in sizes up to 500GB, provide an alternative solution. In either case, cataloguing software, like Portfolio Browser, or a good numbering system is required to help you keep track of your images and their locations. Modems are commonly used to connect personal computers to the internet, but their speed is limited by the transmission capabilities of analogue telephone networks. Newer digital systems such as ISDN and ADSL are much faster.

Finally, a convenient, tidy and stable working environment is essential. Tailor-made computer furniture need not be expensive and makes life easier in the long term. Good working surfaces, effective filing systems and control over ambient light are also important.

EQUIPMENT

COLOUR MANAGEMENT

A monitor, the output device used by the photographer to view images, must be calibrated to display as accurately as possible the final printed picture. Calibration can be achieved using facilities provided within some image-manipulation software, or by using specialized measuring equipment. Some systems are best used in standard ambient light conditions.

Calibration is the first stage of colour management, which is basically the process of ensuring that image colours are repeatable and accurately reproduced on any calibrated system. A number of ICC (International Colour Convention) profiles exist to help standardize colour management. Those most commonly used are Adobe 1998 and sRGB, with the former accepted worldwide as the standard profile for images used in the media.

The capabilities and dynamic ranges of input devices such as cameras and scanners are different from those of output devices such as monitors and printers. The range of colours that can be reproduced by a device is known as its colour gamut. When an input device has a colour gamut that exceeds that of an output device, the colours that cannot be directly reproduced are compromised.

EQUIPMENT

CARD READERS

Digital cameras may remove the need for a scanner, but the images they capture need to be downloaded for storage and viewing at some point. Various options are available. At home they can be downloaded to a computer; in the field a portable storage device such as a laptop or specialized miniature hard drive must be used. Images can be transferred directly from the camera using a USB or FireWire cable, or from the storage card using either a PCMCIA adaptor or, more commonly, a separate hardware card reader (again via a USB or FireWire cable) such as the one shown below.

IMAGE MANIPULATION

The range of software available satisfies needs at every level. Adobe Photoshop has unrivalled features and is widely used by professional photographers. The full version is expensive, but cheaper, cut-down versions, like Adobe Elements, are also available. Other software, such as Roxio PhotoSuite and JASC Paint Shop Pro, offer good features at reasonable prices.

The possibilities offered by digital manipulation of images are endless, and limited mainly by the imagination of the photographer. Images can be changed in size, reversed, rotated, inverted (made negative), changed from colour to black & white, and even from black & white into colour. Duotones, tritones and quadtones are all possible, hues and saturations can be changed, moods altered and special effects easily achieved. Most significantly, however, the pictorial content of the image can be changed. A person can be removed completely from a group, a head can be transferred to another body, eyes can be made

larger and legs lengthened. A press photographer recently told me that it was months since his football pictures had been printed without the ball being repositioned.

Nevertheless, some facilities offered by image-manipulation software have parallels in traditional photographic practice, and these remain among the most commonly used.

Cropping

Cropping is the digital equivalent of cutting a paper print with a guillotine. An area of an image is selected using a 'marquee' tool, or by specifying numerically precise dimensions, and pixels outside the boundary are deleted. File size will be reduced provided image resolution remains unchanged.

Dodging and burning

Dodging and burning are traditional techniques for changing the local density of an image. They are most commonly used in shadow

and highlight areas where contrast is low and existing detail needs to be revealed more clearly. Dodging reduces the density of an area, and burning increases it. Colour dodge and colour burn tools brighten or darken an area of a digital image, and also increase contrast to make detail more visible.

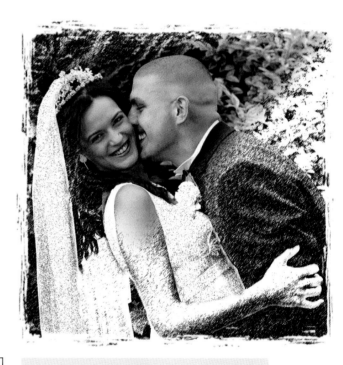

This is the opening page of a wedding album. The background image was created by removing colour information and then adjusting levels and contrast using the curves control. The image of the couple was reduced to little more than a watermark so that the text, which was added as a separate layer, would dominate.

The Wedding of

A Model
and A Guy

at 3.30pm

on Thursday 19th July 2004
at St Someone's Church, Ipswich,

followed by a reception at
The Best Hotel, Felixstowe.

This simple but effective technique can be used to highlight a particular area of an image. The coloured triangle was selected, and the selection then feathered and inverted. A graphic pen was applied to the outer area, before an edge effect was applied to complete the process.

Mosaics can be created in a number of different ways.
This one was produced by progressively moving a standard
square selection around the original digitized image, taking
copies of slightly overlapping pre-planned areas. The copied
selections were pasted into precise positions in a new image
to obtain an improperly registered view.

RETOUCHING

The digital equivalents of spotting and retouching are mostly carried out using 'cloning' or 'healing' tools. These take reference pixels from an area of an image and insert similar information elsewhere. Various controls determine the size and shape of the referenced area, and the extent to which the original pixels are covered by the pasted information. Spotting is used to conceal small defects but does not substantially alter the content of the image. For example, dust specks may be removed by overwriting them at maximum density with pixels taken from an adjacent area of the image. Retouching is a similar process carried out on a larger scale and might be used, for example, to remove facial blemishes or untidy hairs.

The complete restoration of old images is a field of work that has been opened up considerably by image-manipulation software. Damaged, faded and even incomplete prints can be restored using cloning, healing and numerous other techniques. The work is painstaking, and hence expensive to have done professionally. Nevertheless, in the case of a priceless old family photograph it may be worthwhile.

Shadows cast by the model onto the background were removed by selecting the figure, inverting the selection, and then deleting everything to expose a white base. The small shadows around the feet and cane were carefully preserved and pasted back into the final image.

This image was created from the picture on page 54. The original slide was scanned and saved as a greyscale image before applying a solarization filter. Levels adjustments were then made before applying a fresco filter. Finally, the image was inverted and adjusted using curves.

Colour control

Changes can be made to the colour of an image by use of 'colour balance', 'levels' and 'curves' controls. Colour balance is about achieving neutrality, or the appearance of a scene illuminated by white light. Colour balance controls generally make global changes to remove colour casts, but their application can be limited to some extent. Levels controls provide separate adjustments for each colour channel, and greater control over the brightness of highlights, mid-tones and shadows. The curves control is by far the most capable tool, allowing the whole range of tonal reproduction in each channel to be controlled according to a user-defined curve. For example, a colour cast could be removed from shadow areas of a portrait without affecting the remainder of the image.

The 'replace colour' control makes possible the direct replacement of pixels of particular hues by those of others. It is useful for strengthening or weakening colours that do not reproduce well.

PRINTING

An image is a mosaic of pixels arranged in a grid, each element having an unique address consisting of horizontal and vertical coordinates. As with traditional chemical prints, the quality of reproduction falls as the size of the print increases and the available information is spread more thinly. In practice, an A4 image rarely needs a file size greater than 12–15MB. More information, or greater resolution, produces little visible improvement in the printed image.

Digital printing has made it possible to print onto a wide range of materials having very different colour saturations, contrasts and textures. However, the best initial results with inkjet printers are obtained using a custom-made photographic or art paper having a reasonably consistent finish, absorbency and permanence. Working with paper manufactured for your own printer will give a reasonable result, and encourage understanding of how the material behaves with your printer and images. Photo-quality papers are available with various weights and coatings, and with matt, lustre and gloss finishes. Art papers are ultimately more interesting, but results are less predictable because of their increased absorbency and open texture. The range of such specialized materials is constantly expanding, so find out what's available and be prepared to experiment.

Once satisfied with an image on the monitor, the challenge is to transfer it to paper. It is at this point that deficiencies of basic colour management become apparent. Printers are designed to work with the ink supplied by the manufacturer, and printer software may not be

Texture has been added by blending the original picture of the model with a separately scanned texture image. All sorts of everyday items can be used to obtain suitable textures. In this case, a linen table napkin was scanned in a flatbed scanner.

able to cope with colour imbalances and other problems arising from third party or cheap replacement inks. Such products may serve you well, but don't attempt to use them until the limitations of basic printing as recommended by the printer manufacturer are well understood.

The permanence of a digitally printed photographic image depends upon the characteristics of the media and ink used to create it. Inks fade with time, particularly when colours are exposed to strong light. Since some colours fade faster than others, the effect shows itself as an overall colour shift. Pigment-based inks and black & white images are generally more stable than dye-based inks, but papers can also change in colour with time. Nothing survives extended exposure to direct sunlight. However, archival papers remain neutral when exposed to small levels of atmospheric acidity, and consequently should not suffer from discolouration as quickly as cheaper papers.

ON LOCATION

ON LOCATION

SIMPLE SITUATIONS

ON LOCATION

ON LOCATION

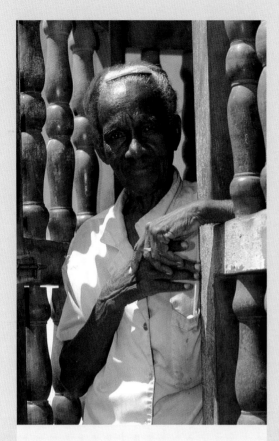

This Cuban woman was watching the world go by from her front door. The characteristic woodwork had already caught my eye and I had spent some time searching for this opportunity to use it.
Nikon F5 with 50mm f/1.4 Nikkor AFD, Fujichrome Sensia 100, 1/250sec at f/8

This shot was not set up in any way – the child had fallen asleep while playing, and the image was captured looking down vertically to the floor.
Nikon F5 with 50mm f/1.4 Nikkor AFD, Kodachrome 200, 1/30sec at f/4

GENERAL CONSIDERATIONS

Good images of people can be created in the simplest of circumstances. Indeed, simplicity can be the most powerful element of an image. If an environment is overcomplicated or cluttered, try closing in on interesting elements that provide meaning or context. Then consider how these relate to other features and to the subject. Colours, lines, shapes and textures are all powerful when used as elements of simple compositions. Colours can be used to frame the subject, shapes and lines provide depth and direction, and textures add interest to surfaces. A setting based around a doorway, or an old boat lying on a beach, may well have more impact than a visually busier location.

EQUIPMENT AND TECHNIQUE

Although it is best to have a couple of ideas in mind at the outset, these inevitably develop as the session progresses. Flexibility is enhanced by mobility and minimal equipment, so use a hand-held camera fitted with a camera-mounted flash wherever possible. Encourage your subject to contribute creatively and explore various camera positions and angles of view. Try to establish some sort of continuity with the flow of events as this maintains the energy and sense of purpose for both subject and photographer.

LIGHTING

Beautiful natural light is generally all that is required, although where contrast needs controlling it can be supplemented by using fill-in flash or a reflector. Visit the location at various times of the day before the planned session, and observe how the light changes. The golden hours following sunrise and preceding sunset are always worth investigating.

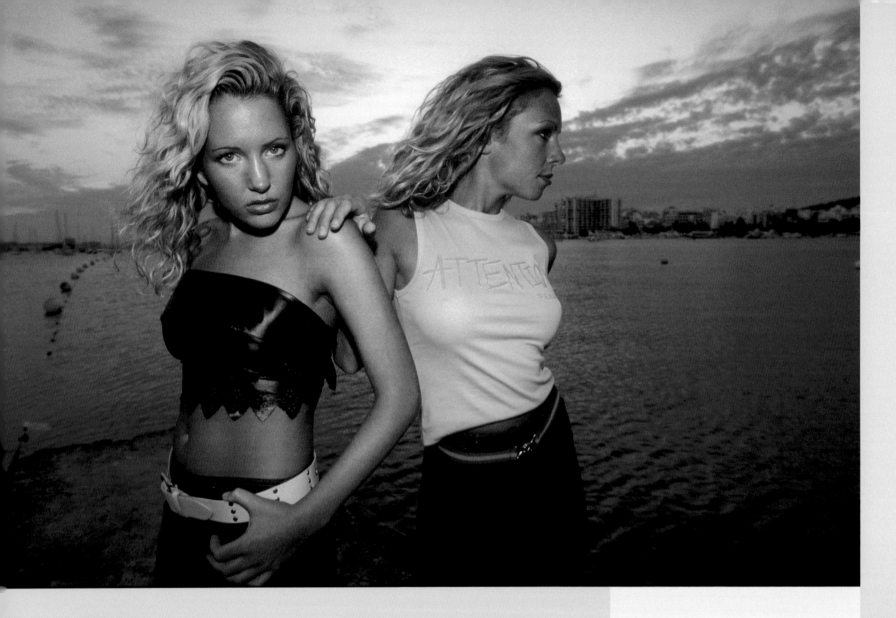

PRO TIP

Simplicity exists in many forms. For example, consider using the colours of rusting corrugated iron, the texture of stonework or the unyielding nature of a bare wall as a backdrop. Where nothing suitable is available go in close or experiment with a high camera angle. Using the ground as a backdrop helps to reduce unwanted detail. Expectations also need to be kept under control. Plan realistically and don't try to cram too many concepts into the time available – you will find that progress is often slower than expected. It is better to do a couple of shots well than to try numerous ideas, get them all wrong and end up with nothing.

A simple jetty in Ibiza, Spain, was the setting for this early evening shot. A crowd of onlookers watched as the models changed their clothes behind reflectors!
Nikon F5 with 20–35mm f/2.8 Nikkor AFD, Fujichrome Astia 100, 1/60sec at f/5.6

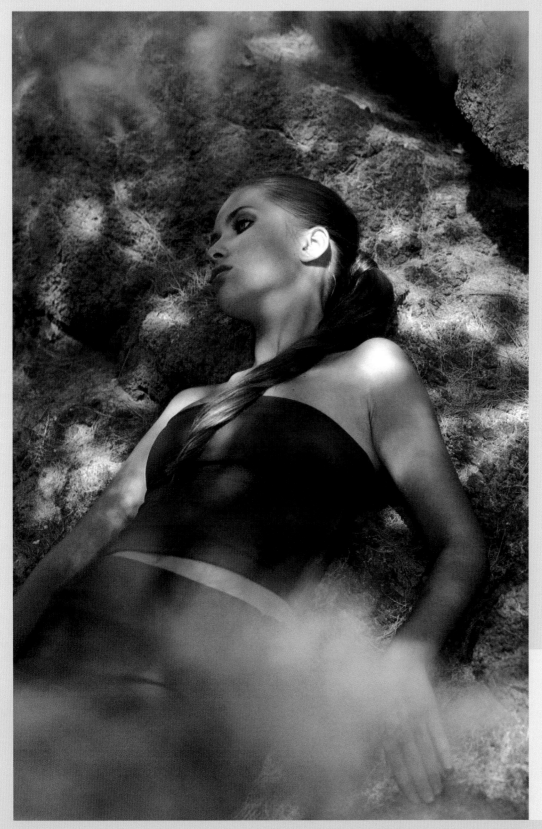

This shot was taken from a café balcony in Santiago de Cuba. I waited until the woman approached the most interesting section of the wall before releasing the shutter.
Nikon F5 with 135mm f/2 DC Nikkor AFD, Fujichrome Sensia 100, 1/250sec at f/5.6

The rocks made a convenient pillow and an uncluttered background for this model as she relaxed between sessions in Greece. She realized she was being photographed but made no attempt to adjust her position.
Nikon F5 with 85mm f/1.8 Nikkor AFD, Fujichrome Astia 100, 1/125sec at f/5.6

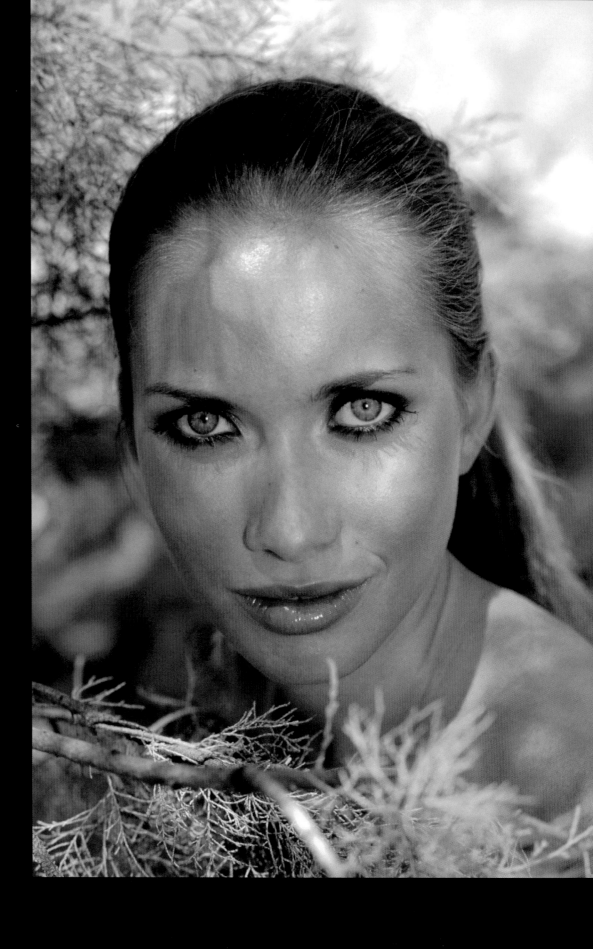

FINISHING, PRESENTATION & PUBLICATION

11

Well-considered presentation can change a good image into something special.

The style and weight of a frame, and the colour and design of a border or mount, have a significant effect upon the impact of even the finest work. Time and effort invested in this last stage are normally well rewarded, and may separate your images from the work of others.

CARING FOR DETAIL

Attention to detail is always important but frequently overlooked. Dust spots, stray hairs on a face and other tiny imperfections all detract from the end result, so it is worth making the effort to remove them.

The process of removing small defects, known as spotting, was traditionally carried out using dyes that were mixed to achieve a perfect colour match and then applied with fine brushes. Glossy surfaces were the most difficult to spot because surface irregularities were easily noticed, although black marks could be tricky to remove from any surface. Retouching, a process similar to spotting, was used to remove more significant defects, scratches and damage. It involved applying dyes and paints, and using sharp blades

to scrape blemishes from prints. Airbrushing was used for larger-scale modifications such as the removal of unwanted shadows or background detail. The relevant area of a print was masked and then carefully sprayed with water-based or spirit-based pigments. In skilled hands remarkable results could be achieved.

In recent years, digital manipulation has revolutionized the methods used for work of this nature. However, the basic objectives remain unchanged and the digital techniques demand no

This model was positioned in patchy light amid the branches of a tree. The intention was to create interesting shadows on her skin.
Nikon F5 with 105mm f/2.8 Micro Nikkor AFD, Fujichrome Astia 100, 1/250sec at f/8

This colour transparency was badly scratched on the emulsion side. However, careful progressive use of healing and cloning tools has rendered it usable.

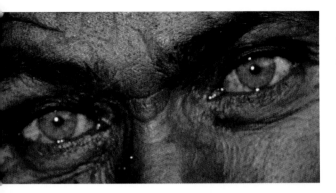

Removing unwanted reflections and secondary highlights from eyelids and the corners of eyes can enhance the intensity of eye contact. The complete image appears on page 2.

PRESENTING IMAGES

Good images usually represent the investment of considerable effort and so deserve to be seen and appreciated. Prints are more satisfying when appropriately mounted, and slides have more impact when projected to best advantage.

For general purposes, consider displaying better images in one of the many types of album available. This approach protects the prints and provides convenient archiving and handling. Favourite images can be enlarged, perhaps to 15x10in (38x25cm), and framed for display on a wall. Simply dry-mount or spray-mount the print onto card and place it under a mat or window cutout.

The mat colour and design should complement the image and frame without being overpowering. It should be cut with an angled blade to slightly smaller dimensions than the print; this enhances presentation and provides for some movement and cropping. The print, sandwiched between the two layers of card, can then be framed behind a sheet of thin glass. Anti-glare glass subdues reflections but generally reduces impact by diffusing and muting colours.

The colour and design of the mat change perception of the image. Both are a matter of personal taste, but good starting points for colour images are black, white, neutral colours such as buff or grey, or a characteristic colour selected carefully from within the image. Designs are generally better when kept simple.

less experience or attention to detail. In portraits, for example, where the eyes are so important, secondary highlights produced by multiple light sources or moisture on the eyelids might be removed to enhance the intensity of a gaze. Whatever method is used, it is the skill and patience of the photographer that counts. High standards are achieved only where there is the determination to identify and eliminate defects. The necessary techniques are available to us all.

The size and style of a framed image are a matter of choice, but remember that overall dimensions grow as a mat and frame are added.

In exhibition environments restrictions will be placed upon the size and style of presentation. Prints submitted to small exhibitions, such as those staged by photographic societies, are usually just sandwiched temporarily between a mat and a backing board using masking tape, and no frame or glass is used. Those hung in more formal exhibitions will be required to observe gallery rules.

Transparencies are ideally presented in clear A4-size sheets that typically accept up to 24 mounted 35mm slides. Sheets of this type are available in flexible plastic suitable for ring binders, or as rigid journals that open like books. Both types offer considerable protection and can be placed on a light box for viewing. Slides can also be projected onto a screen using a projector. This is particularly effective because the increased size of the projected image enables large numbers of people to view photographs simultaneously.

Vignettes may be used to conceal unwanted background detail, and can be created in countless different shapes and styles.

USING AND PUBLISHING IMAGES

The most reliable way to establish whether your images are good enough for exhibition or publication is to seek the opinion of an independent expert. Appropriate people might be contacted through local photographic clubs. Alternatively, try for one of the widely recognized distinctions offered by organizations, such as the Royal Photographic Society (RPS), the Photographic Society of America (PSA), the Australian Photographic Society (APS) or La Fédération Internationale de l'Art Photographique. The assessments are excellent benchmarks against which work can be

measured, and an invaluable source of constructive feedback. You may not like what you hear, but it is worth listening.

Another way to get your work noticed is to send about 20 of your best images to the editor of a magazine. A portfolio of this sort can be submitted electronically on CD, or as prints or slides. Don't expect an immediate response; editors are busy people and may hold your work for a few months if it is felt that it might suit a forthcoming issue. A further possibility is to enter photographic competitions offering worthwhile awards and prizes, and see how your work measures up against that of others.

The path chosen is a personal matter. Some photographers seek nothing more than the joy of creating images; others have competitive spirit and pursue awards at club, regional, national or international level. A minority pursue publication through picture libraries, magazines, books and the internet.

INTERNET PUBLICATION

The internet is an exciting medium increasingly used by photographers to publish their work. Images must be digitized, and you must have a computer connected to the internet to access the Worldwide Web. It is then a matter of deciding what you want to achieve, and establishing an

CHECKLIST

Submitting images to publishers:
- Check relevant magazines and books to see what types of images are used
- Unmounted transparencies – either 35mm or medium format – are preferred
- Mounted transparencies must be without glass
- Avoid using film faster than ISO 400 wherever possible
- Duplicates are of lower quality and higher contrast and will be rejected
- Negative images and prints are not generally accepted
- Good quality black & white images should be submitted as prints
- Digital images of sufficient quality and file size may be accepted on CD – seek advice regarding preferred formats
- Published images must reproduce to full page at 300 dpi

CHECKLIST

Submitting images to picture libraries:
- Contact picture libraries for submission guidelines and advice
- Select a library specializing in images of people
- Submit CDs or colour photocopies that do not need to be returned – not originals
- Good libraries have numerous clients and a good understanding of the market
- They sell reproduction rights – copyright remains with the photographer
- Commissions on sales are typically 50%
- Check contracts for details of payment and periods of retention
- Minimum submission may be 50 or more images
- Contributors may be required to commit to regular submissions of new work
- Sales take time to accumulate – be patient

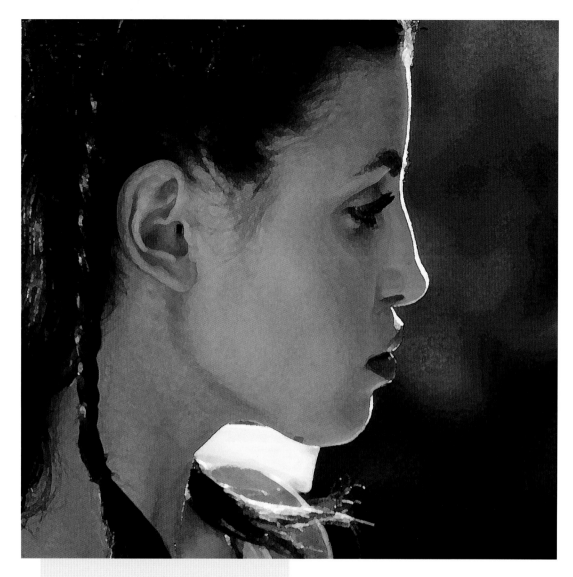

This image was part of a portfolio of close-up face shots created for a publisher. The digital processing is similar in effect to that of a watercolour filter.

COPYRIGHT AND RELEASE

Copyright is handled in different ways in various parts of the world. Its relevance to a photographer's work is consequently difficult to address briefly. Add to this the ways in which images and publications cross national boundaries and the result is a legal minefield.

Photographers, as copyright holders, have exclusive rights to exploit their work, but licences enabling others to use images can be granted. These normally specify when, where and how material may be used, and what the copyright holder will be paid. For example, if you were fortunate enough to capture an extraordinary event in a sharp, well-composed image you might offer it to a national newspaper. The editor would probably be willing to pay a considerable amount of money for your work, particularly if copyright was transferred to the newspaper.

A final issue, not directly related to copyright law, is that of the rights of a subject or model. In most countries, people may be photographed in public places and the images published without obtaining consent. However, if the cooperation of the subjects was obtained, the photographs were shot in a private place, or the images are to be used commercially (such as in advertising), it is only reasonable to seek permission before proceeding. The normal way to do this is to ask those concerned to sign model release forms (see page 198), specifying how the images may be used. A parent or guardian should sign release forms relating to images of minors.

appropriate website. This can be a simple selection of images made accessible to friends and relatives through a basic personal site, or a sophisticated picture library. In the latter case it should include a statement of purpose, background and contact information, and an indexed library of images.

Alternatively, there are numerous organizations that run professional websites designed to facilitate the publication of your images. For an agreed monthly subscription your selection of images is incorporated into a site featuring numerous photographers and types of image. Such sites are well advertised, easily found by surfers, and likely to be seen by interested people all over the world.

CASE STUDY

USING COPYRIGHT

Copyright exists to protect the rights of people who, through their own intellect or skill, create original work. It protects the right to control, copy, publish or broadcast images. In most countries photographers do not need to register to obtain such protection; they automatically hold the copyright to every image they create, and there is no absolute requirement to declare ownership. It is nevertheless good practice to attach the copyright symbol, your name and the year – for example, © Rod Macmillan 2004. However, copyright does not protect ideas upon which images are based. Other photographers are free to recreate them unless releases are covered by non-disclosure agreements.

In the case of digital imaging it is possible to make perfect copies of an original file, so work uploaded to a website is open to abuse. Also, read the small print before using free web space. It may specify that copyright is transferred to the service provider. Further difficulties arise when parts of a copyright image are incorporated into another photographer's digital image. This is resolved, in general terms, by considering the significance of the copyright element in the composite image. If the new image is substantially dependent on the copyright element, copyright may have been infringed.

EQUIPMENT

IMAGE FILE SIZE

Images consist of large amounts of data, and can be slow to download. This is frustrating and discouraging for users of a website. It is therefore necessary to optimize images for internet use. Essentially, this means that each one must be reduced to a minimum size, and compressed using the JPEG or PNG format, prior to uploading. Unfortunately, images of people do not tolerate as much compression as those of other subjects. Subtle contours and tones, such as those of a face, betray loss of detail well before busier textured features. An effective solution is initially to offer surfers a number of thumbnail images that download rapidly. These should be of sufficient quality to enable a selection to be made prior to downloading a larger, higher-quality image.

Gallery

Image 8
Two girls, Ibiza, Spain

© Copyright R H Macmillan 2004

This image is taken from my personal website. Users should always be clear about their position within the overall structure of the site, and how to shortcut to help, contact information, the home page, and so on.

CASE STUDY

WATERMARKS

Two different types of watermark can be added to digital images to offer some protection against misuse. Both normally consist of a copyright statement, a name and contact information, or an unique code embedded within an image in a manner that makes it difficult to remove. True professional watermarks are virtually invisible, but can be detected by image-manipulation software such as Adobe Photoshop. The second type consists of a simple identification or copyright statement 'embossed' over a vital part of an image. Ownership is clearly visible but the content of the image is not substantially obscured.

It is good practice to ask every model to sign a model release form for each session of work. Although not necessarily a legal requirement, such documents record details of agreements between models and photographers regarding payment, publication of the images and so on. The wording of a release can be changed to suit particular circumstances, but the essential information is normally as shown.

Model release form

PHOTOGRAPHER'S DETAILS:

NAME:

ADDRESS:

TEL: FAX:

EMAIL:

PURPOSE OF PHOTOGRAPHIC WORK:

DATE OF WORK:

LOCATION WHERE THE WORK WAS UNDERTAKEN:

IMAGE NUMBERS:

USAGE OF IMAGES (EXCLUSIONS, SUCH AS THE INTERNET, MUST BE STATED):

FEES PAID:

I permit the photographer and his/her licensees or assignees to use and publish the specified photographs in accordance with this agreement. Drawings, reproductions and adaptations derived from the photographs are similarly released.

I understand that the images will be deemed to represent an imaginary person unless otherwise agreed in writing by myself or my representative. I also understand that I do not own or share the copyright of the photographs. I am over 18 years of age.*

NAME OF MODEL (IN CAPITALS):

SIGNATURE OF MODEL OR REPRESENTATIVE:

DATE:

CONTACT DETAILS FOR MODEL OR REPRESENTATIVE:

NAME:

ADDRESS:

TEL: FAX:

E-MAIL:

SIGNATURE OF WITNESS:

DATE:

In accepting this release the photographer undertakes to use the copyright material only in accordance with the stated conditions.

SIGNATURE OF PHOTOGRAPHER:

DATE:

Models who are under 18 years of age must produce evidence of consent by their parent or guardian.

About the author

Roderick Macmillan has been involved in photography for over forty years. He is a Fellow of the Royal Photographic Society and the Royal Geographical Society, and has spent many years travelling the world with his camera. It is this experience that has given him an infectious enthusiasm for photographing people and striving to capture their unique personalities, surroundings and circumstances.

Roderick's work has appeared in numerous publications, including magazines and the *Photography and Imaging Yearbook 2002* (Fountain Press). He also gives regular talks to photographic groups.

Index

Photographers' Institute Press,
Castle Place, 166 High Street, Lewes,
East Sussex BN7 1XU, United Kingdom

Tel: 01273 488005 Fax: 01273 402866
Website: www.gmcbooks.com

Contact us for a complete catalogue, or visit our website.
Orders by credit card are accepted.